ROWLAND B. WILSON'S
TRADE SECRETS

NOTES ON CARTOONING & ANIMATION

ROWLAND B. WILSON'S
TRADE SECRETS

NOTES ON CARTOONING & ANIMATION

Rowland B. Wilson

Suzanne Lemieux Wilson

Focal Press
Taylor & Francis Group

NEW YORK AND LONDON

First published 2012
This edition published 2013 by Focal Press
70 Blanchard Road, Suite 402, Burlington, MA 01803

Simultaneously published in the UK
by Focal Press
2 Park Square, Milton Park, Abingdon, Oxon OX14 4RN

Focal Press is an imprint of the Taylor & Francis Group, an informa business

Notices
Practitioners and researchers must always rely on their own experience and knowledge in evaluating and using any information, methods, compounds, or experiments described herein. In using such information or methods they should be mindful of their own safety and the safety of others, including parties for whom they have a professional responsibility.

Product or corporate names may be trademarks or registered trademarks, and are used only for identification and explanation without intent to infringe.

Library of Congress Cataloging-in-Publication Data
A catalog record for this book is available from the Library of Congress

ISBN: 978-0-240-81734-7 (pbk)
ISBN: 978-0-240-81735-4 (ebk)

Typeset in Futura Book
by MPS Limited, Chennai, India

Contents

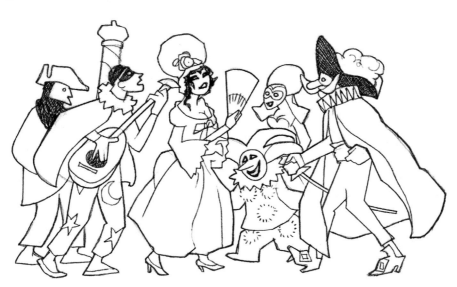

Foreword

TRADITION AND ORIGINALITY

Tradition is the way that has been discovered to do it right.

It's not that it is so hard to find out the way to do it right, which is always the simple way. It is just that the ways to do it wrong are so many.

They are all the other ways than the traditional way.

The problem is to find a way to express your ideas within the tradition.

This can be done in a collection of single modifications of the tradition. These modifications usually relate to the individuality of other artists who work in the tradition.

In other words you can do whatever you like in the areas where the traditional artists differ, but you should hew to the areas that traditional artists have in common.

When you discover what all these other artists have in common, that is the tradition and you should follow it. Everything else is open for interpretation.

The sum total of all these interpretations (and they are many) is your originality and individuality.

And it will be built on something solid.

You can't improve on art—you can only make more.

You can't do better than Rembrandt by putting more highlights in the eyes or making the background murkier. You can only try and learn his principles and apply them again to something else.

You can't make a better classic—only another one.

Art is the extremely hard work of making it look easy.

There is none harder.

THE REMEDY PARADOX

If a thing seems insufficient then subtract some of it. If a thing seems too much then add to it.

Don't let your head get in front of your eyes!

Following the rules of draftsmanship, design, perspective and light doesn't make you look smart. It only stops you looking stupid.

Art is the extra you do after you've gotten all the questions right.

It's what you do after you know it all that counts.

Apply the principles of Drawing to Life.

EXCELLENCE AND PERFECTION

What's wanted is excellence, not perfection. Perfection exists alone. It needs nothing.

Excellence satisfies a relationship in a good way. One of many good ways. There is no better or best in excellence. There is only good. Non-excellence is non-good. It is not partly good, partly mediocre, partly awful—it is simply not excellent. That means it doesn't satisfy its responsibility to complete the whole. Period.

A nut is excellent if it secures a bolt. It's an either–or proposition, related to a specific case.

A play or work of art is a much more complicated object than a nut but it too has a specific function. It satisfies its requirements to the artist and the audience.

And there are unlimited numbers of ways it can do this.

Perfection suggests there is only one way this can be done. This can only be true if there were only one artist and one audience. Perfection is a monologue, not a dialogue.

Sometimes a thing is so hard to do that in order to get it right, you put so much effort in it that it turns out perfect.

What can you do? You can't throw it away just because it's perfect.

You have to be flexible about these things.

Grains of sand in the hourglass of time. The day of liberation comes. The sun comes up like any other day.

The grains of achievement pile up until the thing is done.

The grains of degeneration pile up until the thing is gone.

Put something positive in every day. Take something negative out every day.

Life is a compromise.

Since there isn't enough time to do it all first best, do it second best. And just select what you will do first best.

THE SPIRIT OF SACRIFICE

You can sacrifice without being great, but you can't be great without sacrifice.

Sacrifice means taking twice as long to do a job better, thereby sacrificing either leisure time or earning time.

An artist's potential is circumscribed by his willingness to sacrifice—regardless of his ability.

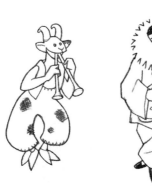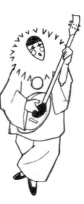

KNOWLEDGE, WISDOM AND INFORMATION

Knowledge is knowing that success requires knowing.
 Wisdom is knowing that success requires knowing what others know not.
 Information is the What.
 You may succeed without knowledge or wisdom but you can't succeed without information.
 Information is a commodity like gold and should be treated as such.

 "Talent" suggests a facility to manipulate materials.
 "Vision" is a way of questing for a specific look that is seen in a thing—that you wish to bring out more sharply and definitely.
 Vision can be emotional, warm, happy, frightening, humorous, serene, contrasting or conflicting, et cetera.
 Or vision can be intellectual—the expression of structure, function, operation.
 Beauty is the successful, shapely, economic expression of the vision.
 Talent is a means—a tool.
 Vision is the guiding idea.
 Art is the realization of the two.

Rowland B. Wilson

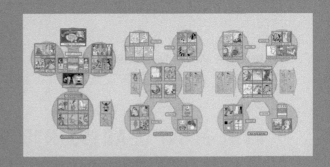

INTRODUCTION

THE FLOW CHARTS

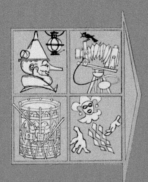

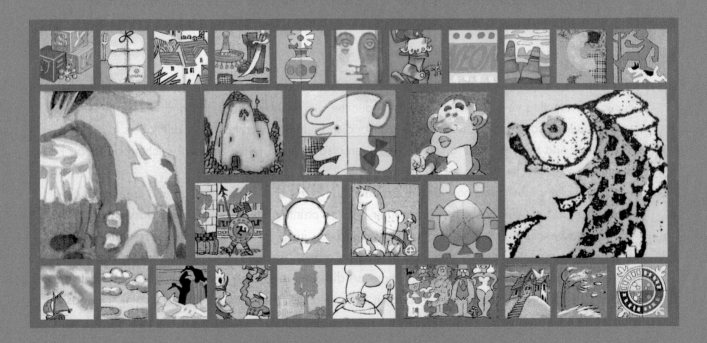

THE FLOW CHARTS: INTERPRETATION, COMPOSITION AND RENDITION

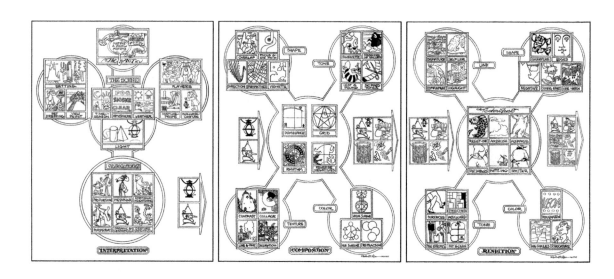

Intention: The picture is not the event. It is a telling of the event by an artist who was there. It should always look like his drawing and never the real event. The story is a system within a system.

A compatriot said it is as difficult to be a work-for-hire artist as a fine artist. You don't have the luxury of selecting your subject. Anything under the sun and beyond it can and will be thrown at you. However complicated, unpalatable, outlandish or indescribable it is—your job is to make it believable and beautiful and to sell it. "Sell" can also be used in the sense of pitching an idea or submitting a character design for animation.

The challenge becomes how best to organize the array of elements that go into creating a picture. Many artists when asked to name their favorite painting say, "The one I'm working on." It's so new and exciting that it is tempting to thoughtlessly jump into the finish (and essentially waste a lot of time repeating earlier mistakes). Taking on a new assignment can be confusing when you have to consolidate the ideas of one or more art directors regarding various products, characters, settings, typography, and logos. In addition to content are the considerations of color, composition, continuity and style. There is almost always a deadline. Although each illustration, cartoon,

animation or game seems unique, it's important not to waste time solving the same problem over and over again. No matter what the genre, certain aspects of image-making are universal.

Efficiency is the key: a logical sequence of steps to avoid backtracking. It is disconcerting to paint something perfectly and then discover a drawing mistake. The goal is to solve each aspect before going on to the next.

> "THERE ARE A MILLION WAYS TO DO IT WRONG...
> BUT ONLY ONE WAY TO DO IT
> RIGHT ! "

The animation industry developed a very efficient method that departmentalized each stage of the film. It begins with solving as much as possible before going into production. Concept, story and character design will all be worked out before moving along to layout, animation, color model, background and others.

Here is a system that combines the organization of animated film production with the concept of computer flow charts. The object was to devise a methodical approach that could be applied to any art genre. The first stage, Interpretation, is about conceptual ideas and design considerations. The next, Composition, covers the arrangements of space, shapes, values, and line on page or screen. Finally is Rendition, the actual finishing of the art in digital or real media. Most often it's the part you want to do first but it is only all the more exciting and successful when all the steps leading up to it have been resolved.

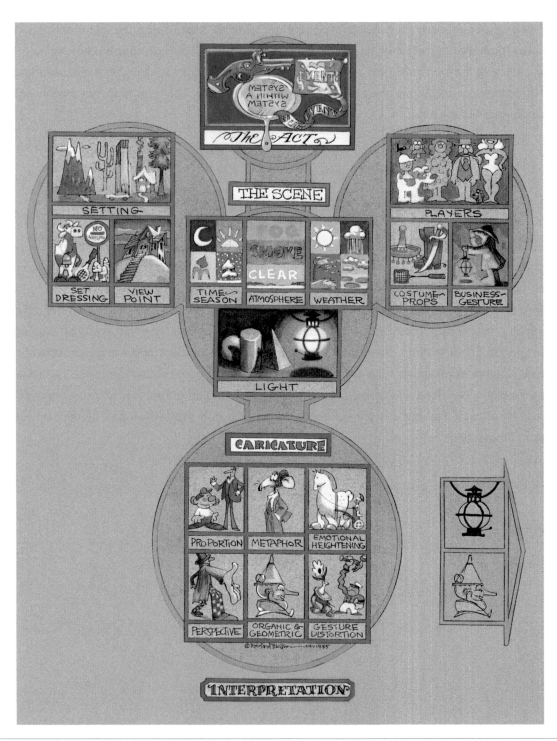

CHART 1—INTERPRETATION

INTERPRETATION

It has been said that everyone wants to direct. When you begin your work, whether it is an animation, a graphic novel, a concept design, an illustration, a four-color cartoon or any visual rendition, consider your role as the Director. You may also be the Playwright, Author, Composer or Impresario if it is your own original material. You are in charge of each and every aspect of the piece. As you move through the process of creating it, you assume varying roles. For example, faced with a Script, which is essentially the Idea, you become the Concept Artist, perhaps using thumbnail sketches to get thinking down on paper. Next, you "wear the hat" of the Art Director and break down your script into panels and pictorials. Sequentially you may wear many other different hats in your creative journey, as an Editor, Writer, Graphic Designer, Character Designer, Costume Designer, Choreographer, Stylist, Set and Lighting Designer, Renderer, Letterer and many more.

We will briefly touch on the elements of each stage and discuss them at greater length in the chapters that follow.

The Act

Start with a fanfare!

Essentially one works from invention—through interpretation, composition and rendition—to final realization. This is the phase of thinking, brainstorming, sketching and initial drawing. Thumbnail sketches are the mainstay of this process: get as many ideas as possible down without investing a lot of technique and detail.

The Act symbolizes the starting point. It could be anything from an idea to a finished script to an animated film (short or feature length) to a graphic novel. It is the nucleus of your project from which you derive inspiration and envision a completed work. In a film or story it often starts with what is called an *inciting incident*. You will want to design it so as to capture attention right at the outset. The *sub-event* is related but subordinate material that contributes substance and variety. Sometimes it gives contrast, such as comic relief, to strengthen the original premise.

A *system-within-a-system* is a time-honored device to suggest that art is reality by inserting artifice within the piece. Some examples are the enactment of *Pyramus and Thisbe* in the midst of William Shakespeare's *A Midsummer Night's Dream,* or the painting on the easel in Jan Vermeer's *Allegory of Painting.* To extend the concept further, think of it purely visually. How do you express that you are working with both a flat surface and an illusion of three-dimensional reality? We will talk about systems such as reverse negatives and compound notan, which give dynamism to the picture.

The Scene

SETTING, SET DRESSING AND VIEWPOINT

The setting, just as the stage set in a play, sets the tone for the entire act. Sometimes in an operatic production, the audience will applaud the set even before the players come onstage. Just like the setting for a precious gem, it is important to have it reflect your main concept. Think about what props are necessary and be sure they are designed in a consistent style. Having constructed the elements of the scene is just the beginning. What point of view will you take to create the greatest drama?

TIME AND SEASON, ATMOSPHERE AND WEATHER

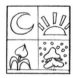

In screenplay writing there is *back story,* a whole raft of information that may never find its way into the actual play. It serves to amplify the work by providing history and insights that lend credence to characters and their actions. In the same way, there are "behind-the-scenes" forces that

set the tone of the picture. Each particular time of day and each particular season have a "personality." How will it contribute to the drama of the scene? What is the visibility? Consider the atmosphere of softness and mystery conveyed by mist compared to the sharp delineation of bright sunlight.

LIGHT

Lighting could be the subject of an entire book. In fact many have been written on the subject. Light affects everything we have talked about before. Don't allow it to "just happen." Use light in the service of your story. Before you begin, have an idea of how light will work to create reality, drama and consistency.

PLAYERS, COSTUME AND PROPS, BUSINESS AND GESTURE

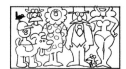 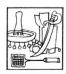 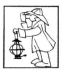

When you design your characters, give thought to more than just the facial features. If they represent a human quality, such as integrity, beauty or nerdiness, think about how the outside matches the inside. Can you emphasize their personality through physical exaggeration? How can you express how different they are from others? What makes them adorable or repulsive?

Perhaps an article of clothing or prop can be used as a trademark. If "clothes make the man," how can you create a costume that expresses personality?

Business and gesture define the players even as much as their physical appearance. "Business" refers to a typical action or behavior of a character. A good example is the commedia dell'arte, an enduring art form where the characters are known for their antics perhaps more than their looks.

A person's characteristic gesture makes them recognizable even at a distance. For example, their attitude may cause them to habitually take a certain stance.

Caricature

PROPORTION, METAPHOR AND EMOTIONAL HEIGHTENING

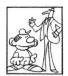 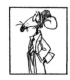 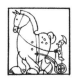

Caricature is a larger category than you might expect at first. One thinks of distorted noses and political cartoons but everything in your picture can be caricatured. Part of creativity is taking liberties with reality. You might want to emphasize proportions for effect. Think of how much you can distort them but still retain the effect you want. How can you make them more humorous?

Metaphor is the application of a characteristic to something that belongs to or is associated with another thing. Metaphors can be illustrated. Consider "That man is a real rat!"

Emotions can be heightened by how you choose to stylize an item, event, person or landscape. You can create drama through your visual interpretation, such as something that "looms large."

PERSPECTIVE, ORGANIC AND GEOMETRIC AND GESTURE DISTORTION

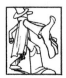 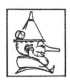 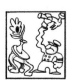

Perspective in caricature doesn't have to be "correct." (Hooray!) Knowledge of how it works is vital though, as you need to understand the structure in order to control the effect. Foreshortening an object close to you and diminishing it in the distance can add dramatic and even hilarious dimension.

Organic and geometric caricature can work together to create new forms. The tin man is part real and part mechanical. This provides two different aspects to play off against each other.

Besides distorting objects, you can distort gestures. It is a classic practice in animation. The "squash and stretch" technique can be very effective.

We have only briefly referred to various ingredients of your interpretive adventure. It is the "thinking" and preparation component of your work. It is a good time to consider the overview of what you are attempting to communicate. What worldview does it encompass? What research can you do to enhance your knowledge of the subject? What mood will dominate? What invisible trappings will make themselves felt? (Not just wind, sounds, smell, temperature, but also emotions such as rage, love and fear. Is there an undercurrent of danger, chaos or impending doom?) Are you going to apply a distinctive style?

When these aspects are solved, proceed to the next area: Composition.

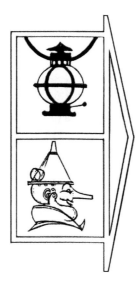

A story is like a jigsaw puzzle.

First you need a large surface to dump the pieces out. (TIME)

Then you need to turn all the pieces face up. (RESEARCH)

Then you put together the border. (STORY SKELETON)

Then you fill in like-areas. (SEQUENCE BUILDING)

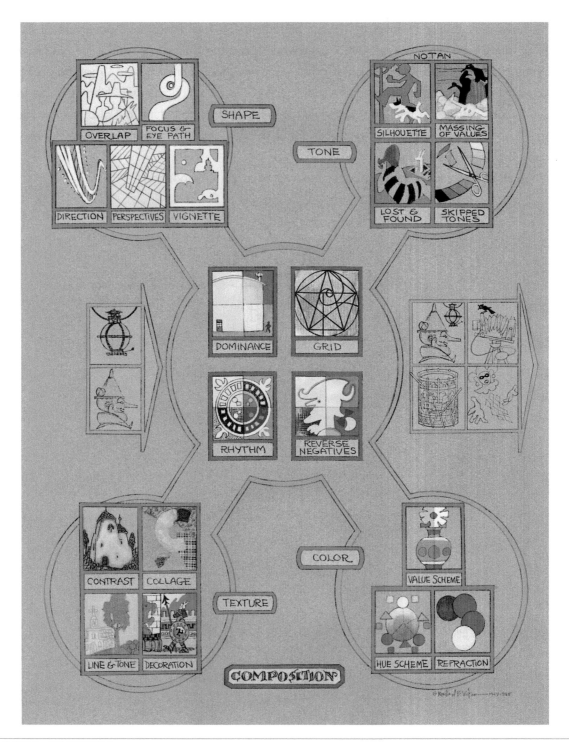

CHART 2—COMPOSITION

COMPOSITION

If it looks good on a postage stamp, it will look good on a billboard.

Composition is the architecture of art. Every masterwork of the Great Masters can be studied for its compositional structure. It is the aspect that will make the difference between a simple rendering and a masterpiece. If you are serious about creating successful art you will want to acquire and refer to a number of the excellent books dedicated exclusively to the subject. Make it a lifetime study and you will continue to improve.

The word "composing" is often associated with music but it applies equally to visual endeavors. Just as the musician depends upon a scale of notes, there are visual scales of tones, grids for structure, rhythms established and broken, silence between notes, and transitions of color.

Composition corresponds to the layout procedure in animation.

Dominance, Grid, Rhythm and Reverse Negatives

 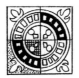 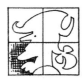

Traditionally the rectangle is the preferred configuration for most pictures. The vital thing is how everything inside this space is arranged. Good compositions will usually have one major shape or mass dominating the picture space. This helps give importance to the subject you want to emphasize.

A grid is one of the best friends an artist can have. Renaissance artists devised their compositions around specific systems. Divine Proportion is based upon a mathematical scale. The Golden Rectangle is also mathematically based. By subdividing it with diagonals you will arrive at shapes that are harmonious.

As mentioned, rhythm is familiar to us from music. The same principle applies to the elements of your picture. For example, repeating shapes will automatically create harmony. Consider setting up such a rhythm and then varying it. Try changing the "tempo," adding jazz rhythms or introducing syncopation.

Always be aware of all the space in your picture, even if is not occupied by your subject. The background is equally important. A dynamic effect can be created by turning the visual tables and accenting the negative areas. Although the viewer knows intellectually that they recede into the distance, they appear to come forward and tension is created. Reverse negatives can give life to your composition.

Shape

Some artists claim that a painting is nothing more than an arrangement of shapes upon a canvas. As you build your composition consider the individual shape of each element as well as its relationship to the whole.

OVERLAP, FOCUS AND EYE PATH, DIRECTION, PERSPECTIVES AND VIGNETTE

 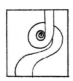

Placing one object in front of another creates a feeling of depth. It also tends to form interesting and unexpected shapes. Overlapping is a good way to combine multiple elements into one picture.

Usually you will want to design with a focal point in mind. Consider where you want to lead the viewer's eye and concentrate your dramatic or contrasting shapes there. Use other shapes in the picture to lead up to it.

Control the direction of the image through shapes. It can appear that an object is moving through space. A shape can be like an "arrow."

Perspectives can be used to create dramatic space. Think of how the planes of buildings and landscape interact.

A vignette can be a picture without a border, either isolated or faded at the edges. Although it may be considered a fragment, it is important to consider what shape the vignette makes on the page. It is a wonderful opportunity to design an interesting shape other than the usual rectangle.

Cropping is another useful tool. Focusing in on one section or cutting off a part of an image can add dynamism and produce more exciting negative spaces.

Tone

Tone, sometimes referred to as *value*, is more than just how light or dark or what shade of gray something happens to be. It is a valuable system you can learn to master in order to greatly strengthen your compositions.

NOTAN, SILHOUETTE, MASSING OF VALUES, LOST AND FOUND, SKIPPED TONES

Notan addresses the mystery of dark versus light. It concerns the interaction between positive and negative space. Although the concept seems simple, it is looked upon as the basis of composition.

The use of silhouette makes the content of your image instantly recognizable, even from a distance. It can almost become a shorthand for the character, prop or landscape. Using a distinctive tone for the silhouette makes it stand out.

Massing of values allows you to group together similar tones so that they read as a more unified compositional shape. Most often a simplified tonal scheme works best. The small desert scene above "reads" more dramatically when organized into large simple areas: the animal skull, dunes and rocks; the vultures and the outcropping; and the sky and clouds.

We have discussed making everything more readable and simple but we also want to add interest. *Lost-and-found* tones engage the viewer by presenting a visual puzzle. It's something like the reversed negative. For example, it is understood intellectually that the stripes are part of a woman's dress, yet in the pictorial space they blend into the background.

Skipped tones strengthen your value pattern. If tones are too close together the eye does not easily distinguish them. It's helpful to use a tone scale divided into ten values from white to black with equal grades in between. Further dividing the scale—for example, limiting the grays to light, middle and dark—gives clarity.

Texture

Texture is an important aspect in contributing richness to your composition. It is more than, for example, a pattern on a fabric or a sandy surface. Other visual aspects lend texture.

CONTRAST, COLLAGE, LINE AND TONE AND DECORATION

Contrast in surfaces is innate in the subject matter. Flesh, clothing, land, seashore, sky, and vegetation—all provide variation. Be sure to exploit the differences to play tactile qualities off each other.

Collage does not have to mean a literal collage, where you paste varying objects onto your page. It indicates an awareness of the abundance of texture available. The challenge is to integrate seemingly disparate elements into a unified whole.

We have discussed line and tone separately but they also contribute to the textural effect. Notice the difference between a shape filled in with line work compared to one filled in with a flat tone.

Decoration adds opulence and variety. The balancing act consists of keeping it from overwhelming more important elements.

Color

Color is a truly exciting element in your composition. It is fun to experiment with it intuitively. We will also see that there are systems to apply that will give remarkable results. Color is wonderful to use for setting a mood, creating harmony, and adding liveliness.

The three properties of color are hue, value and intensity. It is important to understand how each contributes to the final effect.

VALUE SCHEME, HUE SCHEME AND REFRACTION

Deciding on a value scheme even before you add color can make a difference in your painting. Colors are attractive so it is easy to ignore how light or dark they are. Each pure hue of color has a specific value. The intensity can throw our perceptions off. For example, if you want to paint a full deep red in a light area, it may have to be lightened to a pale pink that weakens the effect.

A hue scheme is also important to consider ahead of time. A hue is the specific shade of a particular color. You can create a far more harmonious color range by mixing pure colors together than is possible by adding only black and white to make lighter or darker variations.

Refraction is the bending of a light ray as it passes at an angle. The appearance of color can be altered by this process. Knowledge of the interaction of light and color can be valuable in your process of composing the picture.

Composition is probably the most vital aspect of picture-making. We have seen the roles played by dominance, the use of a grid, rhythm and reverse negatives in planning out your work. Additionally the categories of shape, tone, texture and color, along with their subcategories, are stressed. It can be an enjoyable part of the process and will definitely make the next step go more smoothly.

When these aspects have been resolved, continue to the next section: Rendition.

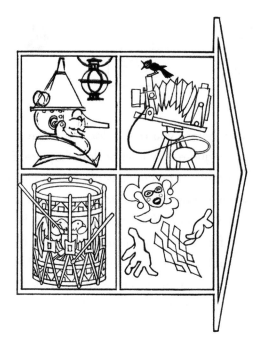

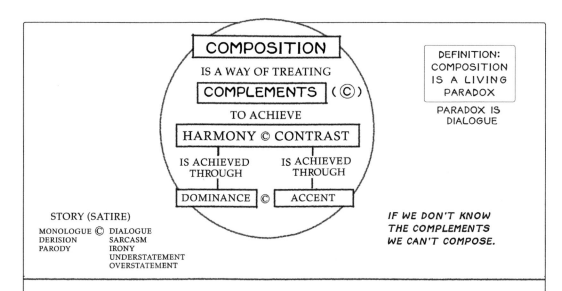

DEFINITION:
COMPOSITION
IS A LIVING
PARADOX

PARADOX IS
DIALOGUE

STORY (SATIRE)

MONOLOGUE © DIALOGUE
DERISION SARCASM
PARODY IRONY
 UNDERSTATEMENT
 OVERSTATEMENT

IF WE DON'T KNOW
THE COMPLEMENTS
WE CAN'T COMPOSE.

A LIST OF COMPLEMENTS

SHAPE © **LINE**
SUBJECTIVE OBJECTIVE
MOTION/MOOD INFORMATION
DIALOGUE MONOLOGUE

GEOMETRIC © ORGANIC

CURVE © STRAIGHT

DIALOGUE © MONOLOGUE
IMPLICATION DESCRIPTION

FIGURE © GROUND
 (BLACK ON WHITE)
 (WHITE ON BLACK)

FORM © ACTION

EDGES: SOFT © HARD

TEXTURE, PATTERN © SOLID
FORMAL, INFORMAL PLAIN

IMAGE © MEDIA

VOLUME © PLANE

TONE:

TONE © **LIGHT**
SHADOW LIT

COLOR:

BLUE © VERMILION

COLD © WARM

CHOOSE YOUR DOMINANTS THEN PROCEED.

UNBALANCED

• **ILLUSION** IS TOO MUCH *IMAGE*-- HARDBOILED, SLICK, SENTIMENTAL, DIDACTIC, MONOLOGUE

• **ABSTRACTION** IS TOO MUCH *MEDIA*-- MINIMAL*, DOODLING, ARTSY-CRAFTSY, MEDIA-DOMINANT

 (AIRBRUSH), (MURALS IN HATCHING, WATERCOLOR, ETC.)

*YOU CAN HAVE TOO MUCH OR TOO LITTLE <u>WITHOUT</u> THE COMPLEMENT.

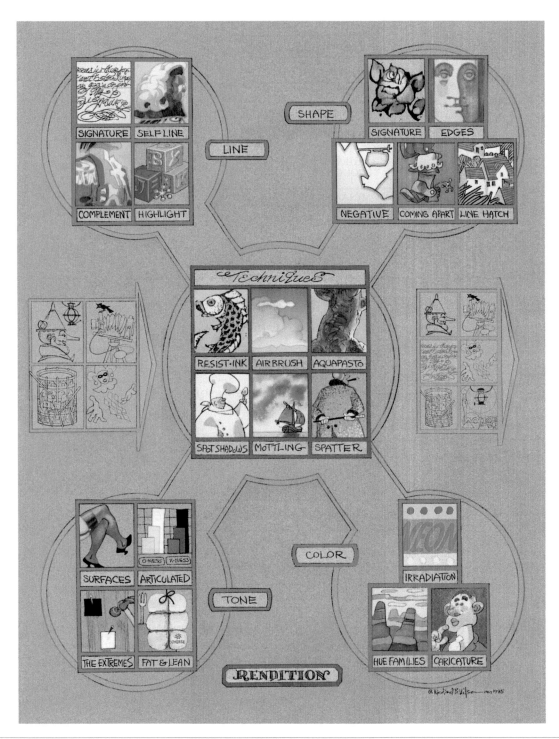

CHART 3—RENDITION

RENDITION

There's an express train to mediocrity but to get to excellence you have to take a local.

Rendition is your final rendering, finishing, or you could say "performance." At last we have come to the moment of putting it all together—the time to shine! Having solved the major elements it should be enjoyable and creative to bring it to a conclusion.

Rendition is the completion of the project in real media, digital output, film, print or other manner. It is the application of all the thought put into previous systems.

Techniques dominate in this step, but we will also meet with our friends Line, Shape, Tone and Color with a different emphasis. We will address them more with the idea of executing them in our own particular style.

Techniques

This is an area where it can be fun to add your own favorite techniques. Every artist has a natural affinity for certain media but it is also important to experiment.

RESIST-INK, AIRBRUSH, AQUAPASTO, SPOT SHADOWS, MOTTLING AND SPATTER

These are all paint-handling techniques but they can be simulated with digital painting. Even if you paint on computer it's a great experience to experiment with real media to get a feel for the finished look.

Resist-ink creates a woodcut effect by the application of ink over gouache. The ink adheres to the unpainted areas giving a bold linear quality.

Airbrush is known for smooth modeling. It produces even gradations and is very effective for a finished look.

Aquapasto is a product added to watercolor. It gives more body to the paint and imparts an impasto effect.

To achieve the spot shadows look, allow the paint to create a shape of its own as it is dotted into the shadow area. This can be more interesting than the default effect of shading.

To create the mottled effect, wet down the watercolor paper and drop paint into it. This is an excellent technique for skies.

Spattering, which gives an all-over texture, is done by various methods, such as striking the brush against a dowel or brush handle. It can liven up large flat areas.

There are numerous other ways of rendering covered in another chapter. Sometimes the above handling techniques can be reserved to accent an area.

Line

Lines are the very basis, the "veins" of art, and we encounter them in every phase. In the rendering section we will be talking about the treatment of line in various media.

SIGNATURE, SELF-LINE, COMPLEMENT AND HIGHLIGHT

Signature denotes the innate personal quality of your style, something like a fingerprint. It will come through anyway but this is to remind you to honor it and create art that contains your own personal stamp.

Self-line produces a different look than black outlines. Where harsh delineation isolates and flattens an object, more depth is created when an area is outlined in its own local color.

As a variation, the outlines can be drawn in the complementary color. This produces a more vibrating effect.

Accenting the highlight can create an interesting linear pattern. The edges of the planes are brought out with linework.

Shape

We have seen the designing of shapes as a vital aspect of composition. The rendering of them is the finishing touch.

SIGNATURE, EDGES, NEGATIVE, COMING APART AND LINE HATCH

If there is a *signature* quality to line, there is also one to the rendition of shapes. Do they tend to be rounded, attenuated, geometric, bulky, compressed? Discover their special properties and emphasize them. Exploit this effect to enhance the originality of your style.

The treatment of *edges* makes a difference. Think of how a razor-sharp edge defines an object compared to a soft disappearing shadow. Consider each edge in your picture and the effect you want it to produce.

We looked at *negative* shapes in composition. You can further support their dynamic effect by shading up to the edge of the positive shape.

When the shapes appear to be "coming apart," it melds the character with the background. This contributes to the lost-and-found effect.

Individual shapes can be separated by adding a texture within them. In *crosshatching* you draw parallel or intersecting lines across the shape. Following the direction of the form often works best although sometimes diagonal lines are used to give a shadow effect.

Tone

The articulation of tones or values will "pay off" the planning you did in the composition phase. Be sure to retain your tone scheme by being mindful of the native tones of color hues.

SURFACES, ARTICULATED, THE EXTREMES, FAT AND LEAN

Learning to modulate tone is helpful for visually describing surfaces and giving dimension to forms. Again, the value scales are a wonderful reference.

Articulated tones work similarly to the value scale. Here you move backward or forward through the values in increments to create harmonious transitions.

Make use of the extremes—make your darkest dark the purest black your medium allows. Paint your highlights or lightest areas the purest white. Nail those tones!

Tones make the difference between a fat or a lean effect. Use your modeling to really emphasize the roundness of an object. Conversely use contrasting tones to bring out something with flat hard surfaces.

Color

When you come to your final rendering, color will almost always be playing a large part. We have discussed color schemes previously. In your finished art you will want to make sure the color is crisp and clear. This is partly accomplished through technique, for example learning how to "charge" the brush with the proper amount of paint and understanding how much water you need to add for graded washes of color. You will also make the color "sing" by being aware of how colors interact when placed next to one another.

IRRADIATION, HUE FAMILIES AND CARICATURE

Irradiation is defined as the visual effect by which a brightly lit thing appears larger against a dark background. By working with the properties of color it is possible to create a neon effect.

Harmony can be achieved through hue families. Each color has variations within it as it moves toward neutral or as it becomes lighter or darker.

Look for opportunities to caricature color. Think of a clown with a big red nose, rainbow hair and a zany vivid costume. The intensity of each color is exaggerated.

We have covered a lot of ground before even beginning our work of art. Each aspect has its importance but there are also the elements of spontaneity and creativity. Art is a paradox that cannot be thought into existence but ultimately occurs in a moment when the "muses" are with us. Remember to be fully aware when you are in the process of creating. Be sure to honor the experience as it unfolds and give leeway to serendipitous discoveries.

Having fully considered all the steps of Interpretation, Composition, and Rendition, proceed to "The Finish."

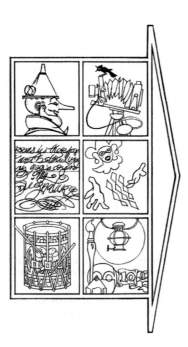

Congratulations!

ABOUT THE LOGOS

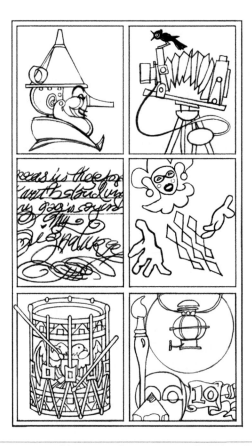

Top Left: A "Tin Man" represents both the geometric and the organic. There is a contrast of solid basic forms and articulated compound forms, the man-made and the natural. This mechanical man reminds you to blend the stylized and the real into a new combination. He also symbolizes caricature and subjective distortion.

Top Right: The Camera stands for the metamorphosis of the three-dimensional into the two-dimensional. It encapsulates all aspects of film and story—direction, scenes, set-ups and design elements. It also represents reversed negatives.

Middle Left: The Calligraphy shows consistency of design. It represents personal expression. "Signature" is the psychologically and personality-specific style that each artist produces. It is as original as handwriting. Be sure to "be yourself" and allow this uniqueness to shine through.

Middle Right: The Harlequin is designed to stand out in a crowd or on the stage. The hands and face are accented so your eye is attracted to them. He stands for the tonal aspects of composition: notan, lighting, silhouette, posterization and value patterns.

Bottom Left: The Drum signifies the rhythm in your composition. It includes texture, color, line, decoration, repetition, design, and dynamic tension.

Bottom Right: This logo depicts the tools of Rendition. Think about the lighting, forms, techniques, tools, and materials when you are rendering your art. Consider paint handling, edges, brushwork, and modeling—all aspects of final treatment. Let your art be media expressive.

The Lantern appears alone and in combination with the other logos. It represents light, atmosphere, dominance and viewpoint. Remember that many aspects of picture-making overlap.

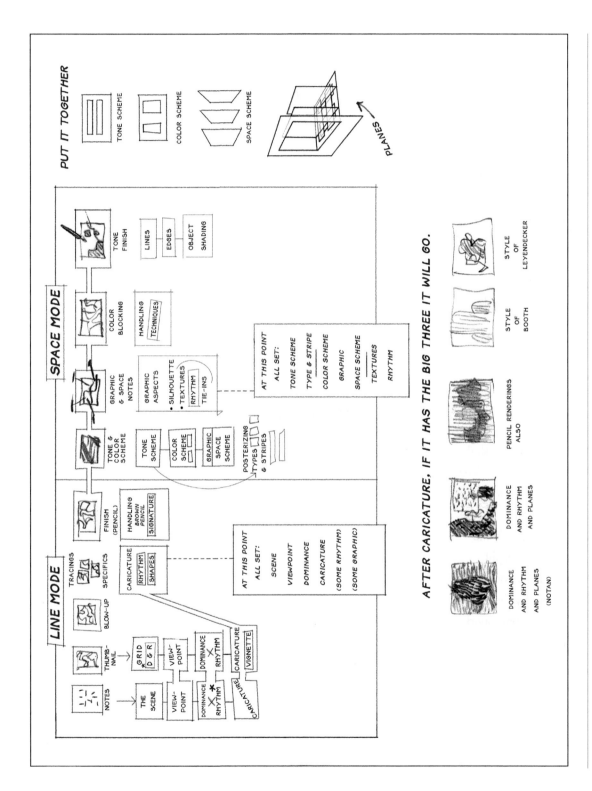

AFTER CARICATURE, IF IT HAS THE BIG THREE IT WILL GO.

EXAMPLE OF A WORKFLOW PROCEDURE FOR A CARTOON OR ILLUSTRATION

BRIEF OUTLINE

THE SCENE

1. Theme—All the Elements of *The Scene*
 A. Mood
 B. Atmosphere
 C. Setting
 D. Props
 E. Light
 F. Denizens
 G. Systems within Systems
 H. The Invisible:
 i. Wind
 ii. Sound
 iii. Smell
 iv. Temperature

COMPOSITION

2. The Layout—All the Elements of *Composition*
 A. Perspective Viewpoint(s)
 B. Angle vs. Angle
 C. Frame
 D. Tone Scheme
 i. By Light
 ii. By Mood
 iii. By Graphic
 iv. Compound Shape
 E. The Graphic

3. The Pencil (Treatment)
 A. Caricature
 B. Pattern
 C. The Graphic
 D. Texture Ideas

RENDITION

4. The Painting—*Rendition*
 A. Color Scheme (by Tone Scheme)
 B. Textures (Background carries the texture load)
 C. Tone Adjustment

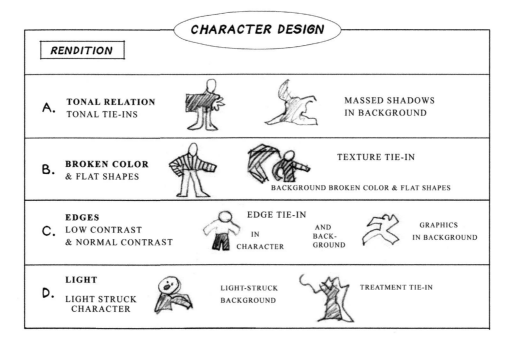

1

THE ACT

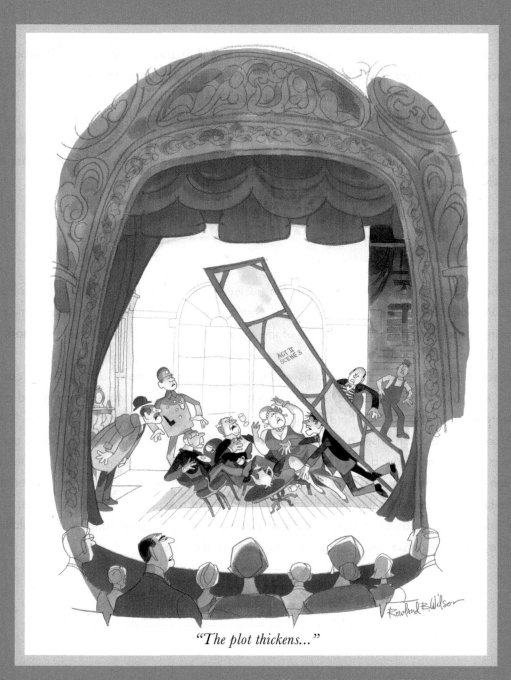

"The plot thickens..."

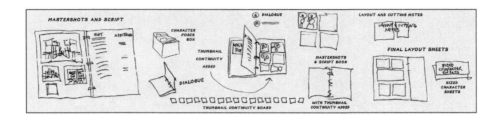

Story: A cause and effect (plot!) series of linked events told (exposition: everything is exposition!) in an uncertain or unpredictable way (suspense, forward motion, foreshadowing, dramatic irony, surprise) intended to involve the audience (empathy, subjectivity!) with the characters to the end (forward motion!) and make a satisfying statement (and statements along the way: the author's viewpoint can't be wholly explored in one end-theme) on life. The thematic statement X leads to Y.

Told how? With words expressed by characters and pictures that show the situations: what, where, when, and how (—and why!—).

STORY

It's all about "Story"! This is the heart and the nucleus of the work from which the visualization springs. Whether it is a script, a book, opera, cartoon, game, commercial or illustration—this is your springboard. The act is the basic unit of the story or script and often you will find more than one act. The artist's job is to translate from written word to the pictorial.

The *script* is the "written half" and answers the "what," "why," "how" and "who." It contains the plot, exposition or sequence of events, suspense, forward motion, foreshadowing, dramatic irony, surprise and characters. There is usually an overall theme and short themes. The "picture half" is *continuity* and comprises a number of elements. *Character design* is akin to actors and acting—who are they and how do they embody the story? *Locale* illustrates the "where" of the action and often creates and enhances the dramatic mood. *Action* can be comic, dramatic, entertaining or adventure. *Plot themes* are the "And then..." of the story, moving along to the next scene.

An additional consideration is the *audience point of view*. It is important for manipulation of subjective effects, suspense, and empathy in characters and events.

THERE IS NO HIGHER VALUE THAN AUDIENCE
EFFECT
IT IS THE FINAL AUTHORITY.

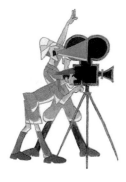

Storytelling: The Point of View

WHERE TO PUT THE CAMERA?

We the audience have to be somewhere in order to see and hear the story.

Sometimes we can hear but not see or see but not hear...for some story reason.

Amateur storytelling puts the camera (audience) in some silly or cute place that draws attention to itself or conversely always puts the audience in the same place regardless.

When you position the audience to look at a scene, imagine you are there. How would you be there? In what capacity?

Would you look down omnipotently?

Look up like a mouse?

Would you be in close like a participant?

Would you be hiding like a voyeur?

Would you be a passerby?

Are you sitting or standing?

Or flying?

Are you short or tall?

Are you one of the characters?

If so, what would you notice?

Why do the good directors put the audience where they do? Always consider if there could be more effective camera/audience work.

The Aspects of Pictorial Storytelling

SUBJECT MATTER

1. Genre: The type of story: Romantic Comedy, Drama, Western, Science Fiction, etc.
2. Characters: The performers.
3. Plot: Such as competition for the desired object.
4. Theme: For example: Metaphor, Power, Personal Aggrandizement, Pride, Love.
5. Style: Farce, Operatic, Slapstick and others. (Farce is said to be derived from the word for stuffing...can it be styled in the sense of "stuffed" or " over-overstuffed"?)

CHAIN OF EVENTS

1. Linked together actions written out.
2. Dialogue written into script.
3. Visuals: Main themes of each section indicated as thumbnails establishing atmosphere, look, style.
4. Pacing: Variations and development.

STORY RENDITION

(Actions, dialogue and visuals woven together by continuities with focal points.)

1. Focal points and themes determined by examination.
2. The Unfolding: Shots and continuities chosen for theme and focus from the diagrams.

STORY THEMES

(Story themes run from the largest to the intermediate down to the specific.)

1. Overall: The "Grand Scheme." What is the over-riding concept, philosophy and totality? (Described in a few words or single sentence.)
2. General: Comedy, Suspense, and Action.
3. Specific:
 A. Attitudinal such as vindictive, superiority complexes, bluster, greed.
 B. Atmospheric: the mystic sea, outer space.
 C. Contradictions, such as false love and true love; flawed people in action.
4. Character: Display of personality.
5. Plot: Goals.

STORY FOCAL POINTS

1. Revelations.
2. Turning Points.
3. Emotional acts and effects.

STORY FOCUS

1. Story Focus means: "The point is this."
2. Story Focus changes as you go through the story. It can be long or short.
 (Pages or a panel.)
3. Story Focus can be cross cut:
 A. For contrast: Dramatic irony or comic effect.
 B. For suspense: Converging with danger; converging with relief.
4. Story Focus can be examined. It should answer the questions:
 A. What is happening?
 B. What is the most important aspect of what is happening?
 C. What is the most satisfying way to show the most important aspect?
 i. Is it more satisfying to show the story focus point *only*?
 ii. Is it most satisfying to show the story focus point *once* or *repeat* it rhythmically?
 iii. Is it more satisfying to show the story focus point in harmony with a story theme or
 secondary story focus point?

TREATMENT

1. The treatment is chosen from the list of possible known continuity treatments and pictorial
 devices.
2. May be invented or combined for special effect.

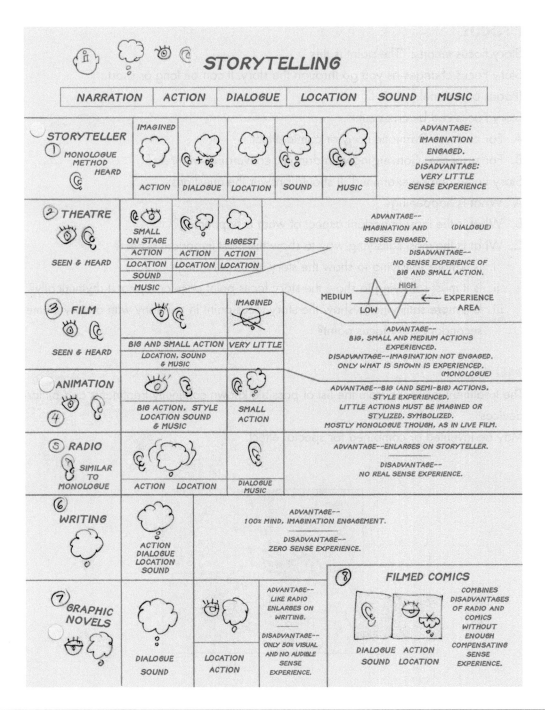

CHART FOR STORYTELLING FORMS

Forms of Storytelling

1. Verbal (Storyteller): Narrator narrates and "dialogues." Also monologue.
2. Theater Drama
 A. Classical: Chorus narrates, actors dialogue and "act."
 B. Traditional: Actors dialogue and "act" within the limits of the set; Reading of play.
 i. Performed to written text.
 ii. To "improvised" theme.
 C. Modified
 i. Musical—Actors sing and dance, chorus sings and dances, contains mood music.

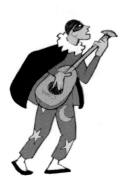

 a. Opera—Singing and dancing, orchestral moods:
 • Grand Opera, recitative and arias.
 • Light Opera, speeches and arias.
 • Petty Opera, speeches and recitatives "disguised" as arias.
 b. Broadway Musical and Operetta—Popular music in light opera form.
 c. Dance Drama—A story told without words. Dance only.
 ii. Mime—Story told in gestures only. First cousin to Dance Drama in form.
 iii. Puppets—Story told in voices augmented with puppets. First cousin to radio.
 iv. Revues—Vaudeville, Music Hall, Pantomime, etc., Part theater, short skits and part concert.
 v. Outside of theater—Concerts of all kinds including classical ballet and others that have incidental narrative aspects.
3. Film Drama (Note: All films are to some degree musical.)
 A. Silent: Camera "narrates" visually, actors act, dialogue written, no physical limits to the set.
 B. Traditional: Same as silent but actors dialogue and mood music.
 C. Television: Includes all of film plus filmed drama.
 i. Combination
 a. Series, soap operas, sit-coms, etc.: Traditional one-act plays with film inserts. Action is mostly stage action.
 D. Other: Narration dominated (travelogues, newsreels and instructional; not usually true narrative).

4. Animation: Same as traditional theater drama plus the non-photographical (art-styles, locations, the unreal).
 A. Pure Animation
 i. Hand-drawn and computer animation.
 ii. Puppets, masks and tricks.
 B. Animation and Live Action combined (includes drawn animation, computer, masks, special effects, etc.).
5. Radio: Story told in voices only; may include music and sound effects.
6. Writing: Novels and short stories (written narration, written action, written dialogue and written sound effects).
7. Graphic Novels: Comics, "fumetti,"* everything written except action, which is depicted in stills (seen and imagined).
8. Filmed Comics: Could be considered a television category, "Saturday morning," limited animation; although considered a subcategory of animation, it is closer to radio writing and especially to puppet shows (a filmed puppet show).

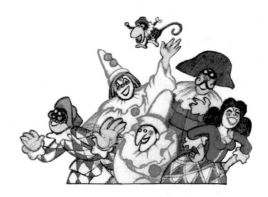

*Note: "fumetti" is an Italian word for comics. It is the plural of *fumetto*, meaning "little clouds of smoke" suggesting speech balloons.

Animation vis-á-vis the Storytelling Forms

WHAT WOULD ADAPT TO ANIMATION?

1. Storyteller: Animation adapts myths, tales, fables, etc. extremely well. The oral tradition emphasizes character action over inner life and writing style.
2. Theater: Scope is similar but dialogue must all be converted to action. (Action theater is enhanced.)
3. Film: Technique enhanced but character curtailed, emotion curtailed and spectacle curtailed.
4. Radio: In most ways, the antithesis of animation; requires even more adaptation than theater. Puppet shows seem similar to animation but they are opposite.
5. Writing: Not easily adapted. Only the images and action will translate.
6. Graphic Novels: Only a step away. Should be easily adapted.

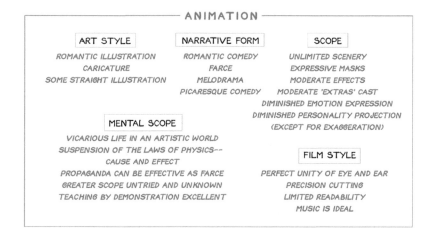

Every great classic has a theme that pre-exists in the reader or viewer. One hour or so is too short a time to generate a concern for the outcome of a story that is external to the concerns of the audience.

You have to find the theme of a classic as a star to steer by. In Victor Hugo the theme is spirituality. Notre Dame is the center of the story, not Quasimodo, Frollo or Esmeralda.

In Hamlet the theme is not wimpy indecision, but the hubris of godlike perfectionism. Hamlet wants everything to be absolutely right: to assume the role of God by judging and condemning.

The result is he destroys more innocents than guilty—Polonius, Ophelia, Laertes and the Queen—and himself if he can be called innocent.

THE RELATIONSHIP BETWEEN STAGE, COMIC STRIP/GRAPHIC NOVEL AND CINEMA

THE *THREE* VISUAL STORYTELLING MEDIA

STAGE COMIC STRIP/GRAPHIC NOVEL CINEMA/FILM

FROM WRITTEN TO SPOKEN AND ACTED FROM WRITTEN TO DRAWN FROM WRITTEN TO DRAWN TO... SPOKEN AND ACTED AND CUT.

STAGE — COMIC STRIP — CINEMA

	STAGE	COMIC STRIP	CINEMA
VIEWPOINT-	FRONTAL	ANY — LIMITED BY DRAWING LEGIBILITY	ANY — NEAR/FAR, HIGH/LOW THAT CAMERA CAN CLARIFY.
ACTION TAKES PLACE -	LIMITED ONSTAGE, UNLIMITED OFFSTAGE (IMAGINATION)	BEFORE YOU, BUT IN STILLS NOTHING IMPORTANT OFFSTAGE.	BEFORE YOU IN ACTION BUT BY RE-PRODUCTION, NOTHING OFFSTAGE.
WORDS & MUSIC -	BEFORE YOU IN REAL TIME	BEFORE YOU BUT READ. MUSIC AND SOUND IS IMAGINED.	BEFORE YOU IN REPRODUCTION.
CUTS -	PHYSICAL ENTRANCES, EXITS AND CURTAINS	ANYTHING UNDERSTANDABLE	ANYTHING UNDERSTANDABLE
DISTANCE -	DISTANT ALWAYS FULL FIGURE	DISTANT--FULL FIGURE TO CLOSE-UP OF THE CHARACTER'S MASK	INTO THE EYES--FULL-FIGURE TO MEANINGFUL CLOSE-UP.
STYLIZATION-	LIMITS ALLOW FOR GREAT STYLIZATION	LIMITS ALLOW FOR GREATEST STYLIZATION	ROOTED IN REALITY--STYLIZATION IS POSSIBLE BUT MUST BE MASTERLY.
MOOD ATMOSPHERE-	LIMITED BUT DO-ABLE	MORE LIMITED BUT STILL DO-ABLE	UNLIMITED. CONTROLLABLE.
ARTISTIC EXPRESSION -	LIMITED TO SETS & COSTUMES	UNLIMITED	LIMITED BY PHOTOGRAPHY, EFFECTS AND BUDGET

IN COMMON

STAGE AND COMIC STRIP

DISTANCE--ACTORS AND ACTION IS AT A REMOVE.
STYLIZATION: ARTIFICIALITY OF THE MEDIUM IS A GIVEN.
ATMOSPHERE--SIMILAR POSSIBILITES

ARTISTIC EXPRESSION--STAGE COMES CLOSER TO VISUAL ARTS THAN CINEMA EXCEPT FOR ANIMATION.

CINEMA AND COMIC STRIP

VIEWPOINT--ANY ANGLE

ONSTAGE/OFFSTAGE ALL ON STAGE

COMIC AS SNAPSHOTS

CUTS--UNLIMITED

UNIQUE TO COMIC STRIP AND GRAPHIC NOVELS

SILENCE	WORDS, SOUNDS AND 'MUSIC' ARE READ.
LIMITED MOOD	THE MEDIUM WHERE MOOD IS HARDEST TO ACQUIRE.
ARTISTIC EXPRESSION	THE MOST NATURAL MEDIUM.
STORYBOARD STYLE	SLOWNESS OF COMIC STRIP READING MAKES SETTING UP OF SIGHT GAGS SEEM A VERY EXTRAVAGANT USE OF SPACE.

OBSERVATIONS ON COMICS/GRAPHIC NOVELS, STAGE AND FILM I

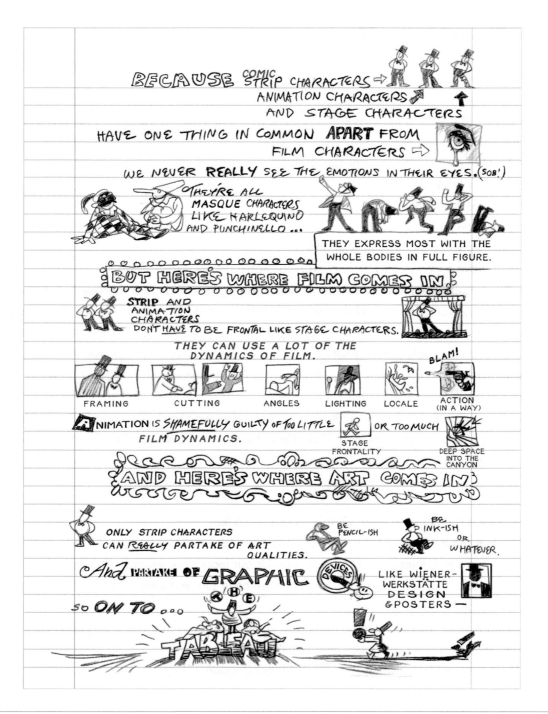

BECAUSE COMIC STRIP CHARACTERS →

ANIMATION CHARACTERS

AND STAGE CHARACTERS

HAVE ONE THING IN COMMON **APART** FROM FILM CHARACTERS →

WE NEVER **REALLY** SEE THE EMOTIONS IN THEIR EYES. (SOB!)

THEY'RE ALL MASQUE CHARACTERS LIKE HARLEQUINO AND PUNCHINELLO ...

THEY EXPRESS MOST WITH THE WHOLE BODIES IN FULL FIGURE.

BUT HERE'S WHERE FILM COMES IN.

STRIP AND ANIMATION CHARACTERS DON'T **HAVE** TO BE FRONTAL LIKE STAGE CHARACTERS.

THEY CAN USE A LOT OF THE DYNAMICS OF FILM.

FRAMING CUTTING ANGLES LIGHTING LOCALE ACTION (IN A WAY) BLAM!

ANIMATION IS *SHAMEFULLY* GUILTY OF *TOO LITTLE* FILM DYNAMICS.

OR TOO MUCH STAGE FRONTALITY DEEP SPACE INTO THE CANYON

AND HERE'S WHERE ART COMES IN

ONLY STRIP CHARACTERS CAN REALLY PARTAKE OF ART QUALITIES.

BE PENCIL-ISH BE INK-ISH OR WHATEVER.

And PARTAKE OF GRAPHIC DEVICES

LIKE WIENER-WERKSTÄTTE DESIGN & POSTERS —

SO ON TO ... THE TABLEAU

OBSERVATIONS ON COMICS/GRAPHIC NOVELS, STAGE AND FILM II

More Thoughts on "Story"

A plot is a net to catch ideas in.

The quality of a story is not based on the number of characters or the number of events, but on the uniqueness of the two elements.

What makes a character or event memorable?

What makes them entertaining?

What makes them funny?

What does an audience want?

An audience wants the familiar with a twist.

Why? To have a vicarious experience, a pleasurable one.

Why? To forget. To explore a pleasurable and satisfying resolution in a short period of time.

Why do they want the familiar? It is their ticket of entrance. Empathy: "Ah yes, this is so-and-so, I know about that." The *pleasant* familiar experience they want to see fulfilled, the appetites. If it is not fulfilled immediately, the appetite for it grows, demanding a greater fulfillment later. The unpleasant experience, they want to see thwarted. If this is postponed, the desire grows to see it thwarted absolutely, once and for all.

How does an audience forget? By having their emotions engaged. The chap is like me; he has to put up with what I do. He likes what I like. He believes what I believe. I fear for him. I love with him. I hate with him. I hope for him. I dare with him.

He sees, hears, feels, smells, tastes as I do.

1. A story is a promise, a wish. Or it is an anxiety, a fear.
2. We feel better when we leave the story. We have seen our wishes materialized—so they seem more real, therefore more attainable. Or our fears materialized—if they do not seem less terrible, they are at least delimited and we have survived them. (If not as the protagonist then as an audience.)
3. To know what will appeal to an audience, know their hopes and fears. Engaging the audience's emotions is to touch their hopes and fears.
4. The hopes and fears of human being fall into categories. They are:
 A. Universal
 B. Categorical
 C. Temporal

5. Each anxiety has its opposite hope.
 A. Universal (Hope/Fear)
 i. Love: Union/Separation
 Adulation/Detestation
 Nurture/Abandonment
 ii. Health Vitality/Debility
 Nourishment/Deprivation
 Plenty/Hunger, Thirst
 Life/Death
 iii. Well-being Contentment/Misery
 Freedom/Confinement
 Fulfillment/Frustration
 Pleasure/Pain
 Success/Failure
 Stimulation/ Sense Deprivation
 Protection/Danger

 Under Universal, the basic drives fall: Food, Clothing, Shelter, Love, and Play.

 B. Categorical: These are the emphasized needs of specific groups—anxieties that special classes of people feel.
 i. By Age (children, adolescents, young adults, middle aged, old people)
 ii. By Class (destitute, poor, middle class, upper middle class, wealthy)
 iii. By Heritage (race, religion, nationality, politics, philosophy)
 iv. By Occupation (job, position, role, ambition, interest)

 C. Temporal: These are anxieties brought out by the times one lives in.
 i. Economic (recession, depression, inflation, boom)
 ii. Political (oppression, free-wheeling, wartime, decline, expansion)
 iii. Social (repressive, traditional, transitional, highly mobile)

If you examine the times you live in, the hopes and fears of those times lead you to good story material. People are most attracted to the strongest opposites.

In times of fear, do stories of hope and wish fulfillment.

In times of hope, do stories of fear and anxiety.

In times of confusion, do stories with certainties.

In times of disruption, do stories of love and peace.

SYSTEMS WITHIN SYSTEMS

The striking thing was to dream of having been asleep in a dream—a system within a system within a system.

A system within a system is a useful device. It can create believability by introducing a "real" element into a fictitious environment. It displaces the attention from the fact that everything is imaginary. In literature some classic examples are *One Thousand and One Nights* and *The Canterbury Tales*, where you accept that the people authentically exist as you become involved in their stories. It removes the reader from the fact that it already is a story. Art and film essentially are already artifice, so each additional layer can resonate, creating multiple levels of experience.

The Play within a Play

It is two system levels revealed. You believe System One because System Two is so clearly a system. At the same time you can suspend criticism and enjoy a simpler system as a child would.

Dramatic conflict is the *clash* between two systems. The essential double-bind is created that way. An idea is the congruence and clash of the two systems, a joke—a surprising unity or synthesis.

Shakespeare is full of double systems, as is all theater. We find conflicting loyalties, plays within plays, women disguised as men, and men disguised as women disguised as men.

In art, the image is one system, the brushwork another. Each aspect is a system from composition to color scheme.

Comedy is two related systems at cross-purposes. Satire is the two systems of pretense and reality revealed. A comedy character may be a hypocrite with good pretensions and bad actions, a knave or villain type. Or a comedy character may be compulsive with good intentions and bad habits. Or a character may be a fool, with good intentions but bad execution (mental and physical). Or a comedy character may be a wise fool with good vision and execution.

Any interesting character has a contradiction.

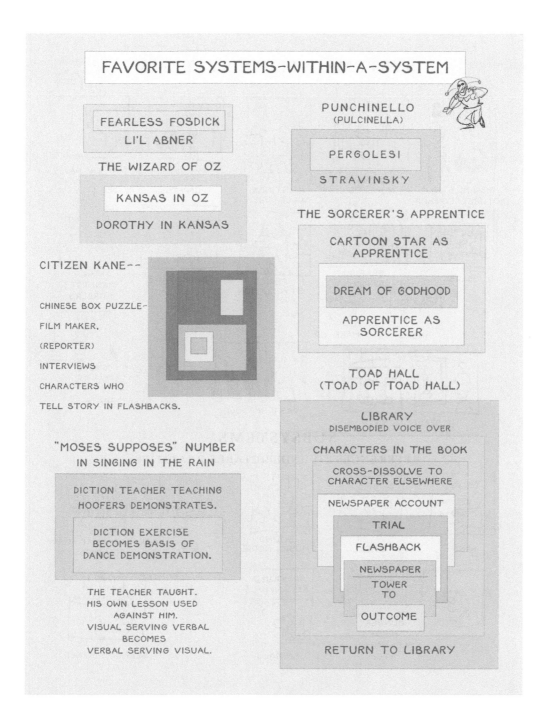

FAVORITE SYSTEMS WITHIN A SYSTEM

SYSTEMS WITHIN SYSTEMS

GRAPHICS IN
PICTURE: POSTERS

SIGNS
NUMBERS

PAINTINGS
SCULPTURES

PLAYS WITHIN
PLAYS--
PUPPETS

OUT OF THE PAGE--
CHARACTER ASKS-
READER ANSWERS

MAPS

GRAPHIC
DEVICES

PERIOD
STYLIZATION

BACKSTAGE

VIGNETTES
BORDERS

MASKS

MAKE-UP

REFLECTIONS

CAST SHADOWS

COYOTE
FALLING

GREAT SPACE

SUBSYSTEMS

REFERENCES TO UNDEPICTABLE REALITIES

WIND

SMELL

SOUND
MUSIC. NOISE

TASTE

(WOLF LOOKING AT WOMAN)
FEELINGS

HUNGER
THIRST
SLEEPINESS
ETC.

ANIMALS

SELF REFERENCE

SYSTEMS WITHIN SYSTEMS

THE GRAMMAR OF FILM

- **CHANGE OF TIME AND/OR PLACE**
 (SEQUENCE CHANGE)

PULL BACK TO LONG

FADE OUT FADE IN LONG-MOVE IN TO CLOSE

- **MOVE TO A SIMULTANEOUS ACTION ELSEWHERE**

LONG

CROSS-DISSOLVE LONG-MOVE IN

- **MOVE FROM EXTERIOR TO INTERIOR IN A NEW SCENE**

FADE IN LONG CROSS-DISSOLVE LONG-MOVE IN

- **CHANGE OF VIEWPOINT IN ESTABLISHED SCENE**

CUT CUT

EXTERIOR TO INTERIOR

 OR

MOVE IN CUT TO LONG FAST CROSS-DISSOLVE (SOFTENS A DRASTIC CHANGE AS FROM DARK TO LIT INTERIOR)

- **PASSAGE OF TIME IN ESTABLISHED SCENE**
 (AS IN A JOURNEY)

 X X X

- **CAMERA MOVES IN ESTABLISHED SCENE**

CUT TO ESTABLISH

ADJUSTS TO FRAME

CUT TO ESTABLISH

CAMERA FOLLOWS ACTION

CAMERA FOLLOWS ACTORS, THEIR MOVES, THEIR GLANCE, NEVER ANTICIPATES ACTORS OR ACTION

- **CHARACTERS ON THE FLY OR RUN**

FIXED ACTION MOVES OUT CUT TO CAMERA ON THE RUN FIXED ACTION GOES THRU

EITHER ALTERNATES BETWEEN FIXED OR PANNING CAMERA
OR
CUTS FROM PAN TO PAN

- **ON THE MOVE FLYING SCENES**

1 OR 2 FRAME DISSOLVES BETWEEN SCENES (EXAMPLE: FANTASIA)

- **SERIES OF CROSS-DISSOLVES**

ALL CROSS-DISSOLVED

EXAMPLE: THE POETIC LINGERING SCENES OF THE WAREHOUSE AT END OF CITIZEN KANE

- **VARIATION OF SHOTS**

OVER THE SHOULDER TWO-SHOT OPEN TWO-SHOT DEEP FOCUS LONG SHOT AS BRIDGE... ...TO LONG SHOT CHANGE-OF-LOCALE (SEE CHAPTER 2)

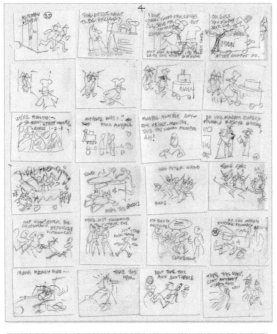
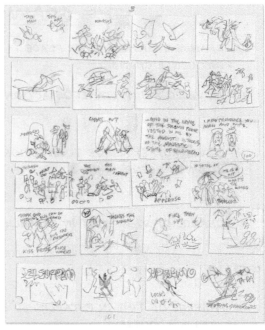
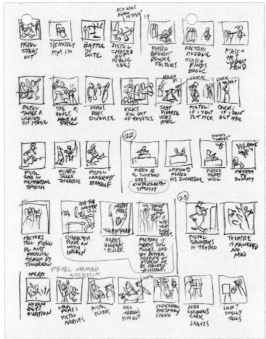

GETTING STARTING

A good method is to begin with loose informational drawings to lay out the entire act.

Top: Post-It notes can be used for small quick sketches and are easy to reposition.

Bottom Left: Thumbnail sketches can help to visualize and organize the scenes.

Bottom Right: Example of breaking down the script into its most important features.

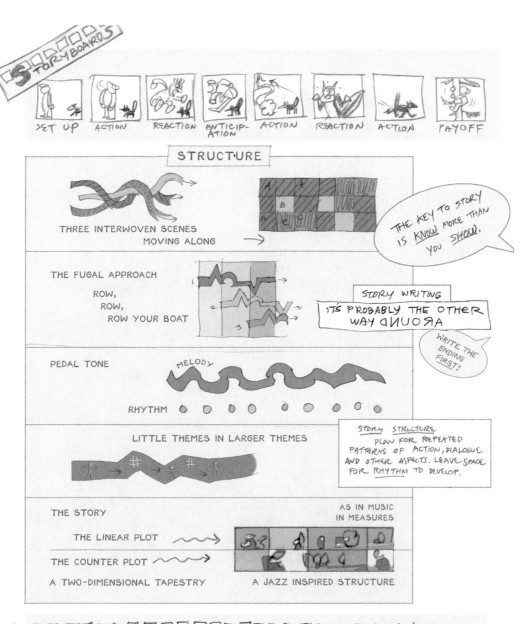

STORYBOARDS

SET UP | ACTION | REACTION | ANTICIP-ATION | ACTION | REACTION | ACTION | PAYOFF

STRUCTURE

THREE INTERWOVEN SCENES
MOVING ALONG →

THE KEY TO STORY IS KNOW MORE THAN YOU SHOW.

THE FUGAL APPROACH

ROW,
ROW,
ROW YOUR BOAT

STORY WRITING

IT'S PROBABLY THE OTHER WAY AROUND

WRITE THE ENDING FIRST!

PEDAL TONE

MELODY

RHYTHM

STORY STRUCTURE
PLAN FOR REPEATED PATTERNS OF ACTION, DIALOGUE AND OTHER ASPECTS. LEAVE SPACE FOR RHYTHM TO DEVELOP.

LITTLE THEMES IN LARGER THEMES

THE STORY

AS IN MUSIC
IN MEASURES

THE LINEAR PLOT

THE COUNTER PLOT

A TWO-DIMENSIONAL TAPESTRY

A JAZZ INSPIRED STRUCTURE

YAWN!

2

THE SCENE

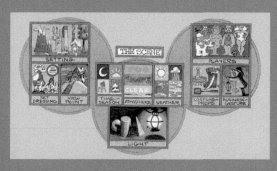

From CAPTAIN PISTOL'S PARADISE

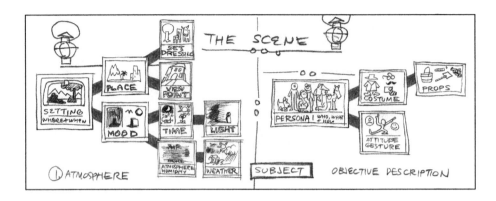

The issue is not how to show everything.

It is what to show as a part that will cause the viewer to imagine that there is an everything.

The Scene is a segment of the told or seen story. The "untold" parts take place between the scenes. Each scene is a subdivision of The Act and is a mini-experience that moves the story forward. A script can contain any number of scenes but many films have approximately thirty. An illustration or cartoon is essentially one scene.

SETTING THE SCENE: THE PLACE

The length of a scene is determined by a change of place or time.

- The place we go to is a place where something important occurs. We change scenes to follow the shifting of our interest.
- Film demands that we go to *all* places where something important occurs. It is "dangerous" to refer to an important event without showing the event.
- The correct choice of place is one where the character of the place *adds* to the events. If the choice of place is indifferent, the character of the place adds nothing to the events. If the choice of place is faulty, the character of the place contradicts events.

Character of place:

1. The Type: (Ship cabin, guardroom, tavern).
2. The Kind: (Crowded, luxurious, shabby, austere).

3. The Purpose: (Factory to manufacture goods, jail to imprison).
4. The Relation to One or More Persons: (The sanctum of the enemy, one's own room).
5. The Location: (Tavern on the waterfront, shack in the desert).

Effects of choice of place:

1. Can influence the action; availability of props or lack of props in a given place determines how events happen.
2. Kind of place can characterize the owners: (Ostentatious, newly rich, slovenly).
3. Contradiction of place and action can create comedy effects: (Whispered talk on noisy subway, disorderly roughhouse in an orderly place such as hospital, courtroom, concert, vaudeville act in a cemetery).
4. Distance of one place from another influences the amount of time needed for persons to get there.
5. Place may foreshadow or symbolize the action.
 A. Discovery of missing person: (empty stairs, empty house).
 B. Person is hurt, as revealed in different places:
 i. Police station—suggests criminal prosecution.
 ii. Hospital—suggests condition.
 iii. Person's home ground—suggests change of conditions.
 iv. Happy place—tragedy heightened by contrast.
6. Action individualized by character of place:
 A. Conflict or evasion is realized differently in hotel lobby, auto parking garage or bakery. The place has:
 i. Exits—doors, windows, chutes, skylights, trapdoors, panels.
 ii. Levels—Ramps, fire escapes, basement, attic, roof.
 iii. Props—Tools, furniture, housewares, décor.
 iv. Atmosphere—Lighting, noise or quiet, busy or not.
 v. Residents—Workmen, Permanents and transients, animals.
 vi. Hiding places—Rooms, boxes, jars, nooks.
 B. Provides more material for action AND
 C. Place is more vividly portrayed.

7. Atmosphere: A place frequented or used by a distinct group or class of people.

USEFUL PLACES FOR COMEDY DISRUPTION

Some places that are orderly and formal are ripe for comedy disruption or comic relief in a serious film. These are places that deal with danger, fragility, value, concentration, cleanliness, precision, quiet and vanity.

1. Hospital.
2. Courtroom.
3. Concert—Audience, pit, backstage, onstage.
4. Airport control tower.
5. Cockpit of aircraft.
6. Bridge of ship.
7. Any sporting event.
8. Any tournament—chess, jousting, bridge, pool.
9. Church service, wedding, funeral.
10. Army drill, inspection parade, service comedy.
11. Any line up or "queue"—customs, tickets.
12. Police line-up.

13. Any place of elegance—restaurant, high tea, lawn party, banquet, testimonial.
14. Kitchen, bakery, dishwashing.
15. Any manufacturing place—assembly line, foundry, food, clothing, plastics, glass.
16. Any place to do with money—casino, bank, mint, armored car, stock exchange.
17. Museum or exhibition.
18. Days of old—The Court, monastery, Inquisition.
19. Library, lecture, classroom.
20. Research lab.
21. Places or situations requiring stealth.
22. Courting, sex, glamour.
23. Creating art—portrait, model, sculpture, music, dance, play.
24. Fashion show, beauty contest, beauty parlor, exercise.

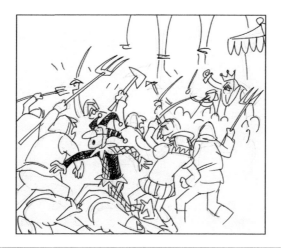

"Excuse me! Pardon me! Let me by, please..."

ATMOSPHERE

IS UNDERSTOOD BY THE QUALITY OF VISION IN A PICTURE.

VISION THESE FACTORS AFFECT VISION

LIGHT

DIRECT INDIRECT DARK

DISTANCE

NEAR FAR

COLOR

WARM COOL

FOCUS

SHARP/SOFT

SKY → ← SUN
LIGHT + SHADE

AIR QUALITY

FOG SMOKE MOISTURE
CLEAR DIFFUSED

LINEWORK IN ATMOSPHERE

DIRECT LIGHT **INDIRECT LIGHT** DARK

SHADOW
SOFT EDGES
LOW TONE CONTRAST.

LIGHT
HARD EDGES
TEXTURE
HIGHER TONE CONTRAST.

HARD EDGES DOMINANT
SOFT EDGES MINIMAL IN
MINOR SHADING + CLOSE
VALUE LOCAL COLOR.

SOFT EDGES DOMINANT
THATS WHY IT IS "HARD
TO SEE."

STYLIZATIONS

 STYLE I

BURNED OUT
LIGHT SIDE
WITH LINE
IN SHADE

LINEWORK
IN ALL
ASPECTS
OF LIGHT.

LINEWORK
IN TONED AREAS
AND UNTONED ONES
SENSE OF BRIGHT
INDIRECT GLARE

(2)-3

THE SCENE—ATMOSPHERE

VIEWPOINT

2

CHARACTERS

FRONT

PROFILE

BACK

COMBINATIONS

NEAR AND FAR

ON THE FLOOR

ON THE ROOF

DOG'S-EYE VIEW

GIANT VIEW

SETS

DOWN THE GALLERY

ON A HILL (TILT UP)

UPSTAIRS (TILT UP)

OFF THEIR FEET

LYING DOWN

DOWNSTAIRS (TILT DOWN)

DOWNHILL (TILT DOWN)

OVER A CURVE (TILT UP THEN DOWN)

PERSPECTIVE DRAMATIZED BY INCLUSION OF A NEAR 90° ANGLE

HORIZON OUT OF THE PICTURE

MULTIPLE HORIZONS

2-5

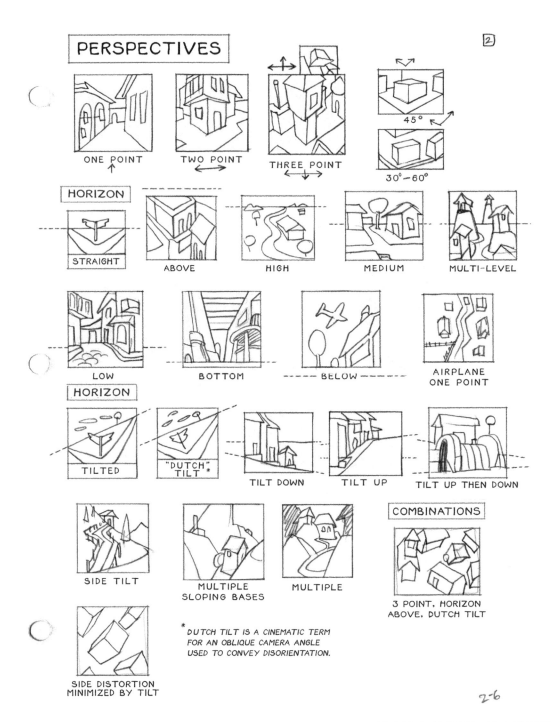

PERSPECTIVES

2

ONE POINT

TWO POINT

THREE POINT

45°

30°–60°

HORIZON

STRAIGHT

ABOVE

HIGH

MEDIUM

MULTI-LEVEL

LOW

BOTTOM

BELOW

AIRPLANE
ONE POINT

HORIZON

TILTED

"DUTCH"
TILT *

TILT DOWN

TILT UP

TILT UP THEN DOWN

SIDE TILT

MULTIPLE
SLOPING BASES

MULTIPLE

COMBINATIONS

3 POINT, HORIZON
ABOVE, DUTCH TILT

SIDE DISTORTION
MINIMIZED BY TILT

* DUTCH TILT IS A CINEMATIC TERM
FOR AN OBLIQUE CAMERA ANGLE
USED TO CONVEY DISORIENTATION.

2-6

THE SCENE—PERSPECTIVES 1

PERSPECTIVES

2

SCALE

SMALL OR DISTANT	MEDIUM	LARGE OR CLOSE

HIGH HORIZON
MINIMUM CONVERGENCE

MID HORIZON
MEDIUM CONVERGENCE

LOW HORIZON
SHARP CONVERGENCE

EYE TILT

VIEWPOINT SHIFTS
IN DIRECTION
OF GLANCE

PANORAMA (FLAT ON)

INTERIOR (ONE POINT) EXAGGERATED

EYE TILTS 10°
MAKING V.P.'S
ON SIDES 55°
ANGLES.
V.P. AT CENTER
IS 45° ANGLE.

BIRD'S-EYE (3 POINT)
DOWN VIEWPOINTS SPREAD APART

MINIMAL EYE
TILT EFFECT
IN 2 POINT

...EXCEPT FOR
FLOOR

MINIMAL EYE TILT EFFECT ON
SMALL OR DISTANT OBJECTS WITH
MINIMUM CONVERGENCE

2-7

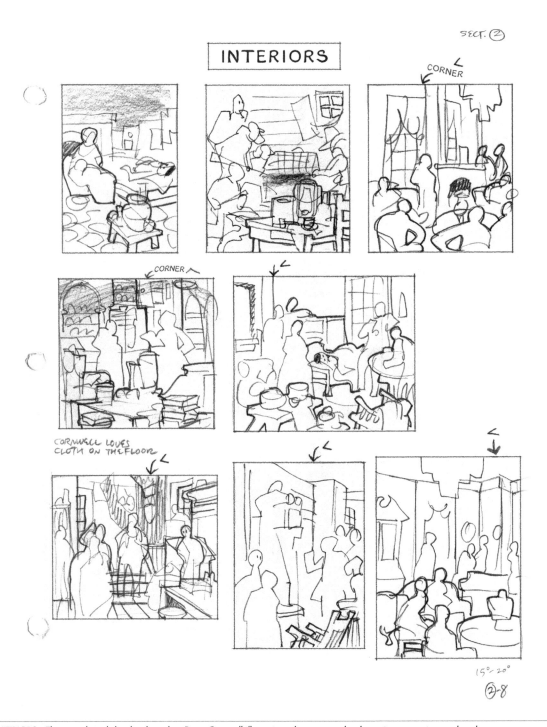

INTERIORS—These analytical sketches based on Dean Cornwell illustrations demonstrate the dynamic perspective produced by using corner angles.

THE SHOT

film Aspects

		EFFECT	SPEED	COMPLEMENT	
		ON AUDIENCE	OF COMPREHENSION	EFFECT	
LONG SHOT I DISTANCE		PICTORIAL, OUTDOOR THEATER SEAT. DISTANCED BUT CAN BE INVOLVING. MYSTERY AWESOME	DEPENDS ON PICTORIAL	CLOSE-UP HALF SHOT	
FULL SHOT		BASIC COMEDY SHOT —	THEATER SEAT. DISTANCED	FAST	OUT OF THEIR SEAT
HALF SHOT			IN THE SPACE WITH THE CHARACTER. PARTICIPANT OR CLOSE OBSERVER	FAST	DISTANCED
CLOSE UP		INTIMATE MENACING CONFINING	SLOW	DISTANCED	
FLAT ON II ANGLE BASIC (ALSO A DIRECTION)		THEATER SEAT. BASIC	FAST	UNUSUAL ANGLE	
UP SHOT		FEELING OF BEING SMALL, FROM A CHILD TO A BUG. — INFERIORITY	MEDIUM TO SLOWER	DOWNSHOT	

①

		EFFECT	SPEED	COMPLEMENT
DOWN SHOT	(ANGLE)	ON AUDIENCE	OF COMPREHENSION	EFFECT
		FEELING OF *SUPERIORITY* – VANTAGE POINT	MEDIUM SLOW	UPSHOT
TOP SHOT		*VOYEUR* I SEE THEM BUT THEY CAN'T SEE ME. – *VERTIGO*	MEDIUM SLOW	FLAT ON
BOTTOM SHOT		*DANGER* VERTIGO	MEDIUM SLOW	FLAT ON
INWARD	DIRECTION	·IT'S· GETTING AWAY. BEING LEFT BEHIND OR GOING 'THERE' OR DISTANCING.	FAST MEDIUM	OUTWARD FLAT ON
OUTWARD		COMING 'BACK' COMING AT YOU. *DANGER!* EVEN A GOOD THING SLIGHTLY THREATENING.	FAST MEDIUM	INWARD FLAT ON
DIAGONAL		*VARIETY,* INTERESTING. OR EFFORT OR CAREENING.	FAST	FLAT ON
UP OR DOWN		NOT AS EFFECTIVE IN PRINT AS IN FILM. *SURPRISE* IN FILM.	MEDIUM	FLAT ON CENTERED

②

THE SHOT

Subject Matter

		EFFECT	SPEED	COMPLEMENT
		ON AUDIENCE	OF COMPREHENSION	EFFECT
FULL SHOT DIALOGUE		THEATER SEAT BASIC. COMEDY. ADVENTURE.	FAST	OTHER
HALF FIGURE SHOT		CLOSE VIEW OF CHARACTER EXPRESSION. VOYEUR.	FAST	OTHER
LONG SHOT		DISTANCED. COMMENT ON LOCALE. INSIGNIFICANT SPEECH.	DEPENDS ON PICTORIAL. OR SLOW.	FULL SHOT OTHER
CLOSE UP		(HARD TO JUSTIFY IN A CARTOON) IN FILM. EXPRESSION. CHARACTER REVEALER.	SLOW	FULL OTHER
HALF SHOT EYE CONTACT		SUBJECTIVE PARTICIPATING. JUDGING. SIGNIFICANT.	SLOW	NO EYE CONTACT
CLOSE UP EYE CONTACT		INTIMATE. VERY SIGNIFICANT.	SLOW	NO EYE CONTACT

③

LONG SHOT PANORAMIC OFFSTAGE SHOT		*EFFECT*	*SPEED*	COMPLEMENT
	DIALOGUE	ON AUDIENCE	OF COMPREHENSION	EFFECT
ALSO, CAN INDICATE LOUDNESS.		EMPHASIS IS OFF DIALOGUE. SPEECH IS GENERAL, INCIDENTAL, INSIGNIFICANT OR PHILOSPHICAL.	PICTORIAL	FULL SHOT
OFFSTAGE SHOT		EAVESDROPPING, FORESHADOWING THE LOCALE, DRAMATIC OR COMIC IRONY OR MYSTERY.	FAST	FULL SHOT
OFFSTAGE GADGET SHOT	ALSO PERSON AS OBJECT ALSO DRUM! GESTURE	FORESHADOWING THE OBJECT. OR DRAMATIC OR COMIC IRONY, OR MYSTERY.	MEDIUM	FULL SHOT
OFFSTAGE SUBJECTIVE POINT OF VIEW		INVOLVING. SUBJECTIVE.	FAST MEDIUM	FULL SHOT
OFFSTAGE REACTION SHOT		INVOLVING, VOYEUR, OR SUBJECTIVE OR SIGNIFICANT.	MEDIUM	FULL SHOT
MULTIPLE CLOSE UP MAGNIFICENT AMBERSONS		INVOLVING, VOYEUR, OR CONSPIRACY OR GOSSIP.	SLOW	SINGLE FULL SHOT
MULTIPLE COMBINATION OF CHARACTERS CIRCUS SHOT CLOWNS		VOYEUR, EAVESDROPPING, A HULLABALOO, OR MOB OR GANG.	SLOW	SINGLE FULL SHOT

④

GRAPHIC DEVICE	EFFECT	SPEED	COMPLEMENT
	ON AUDIENCE	OF COMPREHENSION	EFFECT
POSTER / NOTE LETTER BOOK / HEADLINE	SYSTEM WITHIN SYSTEM. AUTHENTICATES CHARACTERS, EVENTS, SOCIETY	FAST	CHARACTERS
LEVELS — PULPIT, STAIR, TERRACES	SUGGESTS WORLD BEYOND FRAME. STRONG SENSE OF LOCALE. MILDLY SYMBOLIC OF HIERARCHY.	MEDIUM	NO BACKGROUND
TITLE SHOT — VARIANT OF GRAPHIC DEVICE	"YOUR ATTENTION PLEASE." NARRATION STYLE FORESHADOWING	MEDIUM	THEME SHOT
TRANSITION SHOT — PASSAGE OF TIME. CHANGE OF SITUATION.	DISTANCING	FAST	CHARACTERS
ONSTAGE GADGET SHOT — GADGET MAY BE IN USE IN FOREGROUND. ALSO STRIP SHOT	FORESHADOWING	MEDIUM	BASIC

THE SHOT

PICTORIAL ASPECTS

	EFFECT ON AUDIENCE	SPEED OF COMPREHENSION	COMPLEMENT EFFECT
THE WORDLESS SHOT (SEE DOMINANCE) NUMBER ONE IN POWER.	PURE IMAGE *POWERFUL ABSOLUTE OR DREAMLIKE.* A THEME SHOT— OR COMEDY OR ADVENTURE OR DRAMA.	THE FASTEST AND THE STRONGEST	DIALOGUE SHOT HARMONY: PANORAMIC LONG SHOT STRIP SHOT SOUND FX SHOT
SOUND EFFECT SHOT REQUIRES CARE. MIGHT WORK AS A STRIP SERIES.	A CONVENTION. RISKS BEING IGNORED OR TOO FANCY AND DISTRACTING. A CRUTCH FOR ACTION.	FAST	OTHER
PURE SILHOUETTE STYLIZATION (MASKING) POWERFUL BUT CAN BE DISTANCING IF SEEN TO BE A CONVENTION.	SUBJECTIVE VERY INVOLVING. A PICTORIAL DIALOGUE. TOUCHES VIEWER'S 'CAVEMAN' INSTINCTS OR GESTALT.	SURPRISINGLY FAST	OTHER
DECORATIVE SILHOUETTE	DISTANCING. THE CONVENTION IS VERY OBVIOUS BUT IS ENJOYABLE IN AN ENTERTAINMENT CONTEXT.	FAST	CONVENTIONAL "REALISM"
JUSTIFIED SILHOUETTE FOG SMOKE WEATHER	SUBJECTIVE. INVOLVING. OVERCOMES THE CONVENTION OF PURE SILHOUETTE. *MYSTERY SUSPENSE*	FAST	USUAL
PARTIAL SILHOUETTE EMERGING FROM DARKNESS **INDELIBLE** WHEN DONE WELL N.C. WYETH	THE MOST INVOLVING PARTICULARLY WHEN COUPLED WITH THE WORDLESS SHOT.	MEDIUM TO SLOW	USUAL ⑤

STYLIZATION	EFFECT	SPEED	COMPLEMENT
	ON AUDIENCE	OF COMPREHENSION	EFFECT
PARTIAL SILHOUETTE LOST AND FOUND HOHLWEIN. POSTERS	INVOLVING. THE 'READING' TIME GIVES AN ARRESTED EFFECT.	MEDIUM TO SLOW	IN THE CLEAR USUAL
PARTIAL SILHOUETTE BACKLIT AND TOPLIT NIGHT LIGHT N.C. WYETH	INVOLVING. MUCH THE SAME AS 'EMERGING FROM DARKNESS'.	MEDIUM TO SLOW	USUAL
CAST SHADOW THE CLICHÉ IS FIGURES BUT NOT SETS	INVOLVING. IF NOT SEEN AS A CONVENTION. FIGURES ARE TRICKY TO HANDLE STRAIGHT BUT MIGHT BE GOOD FOR A PARODY EFFECT. *MYSTERY SINISTER*	MEDIUM	USUAL
BOTTOM LIGHT 	THE CLICHÉ EERIE LIGHT- BUT IT STILL WORKS.	MEDIUM	
MASKING (HIDING THE FACE) BACK SHOT	*VOYEUR* SPEECH IS AMBIGUOUS. DISTANCING. *COMEDY DRAMA* NOT MUCH IN *ADVENTURE.*	FAST	
OBJECT MASK GRID 	*VOYEUR* DEHUMANIZING IN COMEDY. ——— *SINISTER* IN *MYSTERY*	FAST IN COMEDY ——— SLOWER IN MYSTERY	
ANGLE MASK PSYCHO	*VOYEUR* SAME AS TOP SHOT *EXCEPT* WHEN USED AS MASK.	MEDIUM	

⑥

			EFFECT	SPEED	COMPLEMENT
FRAMING		**COMPOSITION**	**ON AUDIENCE**		**EFFECT**
			HEIGHTENS VOYEURISM. HEIGHTENS SUBJECTIVE FEELNG OF LOCALE.	FAST	
DOMINANCE			MAKES READER HOLD TWO IMAGES IN MIND AT ONCE. THEME IMAGE	SLOWS READING SOMEWHAT DUE TO EYE-CATCHING.	BALANCE
FRAME (SCALE) FRAME TONE	PAGE SCALE PAGE TONE				
'AIR' WITHIN FRAME		SPACE ON TOP AND AT SIDES	KEEPS A FULL SHOT FROM LOOKING CROWDED. EASIER READING	SPEEDS UP SLOW PIC	NO BG. / NO AIR NO BACKGROUND/ NO AIR

MYSTERY		**INSERT SHOT**	
	CHARACTER SHOT SHROUDED IN SHADOWS - HALF SILHOUETTE		FLASHBACK

PICTORIAL VALUES

① ALL THE THINGS THAT GO TO MAKE AN EFFECTIVE IMAGE------------------ THE SHOT

② ALL THE THINGS THAT GO TO MAKE AN EFFECTIVE SERIES OF IMAGES------ THE STYLE

THE STRIP -----THE CUT

⑦

STRIP SHOTS

ALL STRIP SHOTS ARE COMPLEMENTS OF SINGLE SHOTS.

ONLY FIXED CAMERA IS 'FAST'-REST ARE SLOW.

(TO READ, NOT IN FILM.)

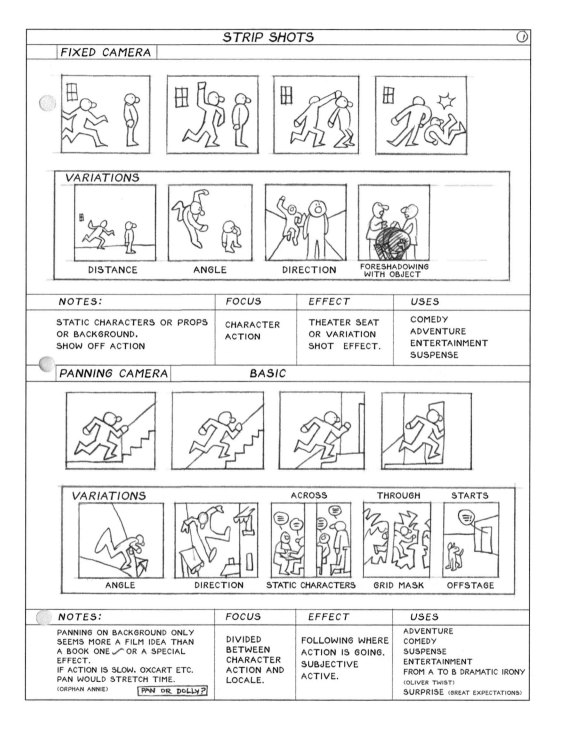

STRIP SHOTS

FIXED CAMERA

VARIATIONS

DISTANCE ANGLE DIRECTION FORESHADOWING WITH OBJECT

NOTES:	FOCUS	EFFECT	USES
STATIC CHARACTERS OR PROPS OR BACKGROUND. SHOW OFF ACTION	CHARACTER ACTION	THEATER SEAT OR VARIATION SHOT EFFECT.	COMEDY ADVENTURE ENTERTAINMENT SUSPENSE

PANNING CAMERA BASIC

VARIATIONS ACROSS THROUGH STARTS

ANGLE DIRECTION STATIC CHARACTERS GRID MASK OFFSTAGE

NOTES:	FOCUS	EFFECT	USES
PANNING ON BACKGROUND ONLY SEEMS MORE A FILM IDEA THAN A BOOK ONE ⌐ OR A SPECIAL EFFECT. IF ACTION IS SLOW. OXCART ETC. PAN WOULD STRETCH TIME. (ORPHAN ANNIE) PAN OR DOLLY?	DIVIDED BETWEEN CHARACTER ACTION AND LOCALE.	FOLLOWING WHERE ACTION IS GOING. SUBJECTIVE ACTIVE.	ADVENTURE COMEDY SUSPENSE ENTERTAINMENT FROM A TO B DRAMATIC IRONY (OLIVER TWIST) SURPRISE (GREAT EXPECTATIONS)

TRUCK IN

VARIATIONS

DISTANCE — ANGLE — BACKGROUND ONLY (CROSS CUT) — CIRCUS SHOT — MASK GRID OR FRAME

NOTES:	FOCUS	EFFECT	USES
SHOULD HAVE GOOD REASON TO RELATE CHARACTER TO LOCALE. EASILY OVERUSED. CUTS PREFERRED.	REVEAL OBJECT OR CHARACTER IN LOCALE.	BEING LED TO SEE SOMETHING IN PARTICULAR. SUBJECTIVE.	EXPOSITION OF CHARACTER & LOCALE. SUSPENSE POSSIBLE IN DIALOGUE. SURPRISE IF CHARACTER HAS IT.

TRUCK OUT

VARIATIONS CIRCUS SHOT

DISTANCE — ANGLE — CHARACTERS ARRIVE

NOTES:	FOCUS	EFFECT	USES
POWERFUL TOOL OF DRAMATIC IRONY. SCARLETT AT THE R.R. HOSPITAL. KANE'S POSSESSIONS. A GATHERING CROWD. BEING WATCHED. WEAK IF USED ONLY FOR SCENERY. CUTS PREFERRED.	ON LOCALE SITUATION. VIS-À-VIS CHARACTERS.	DRAMATIC IRONY CHANGE OF FEELING TOWARD CHARACTER SITUATION AS FIRST SEEN. OMNIPOTENT.	ADVENTURE COMEDY SURPRISE

③

TILTING AND ROTATING

VARIATIONS

CHANGE OF DIRECTIONS

A ROUGH RIDE

TRUCK IN OR OUT ON THE DOLLY THE NAUSEA CRANE

NOTES:	FOCUS	EFFECT	USES
HEIGHTENS PANNING CAMERA STRIP. FOR MOST DRAMATIC ACTION ONLY. USE SPARINGLY. COMIC BOOK CLICHÉ. JUMP CUTTING. IN FILM: HANDHELD.	DIVIDED- ACTION & LOCALE	SUBJECTIVE ACTIVE DIZZYING	ADVENTURE SUBJECTIVE BANGING ABOUT

SWIVELING CAMERA

VARIATIONS

PANORAMA

DANCE OF HOURS

DOUBLE PERSPECTIVE

NOTES:	FOCUS	EFFECT	USES
USED IN ROADRUNNER CARTOONS.		VIEWER IS ROOTED TO THE SPOT. SLIGHTLY UNPLEASANT.	SUBJECTIVE COMEDY SHOT FRUSTRATION DANGER

④

RANGING CAMERA

RANGING AROUND DYNAMIC ACTION

VARIATIONS

RANGING AROUND STATIC ACTION

LOOPING ANGLES (TILTING ROTATING)

BACKGROUND ONLY IF FLYING OR FALLING

NOTES:	FOCUS	EFFECT	USES
SIMILAR TO SWIVEL BUT FOCAL OBJECT IS CONSTANT. OVERLAPS TILTING. ROTATING. CRANE.	LOCALE. DIVIDED, OR ACTION.	SUBJECTIVE MOVEMENT: RUNNING, RIDING, FLYING, FALLING	ADVENTURE SUSPENSE ENTERTAINMENT TO EXTEND DURATION

DOLLYING CAMERA BASIC

VARIATIONS

THROUGH

BACKGROUND ONLY THROUGH GRIDS THROUGH CROWD SPECIAL VIEWPOINT STATIC ACTION

NOTES:	FOCUS	EFFECT	USES
VERY DRAMATIC IN SPECIAL PLACE. TRENCHES IN 'PATHS OF GLORY' JUNGLE. CITIZEN KANE'S LOCALES. COULD BE USED MORE IN COMEDY (MR. HULOT) DOLLY OR PAN?	LOCALE. SECONDARILY, CHARACTERS BUSINESS IN IT.	SUBJECTIVE. MOVING WITH OR AS THE CHARACTER. FOLLOW ME.	SUSPENSE LOCALE ADVENTURE LOCALE COMEDY LOCALE DRAMA LOCALE ENTERTAINMENT MOBILITY SURPRISE DRAMATIC IRONY

⑤

REVEALS

TURN ON A LIGHT

HARRY LIME

FRANK MILLER

MYSTERY INTO MENACE

MYSTERY INTO MENACE: THE INTRODUCTION OF A KEY ELEMENT IS GIVEN EXTRA EMPHASIS.
HARRY LIME (THE THIRD MAN) IS FULL OF SYMBOLISM AND THOUGHT. CAMERA FOLLOWS
GIRLFRIEND'S CAT. CAT SEES OLD FRIEND IN DARK. LIGHT REVEALS THE 'DEAD' HARRY.
HE IS BROUGHT TO LIGHT. AND LIFE. HE AND THE CAT ARE NIGHT CREATURES.
FRANK MILLER (HIGH NOON) LOOKS SLEEK. THEN YOU SEE FACIAL CONDITION.

TRUCK IN ON AN EXPRESSION

DONE MECHANICALLY AND FROM RIGHT DISTANCE.
DIALOGUE OR SFX (SPECIAL EFFECTS) WOULD HELP.

SHOTS

SHOTS ARE PURVEYORS OF INFORMATION. WHERE, WHEN, WHAT, WHO.

THEY MUST NOT BE "ON-THE-NOSE." MAKE THE DATA PART OF A COMPOSITION TO BE INTERPRETED BY THE AUDIENCE.

THE SHOT CUTS

DIALOGUE CUTS

CUT IN

NOTES:

CUT *IN* FOR EXPRESSION, INVOLVEMENT FOCUS: CHARACTER, SPEECH

CUT *OUT* FOR ACTION, DISENGAGEMENT FOCUS: ACTION LOCALE

CUT OUT

FOCUS ON SPEAKER

FOCUS ON REACTION

ACCENT CUT

NOTES:

CLOSE-UP USED AS ACCENT TO ACTION.

FIND COMPLEMENT TO FOCAL ACTION
SHOT AND USE IT FOR ANTICIPATION.

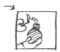 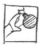 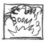

REVERSE ALSO
CLOSE-UP TO LONG SHOT.

MONTAGE

COMPOSITIONAL ELEMENTS USED AS THEME THEME CHANGE

NOTES:

USED BY EISENSTEIN

EXCITEMENT MONTAGE

NOTES:

RAPID VIEWPOINT ANGLE CUTTING USED FOR ALARMS AND EXCITEMENT.

EVERY SHOT IS SUBJECTIVE

There are only a few possible ways to show pictorial locales. Decide which suits the action best.

Examples

The main ways to treat master shots are four-square (theater frame), pictorial and cropped. The type of pictorial in the graphics suggests the sort of tale, flashback or song to be done.

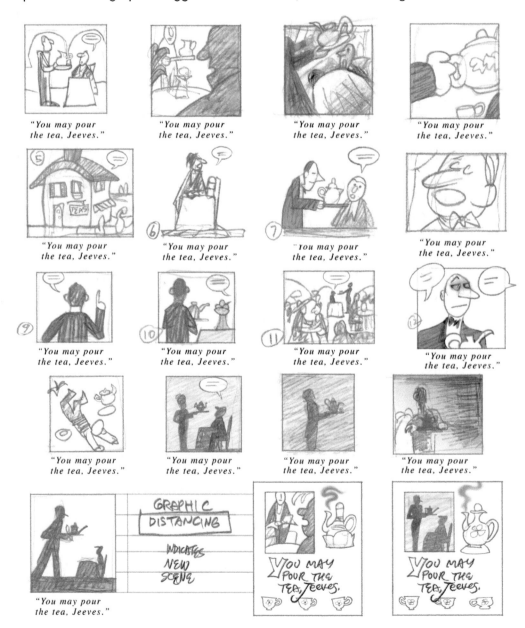

3

CARICATURE

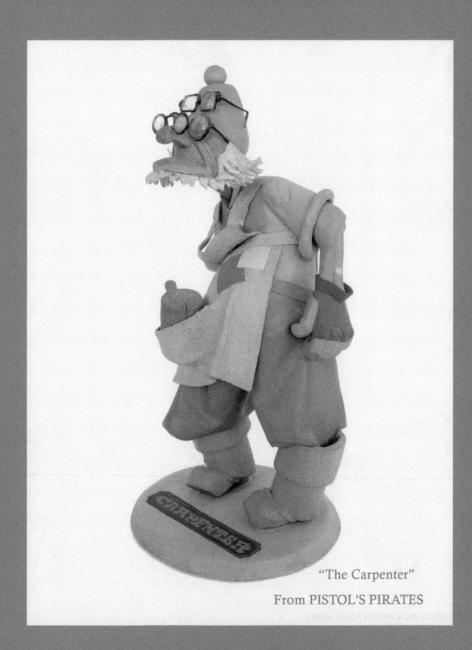

"The Carpenter"

From PISTOL'S PIRATES

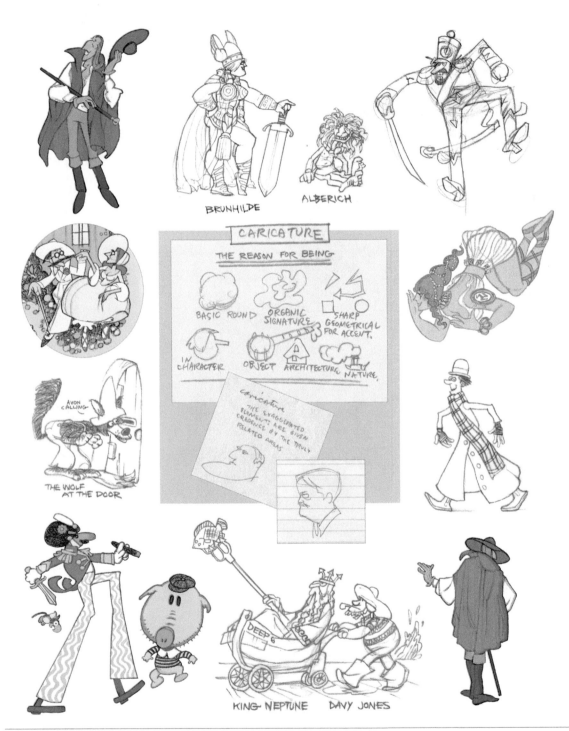

BRUNHILDE

ALBERICH

CARICATURE

THE REASON FOR BEING

BASIC ROUND

ORGANIC SIGNATURE

SHARP GEOMETRICAL FOR ACCENT.

IN CHARACTER

OBJECT

ARCHITECTURE

NATURE.

Caricature
THE EXAGGERATED ELEMENTS ARE GIVEN CREDENCE BY THE TRULY RELATED AREAS

AVON CALLING

THE WOLF AT THE DOOR

DEEP

KING NEPTUNE

DAVY JONES

DEVELOPMENT ART FROM THE CAPTAIN PISTOL SERIES

CARICATURE

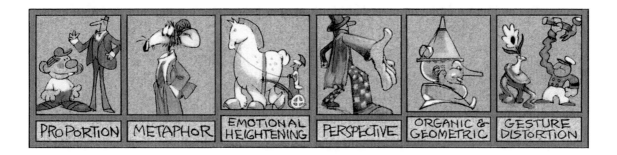

Caricature should go all the way—caricature of proportions, caricature of anatomy, caricature of surroundings, caricature of treatment. Even of intention: caricature of emotions, expression and statement.

Therein lies the signature of style.

Caricature: A name for expression in a drawing. Heightening for effect. It is more than just exaggerating facial features. Consider every area where caricature may be applied.

Possible Effects

- Portraiture, Idealization:
 - To aggrandize—drawn taller, more handsome, more commanding. Visionary.
- Religious Painting, Idealization:
 - To deify—drawn to express piety, godliness, suffering and strength, power, ascendancy.
 - By symmetry—grid or interlocking framework.
- Nudes and Figures, Idealization:
 - To beautify—drawn to perfect symmetry and relations of parts. Flowing, smooth lines to evoke sensuous surfaces.
- Landscape, Still Life, Pure Painting and Decorative Art:
 - To create harmony—the Aesthetic Effect, a quiet or grand landscape, a sensuous still life, harmonic forms or variety of surfaces. By harmony of shapes.
- Classic Caricature:
 - To evoke humor and fun—by means of gesture, expression and metaphor.

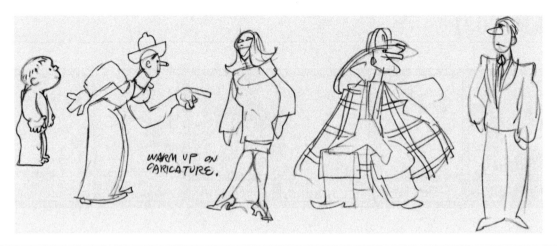

WARM UP ON CARICATURE

Gesture and Expression

Gesture and Expression reveal the character's mental attitude and are rooted in action: either intended action or mid-action or reaction, and either physical action or mental action.

This emphasis on action slants the drawing, if not toward the outright comic, at least away from the sublime. Our concept of the sublime is rooted in the eternal and we think of the eternal as being static—at least in a pictorial depiction. We may know the eternal is cyclical as are the seasons or the ocean waves but depicting eternal movement in a still picture is daunting if not impossible.

The depicter of the serious is on safer ground by showing the subject in repose, however momentary. That's why academic paintings of heroic cavalry charges seem overreaching and unconvincing.

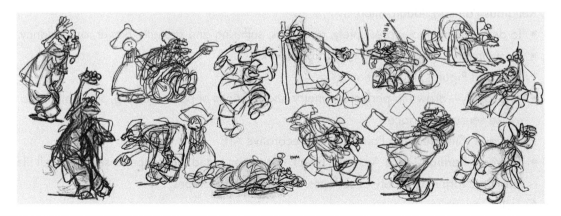

GESTURE DRAWINGS OF THE CARPENTER

Metaphor

Metaphor: a visual pun. A depicting of a person or object with its *recognizable* qualities transformed. A huge locomotive made into a child's toy with its most obvious (but least important) characteristics emphasized: big smokestack, cowcatcher, bell and whistle or a person drawn with a "tomato nose, pig-eyes, square head and lantern jaw." The deviations from the ideal are not incorporated into the ideal but pulled out from it.

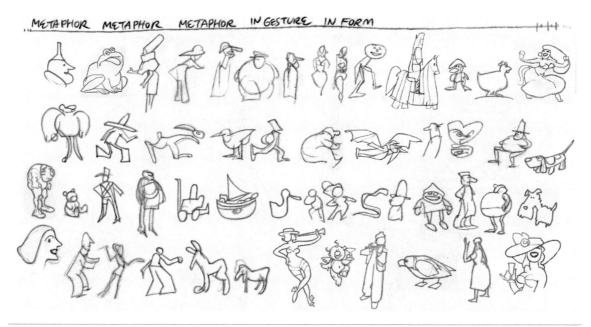

EMPHASIS ON METAPHOR

Atlas, a character in *Pistol's Pirates*, is crazy about potatoes. It may be true that you are what you eat—everything about him is potato-esque.

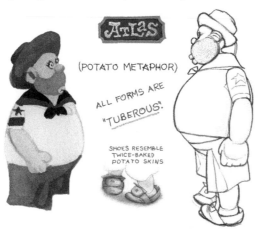

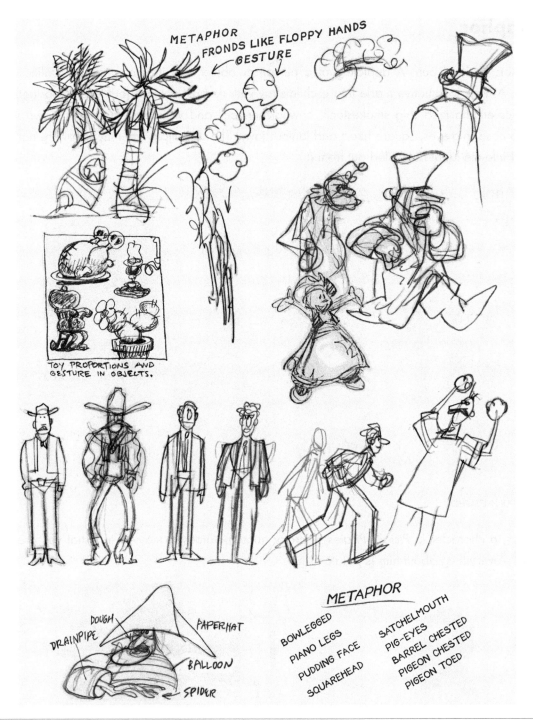

METAPHOR
FRONDS LIKE FLOPPY HANDS
GESTURE

TOY PROPORTIONS AND GESTURE IN OBJECTS.

DOUGH
DRAINPIPE
PAPERHAT
BALLOON
SPIDER

METAPHOR

BOWLEGGED
PIANO LEGS
PUDDING FACE
SQUAREHEAD

SATCHELMOUTH
PIG-EYES
BARREL CHESTED
PIGEON CHESTED
PIGEON TOED

Form

You can learn about caricature of form by studying artists in various disciplines. Below is a list of examples. Surprisingly you may discover that some painters known for simple powerful representation may be employing an element of caricature. Distortion, stylization, exaggeration and emphasis are qualities to look for.

William Auerbach-Levy (1889–1964)—Russian-American artist known for his paintings, etchings and caricatures. Examples: *Is That Me? A Book About Caricature.*

Ralph Barton (1891–1931)—American artist best known for his cartoons and caricatures of famous people of the time. Examples: Illustrations for *But Gentlemen Marry Brunettes,* Honoré de Balzac's *Droll Stories,* individual caricatures of marine, storyteller, cook, French *gendarme,* Russian dancer, clarinetist, portraits of John C. Calhoun and Henry Clay in *God's Country* by Ralph Barton, 1929.

Franklin Booth (1874–1948)—American artist admired for detailed pen-and-ink illustrations. Example: Treatment of foliage.

Umberto Brunelleschi (1879–1949)—Italian artist of fashion, illustration, stage and costume; a master of the *pochoir* stencil technique; good use of "signature shape." Examples: commedia del'arte illustrations, *Les Masques et les Personnages de la Comédie Italienne, Candide,* clouds and drapery.

Covarrubias (José Miguel Covarrubias Duclaud) (1904–1957)—Mexican painter and caricaturist, known for depicting public figures and the jazz scene in *Vanity Fair* magazine. Examples: caricatures, including *Marie of Romania vs. Mae West* from "Impossible Interviews," Marlene Dietrich, Benito Mussolini.

Will Crawford (1869–1944)—American artist noted for pen-and-ink virtuosity in his illustrations for magazines and books.

Rowland Emmett (1906–1990)—English cartoonist, production designer and inventor. Examples: *Punch* magazine, train and boat paper sculptures.

Lyonel Feininger (1871–1956)—German-American painter associated with the Bauhaus, innovative caricature can be found in his comic strips. Examples: *The Kin-der-Kids* and *Wee Willie*

Winkie's World, early newspaper comics, *Lyonel Feininger, Caricature and Fantasy* by Ernst Scheyer.

A. B. Frost (1851–1928)—American illustrator and painter who achieved recognition for pen-and-ink and wash illustration. Examples: Stuff and Nonsense by A.B. Frost, The Bull Calf and Other Tales, *Out of the Hurly-Burly, or, Life in an Odd Corner* by Charles Heber Clark (Max Adeler).

Vernon Grant (1902–1990)—American illustrator famous for designing cereal advertising characters; developed a unique charming storybook style and a notable technique of sharpening brush line with opaque white on line drawings. Examples: *The Cow and The Silver Cream* and *Flibbity Jibbit.*

John Held, Jr. (1889–1958)—American, one of the most famous magazine illustrators of the 1920s; created a style that became synonymous with the flapper era. Examples: Girls, bellbottoms, horse, and goat.

Gene Holtan (b.1930)—Illustrator and printmaker, unique grotesquerie pen and ink style. Examples: *A Picture Picker's Picture Collection, The Drawings and Iconographic Projections of an Illustrator & Near Artist in Need of Encouragement* (artist's catalog, 1967), opera singers, Spanish don (*Far-Sounding Reverberating Drum*), rabbits, and birds.

Albert Hurter (1883–1942)—Character designs for animation. Examples: *He Drew as He Pleased: A Sketchbook by Albert Hurter* by Ted Sears.

Heinrich Kley (1863–1945)—German caricaturist, editorial cartoonist and painter. Examples: Illustrations of the Greek myths, sketchbooks, *The Drawings of Heinrich Kley,* Dover 1961.

David Levine (1926–2009)—American artist and caricaturist for the *New York Review of Books* and many other publications. It is of interest to note how the element of caricature translates from the black-and-white drawings to the paintings, in particular the portraits. Examples: Caricatures, *No Known Survivors, David Levine's Political Plank* and watercolor paintings, *Coney Island Watercolors, Old Faded Glory, Irvine Standing, Gaunt, Blonde Frizz, The Smirk.*

Jack Levine (1915–2010)—American social realist painter and printmaker of satirical, political and biblical subjects. Examples: Paintings of *Adam and Eve, Six Masters: A Devotion, The Judgment of Paris* series.

Joseph Leyendecker (1874–1951)—Famous advertising and magazine illustrator; observe the manipulation of form for sculptural effect. Examples: covers for *The Saturday Evening Post* Magazine.

Norman Lindsay (1897–1969)—Australian artist and writer; good reference for poses. Examples: Illustrations for Aristophanes' *Lysistrata*.

Charles Saxon (1920–1988)—American, cartoonist for *The New Yorker* and advertising illustrator. Examples: *A Child's Garden of Misinformation* by Art Linkletter, *One Man's Fancy* by Charles Saxon, pilgrim, basset hound, spy spoof, toy animals and soldiers.

Ronald Searle (1930–2011)—English artist and cartoonist, creator of the St. Trinian's School and Molesworth series. Examples: *Punch* magazine theater column illustrations of the1950s, cartoons in *Le Monde*, cats, animals, French waiter.

Elsie Segar (Elzie Crisler Segar) (c.1894–1938)—American cartoonist, best known as the creator of Popeye, Olive Oyl and other cartoon characters, *Thimble Theatre*.

Simplicissimus (Published 1896–1967)—Satirical journals published in Germany containing the work of various artists. Examples: cover art and cartoons.

Edward Sorel (b. 1929)—American illustrator and cartoonist. Examples: *Making the World Safe for Hypocrisy*, caricatures of Jacqueline Onassis and others.

T.S. Sullivant (1854–1926)—American, cartoonist for *Life* magazine, *Judge* and other publications in pen and ink style. Examples: Ducks, monkey, women, snake and cowboy.

Gustaf Tenggren (1896–1970)—Swedish-American illustrator, design for characters and animation. Examples: Development art for Walt Disney films, *The Tenggren Tell-It-Again Book*, 1942.

Sir John Tenniel (1820–1914)—British illustrator known for illustrating Lewis Carroll's *Alice's Adventures in Wonderland* and *Through the Looking Glass*. Examples: *Punch* magazine illustrations, initial characters, Father William and carpenter.

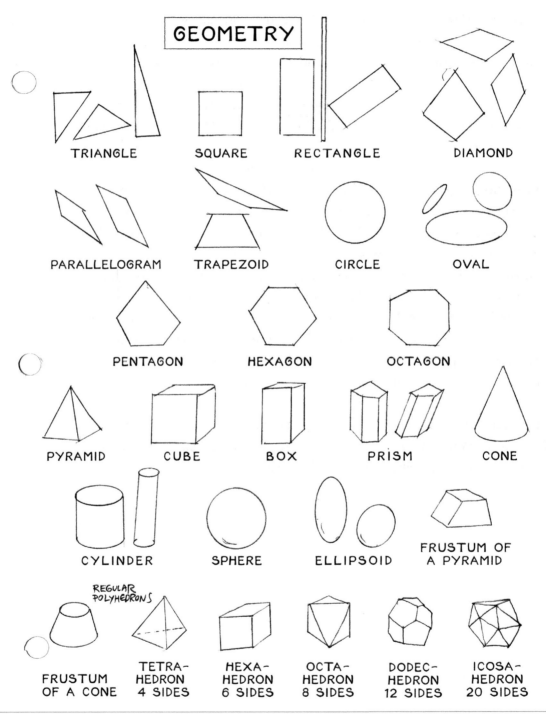

GEOMETRY

TRIANGLE SQUARE RECTANGLE DIAMOND

PARALLELOGRAM TRAPEZOID CIRCLE OVAL

PENTAGON HEXAGON OCTAGON

PYRAMID CUBE BOX PRISM CONE

CYLINDER SPHERE ELLIPSOID FRUSTUM OF A PYRAMID

REGULAR POLYHEDRONS

FRUSTUM OF A CONE | TETRA-HEDRON 4 SIDES | HEXA-HEDRON 6 SIDES | OCTA-HEDRON 8 SIDES | DODEC-HEDRON 12 SIDES | ICOSA-HEDRON 20 SIDES

GEOMETRY CHART

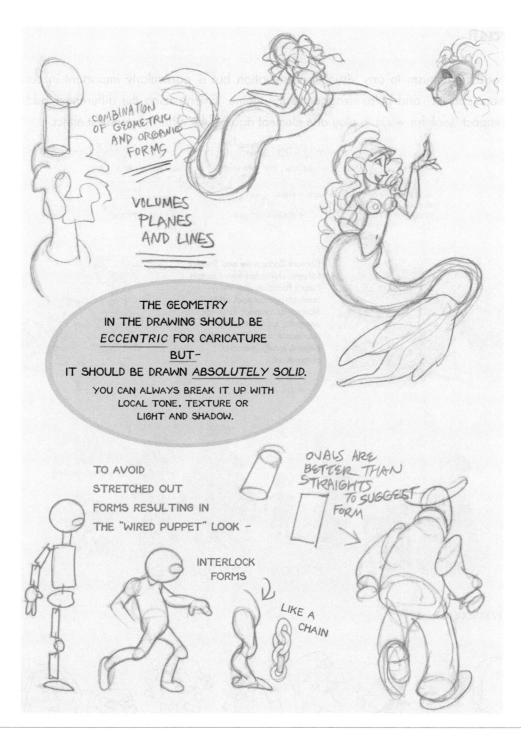

COMBINATION OF GEOMETRIC AND ORGANIC FORMS

VOLUMES PLANES AND LINES

THE GEOMETRY
IN THE DRAWING SHOULD BE
ECCENTRIC FOR CARICATURE
BUT–
IT SHOULD BE DRAWN *ABSOLUTELY SOLID.*
YOU CAN ALWAYS BREAK IT UP WITH
LOCAL TONE, TEXTURE OR
LIGHT AND SHADOW.

TO AVOID STRETCHED OUT FORMS RESULTING IN THE "WIRED PUPPET" LOOK –

OVALS ARE BETTER THAN STRAIGHTS TO SUGGEST FORM

INTERLOCK FORMS

LIKE A CHAIN

NOTES ON FORM IN CARICATURE

Contrast

Contrast adds dynamism to any visual representation but is particularly important in caricature. It gives extra "punch" and helps exaggerate the theme. Emphasizing the differences adds to the comedic impact. Look for ways to play one element against the other for greatest effect.

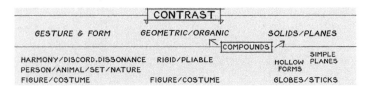

CONTRAST		
GESTURE & FORM	GEOMETRIC/ORGANIC	SOLIDS/PLANES
	COMPOUNDS	
HARMONY/DISCORD.DISSONANCE	RIGID/PLIABLE	HOLLOW FORMS / SIMPLE PLANES
PERSON/ANIMAL/SET/NATURE		
FIGURE/COSTUME	FIGURE/COSTUME	GLOBES/STICKS

Captain Corkscrewe and Smellez LaFeete, characters from Captain Pistol's Paradise, play many contrasts against each other: elongated/compact, languid/ energetic, tall/short, cool/ passionate, angular/ rounded, elegant/scruffy, melodic/ abrasive, etc.

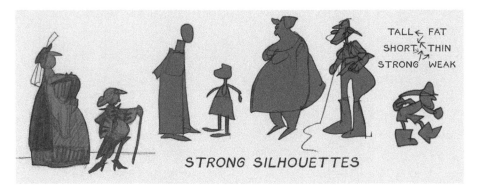

STRONG SILHOUETTES

CONTRAST IN SILHOUETTE

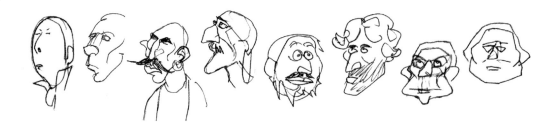

Heightening

Heightening is a concept borrowed from the stage. For example, Greek drama made catastrophe seem more catastrophic by intensifying the action directly before it in a part of the play called the *catastasis*. Or a comedian may create ever-increasing hilarity by presenting subsequent crazier variations on a seemingly simple theme.

It's a paradox! Think about employing the opposite quality to build up the characteristic you are portraying…

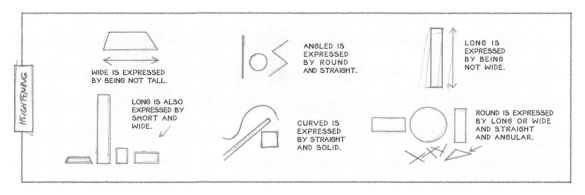

HEIGHTENING CHART

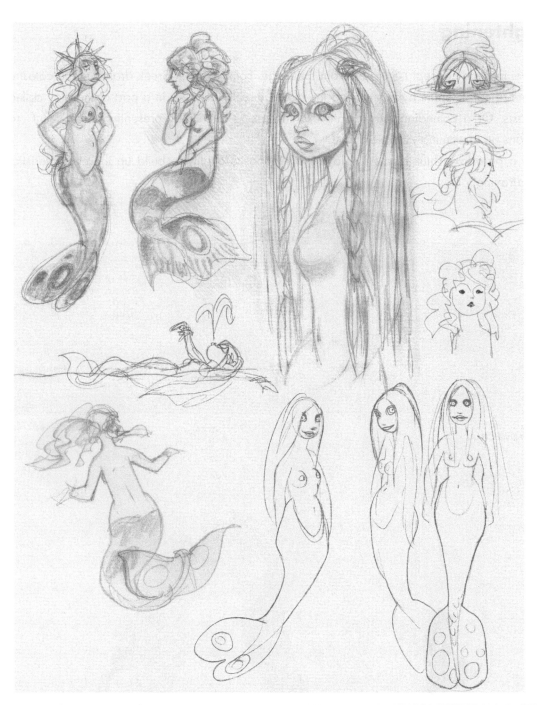

MERMAID SKETCHES

Light for Caricature

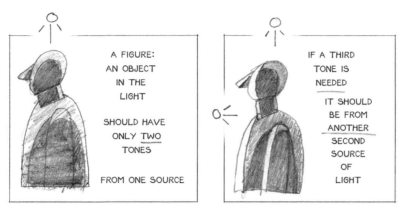

A FIGURE:
AN OBJECT
IN THE
LIGHT

SHOULD HAVE
ONLY TWO
TONES

FROM ONE SOURCE

IF A THIRD
TONE IS
NEEDED

IT SHOULD
BE FROM
ANOTHER
SECOND
SOURCE
OF
LIGHT

TO KEEP THE NECESSARY SIMPLICITY.

Color in Caricature

BE ON THE LOOKOUT FOR COLORS TO EXAGGERATE.

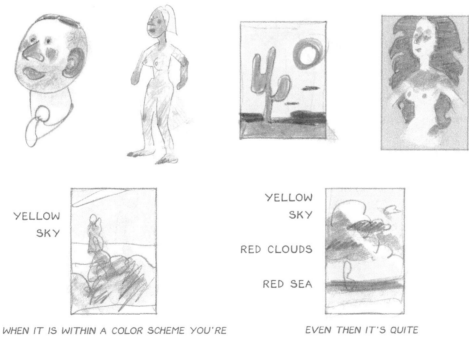

YELLOW
SKY

YELLOW
SKY

RED CLOUDS

RED SEA

WHEN IT IS WITHIN A COLOR SCHEME YOU'RE
NOT AWARE OF AN ECCENTRIC COLORING –
UNLESS YOU CALL
ATTENTION TO IT.

EVEN THEN IT'S QUITE
EASILY ACCEPTED.

Character Drawing

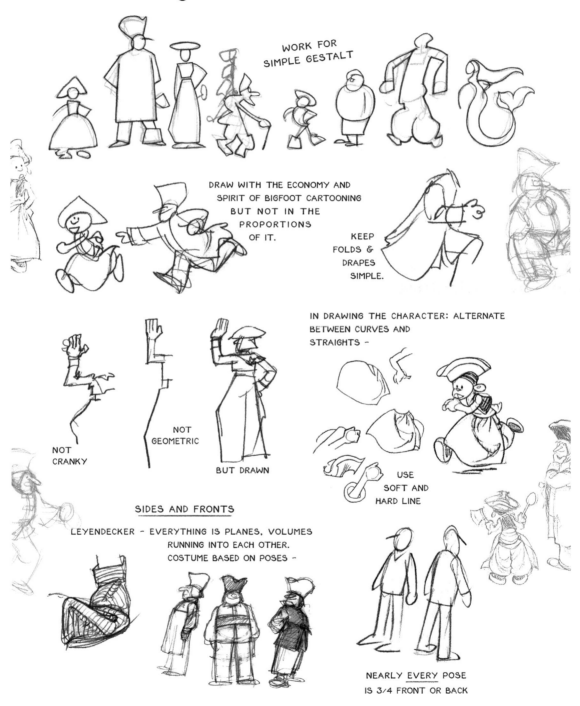

WORK FOR SIMPLE GESTALT

DRAW WITH THE ECONOMY AND SPIRIT OF BIGFOOT CARTOONING BUT NOT IN THE PROPORTIONS OF IT.

KEEP FOLDS & DRAPES SIMPLE.

IN DRAWING THE CHARACTER: ALTERNATE BETWEEN CURVES AND STRAIGHTS –

NOT CRANKY

NOT GEOMETRIC

BUT DRAWN

USE SOFT AND HARD LINE

SIDES AND FRONTS

LEYENDECKER – EVERYTHING IS PLANES, VOLUMES RUNNING INTO EACH OTHER. COSTUME BASED ON POSES –

NEARLY EVERY POSE IS 3/4 FRONT OR BACK

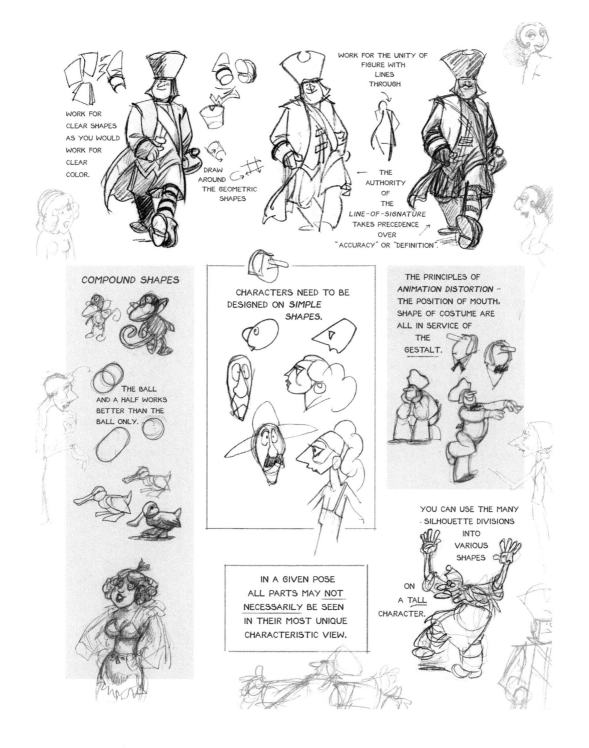

WORK FOR THE UNITY OF
FIGURE WITH
LINES
THROUGH

WORK FOR
CLEAR SHAPES
AS YOU WOULD
WORK FOR
CLEAR
COLOR.

DRAW
AROUND
THE GEOMETRIC
SHAPES

THE
AUTHORITY
OF
THE
LINE-OF-SIGNATURE
TAKES PRECEDENCE
OVER
"ACCURACY" OR "DEFINITION".

COMPOUND SHAPES

THE BALL
AND A HALF WORKS
BETTER THAN THE
BALL ONLY.

CHARACTERS NEED TO BE
DESIGNED ON SIMPLE
SHAPES.

IN A GIVEN POSE
ALL PARTS MAY NOT
NECESSARILY BE SEEN
IN THEIR MOST UNIQUE
CHARACTERISTIC VIEW.

THE PRINCIPLES OF
ANIMATION DISTORTION –
THE POSITION OF MOUTH,
SHAPE OF COSTUME ARE
ALL IN SERVICE OF
THE
GESTALT.

YOU CAN USE THE MANY
SILHOUETTE DIVISIONS
INTO
VARIOUS
SHAPES
ON
A TALL
CHARACTER.

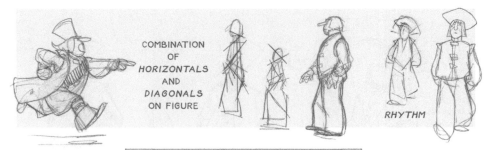

COMBINATION
OF
HORIZONTALS
AND
DIAGONALS
ON FIGURE

RHYTHM

THE DEFINITION OF THE CARICATURE STYLE					
CARTOONS ARE STEREOTYPES:	MAN	"TOOTSIE"	DOG	CAT	BIRD
CARICATURES ARE *INDIVIDUALS* HEIGHTENED AND DIMINISHED:	MAIL-MAN	SHOW-GIRL	AIRE-DALE	ALLEY CAT	SEA GULL

SQUASH
&
STRETCH
IN
CHARACTERS.

COSTUME

TIME PERIODS DEFINED BY SILHOUETTE

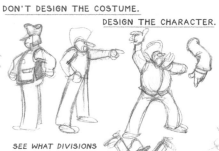

1800'S 1700'S 1600'S 1560'S 1400'S

ACTION FIGURES CAN'T BE SO SWADDLED IN CLOTHES THAT YOU CAN'T SEE THEIR ACTION POSES.

DON'T DESIGN THE COSTUME.

DESIGN THE CHARACTER.

DESIGN COSTUMES ON CHARACTERS IN ACTION POSES FIRST.

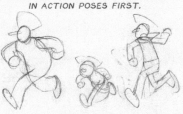

SEE WHAT DIVISIONS BRING OUT THE POSE BEST.

THEN IN REPOSE.

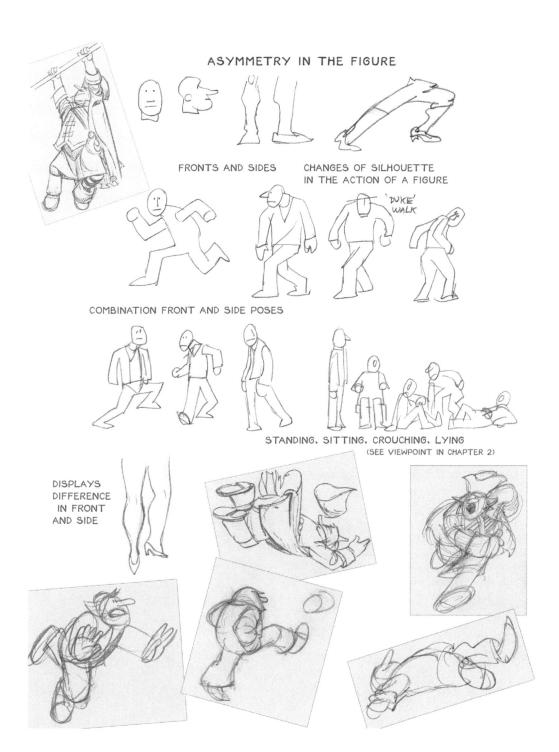

ASYMMETRY IN THE FIGURE

FRONTS AND SIDES

CHANGES OF SILHOUETTE
IN THE ACTION OF A FIGURE

'DUKE' WALK

COMBINATION FRONT AND SIDE POSES

STANDING, SITTING, CROUCHING, LYING
(SEE VIEWPOINT IN CHAPTER 2)

DISPLAYS
DIFFERENCE
IN FRONT
AND SIDE

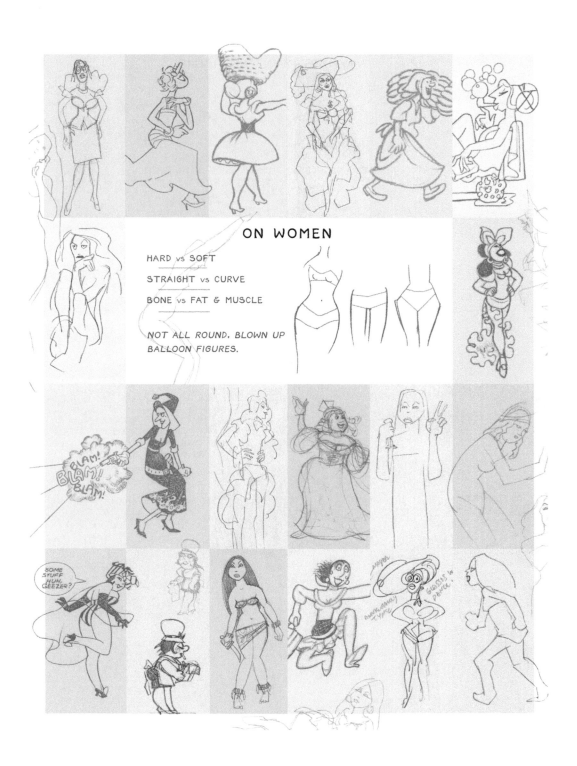

CARTOON STOCKY CHARACTERS

ARMS ARE
FULL LENGTH
LEGS ARE SHORT

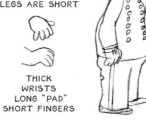

THICK
WRISTS
LONG "PAD"
SHORT FINGERS

POSES MUST BE
FOUND THAT
EXPRESS A FEELING
AND
FIT THE DESIGN.

MOST OF THE EARLY CLASSIC CHARACTERS ARE OUT OF PROPORTION THIS WAY.

A POSE
CANNOT
ALWAYS BE EXPECTED
TO FIT A CHARACTER
OF A DIFFERENT
BODY DESIGN.

*PERSONALITY IS
OFTEN EXPRESSED
IN JUST A FEW
STRONG
POSES*

REPEATED

*Madame
Mendous*

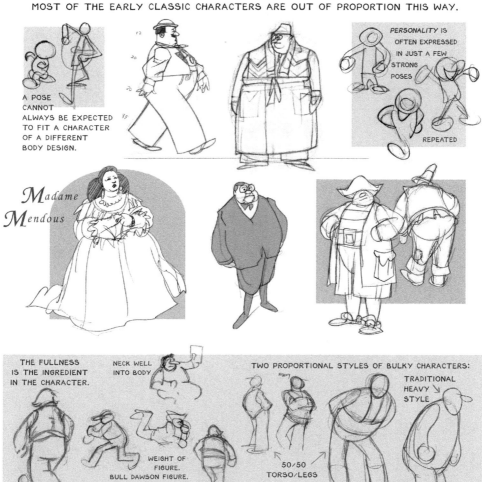

THE FULLNESS
IS THE INGREDIENT
IN THE CHARACTER.

NECK WELL
INTO BODY

TWO PROPORTIONAL STYLES OF BULKY CHARACTERS:

TRADITIONAL
HEAVY
STYLE

WEIGHT OF
FIGURE.
BULL DAWSON FIGURE.
(CHARACTER FROM ROY CRANE'S
WASH TUBBS)

50/50
TORSO/LEGS

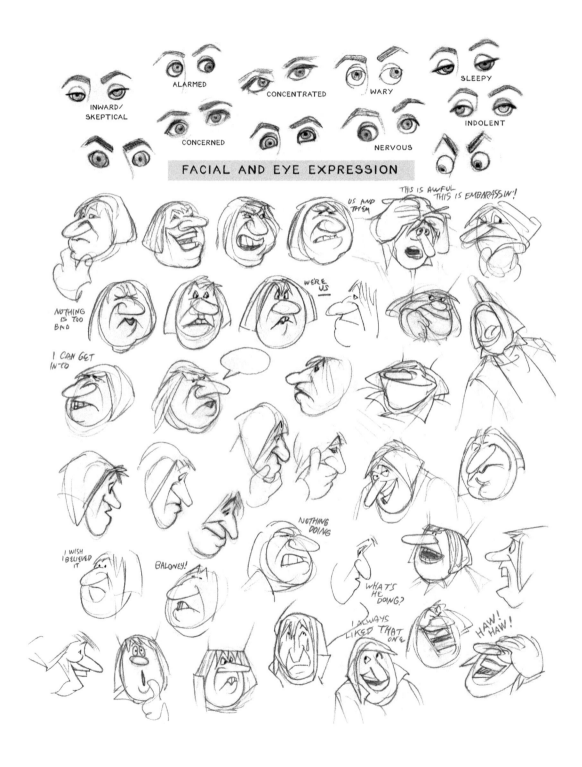

FACIAL AND EYE EXPRESSION

Peter Vatsures, Art Director
EXAMPLES FOR A PROMOTIONAL PIECE 1

EXAMPLES FOR A PROMOTIONAL PIECE 2

EXAMPLES FOR A PROMOTIONAL PIECE 3

EXAMPLES FOR A PROMOTIONAL PIECE 4

CARICATURE

(1.) PROPORTION CONSISTS OF:

(A) HEIGHTENING/SUPPRESSING

1. THE MANY / THE FEW

2. THE LARGE / THE SMALL

3. THE FULL / THE LEAN

4. THE CONGESTED/THE OPEN

(2.) METAPHOR

(A) OBJECT AS HUMAN

(B) HUMAN AS OBJECT

ANIMAL, VEGETABLE,
MINERAL

(3.) EMOTIONAL HEIGHTENING

(A) THE EMOTIONS: FEAR, LOVE, AWE, ETC.

(B) EXPRESSED VISUALLY THROUGH SCALE, PERSPECTIVE,
TREATMENT, ETC.

(4.) PERSPECTIVE

(A) GEE WHIZ* PERSPECTIVE ON A CHARACTER
OR SCENE

(B) BROKEN OR MULTIPLE PERSPECTIVE

(C) SCALE PERSPECTIVE

(10)

CREATIVELY APPLIED
FOR EFFECT

*"GEE WHIZ" REFERS TO THE EXTREME PERSPECTIVE ONCE USED IN COMMERCIALS FOR DRAMATIC EXAGGERATION.

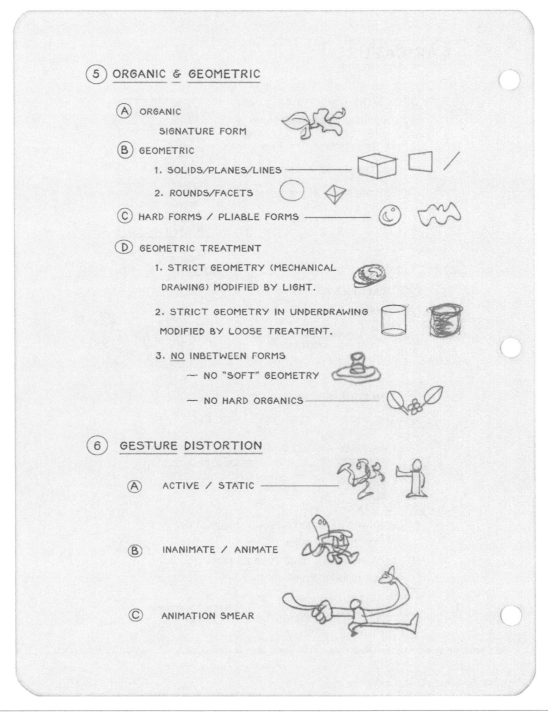

(5) ORGANIC & GEOMETRIC

(A) ORGANIC

SIGNATURE FORM

(B) GEOMETRIC

1. SOLIDS/PLANES/LINES ————

2. ROUNDS/FACETS

(C) HARD FORMS / PLIABLE FORMS ————

(D) GEOMETRIC TREATMENT

1. STRICT GEOMETRY (MECHANICAL DRAWING) MODIFIED BY LIGHT.

2. STRICT GEOMETRY IN UNDERDRAWING MODIFIED BY LOOSE TREATMENT.

3. NO INBETWEEN FORMS

— NO "SOFT" GEOMETRY

— NO HARD ORGANICS ————

(6) GESTURE DISTORTION

(A) ACTIVE / STATIC ————

(B) INANIMATE / ANIMATE

(C) ANIMATION SMEAR

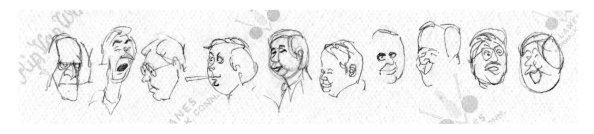

Caricatures of cartoonists and writers in the Friday afternoon bowling club, Westport, Connecticut

There are those who feel that the cartoon is an amusement for the feeble-minded. And very often it is. But for me the appeal of a cartoon as discharged by its very best masters is the appeal of an art form that combines maximum expression with the greatest economy of means.

In such a magical combination you will find some everlasting human folly presented with the eternal power of an icon. Such a surprising combination has the power to make you weep or better still, laugh.

A cartoon in that exalted state of grace is blood brother to the work of Picasso and the master carvers of New Guinea's Sepik River.

4
COMPOSITION

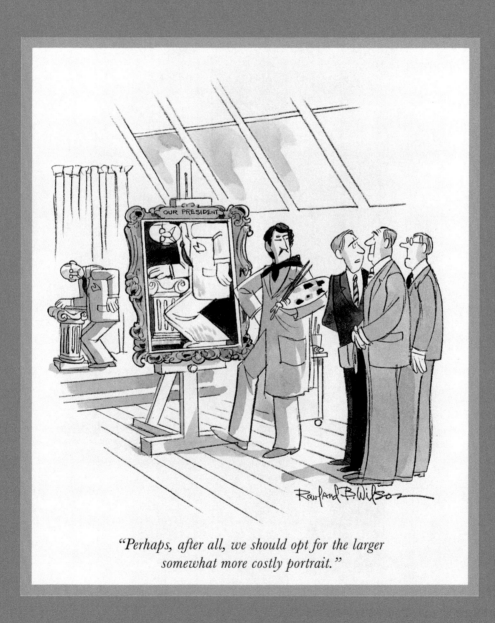

"Perhaps, after all, we should opt for the larger somewhat more costly portrait."

THUMBNAIL STUDIES OF COMPOSITIONS BY VARIOUS ARTISTS

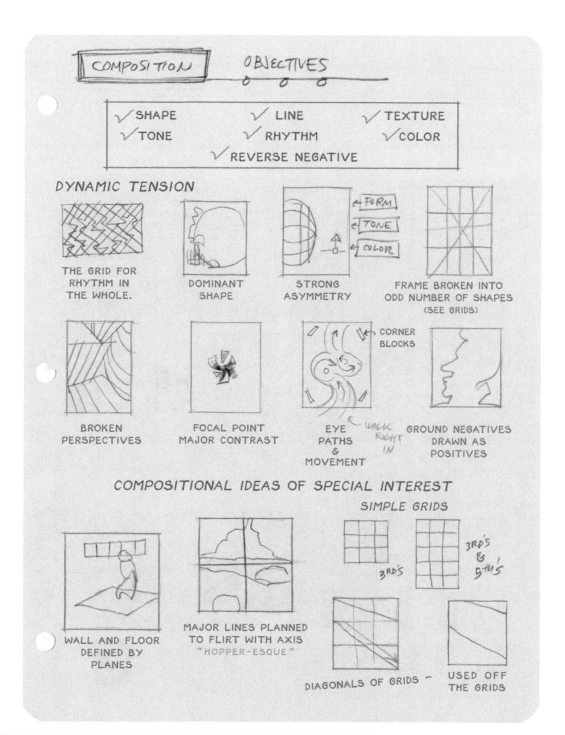

COMPOSITION OBJECTIVES

✓ SHAPE ✓ LINE ✓ TEXTURE
✓ TONE ✓ RHYTHM ✓ COLOR
 ✓ REVERSE NEGATIVE

DYNAMIC TENSION

THE GRID FOR
RHYTHM IN
THE WHOLE.

DOMINANT
SHAPE

STRONG
ASYMMETRY

← FORM
← TONE
← COLOR

FRAME BROKEN INTO
ODD NUMBER OF SHAPES
(SEE GRIDS)

BROKEN
PERSPECTIVES

FOCAL POINT
MAJOR CONTRAST

CORNER
BLOCKS

EYE
PATHS
&
MOVEMENT

WALK
RIGHT
IN

GROUND NEGATIVES
DRAWN AS
POSITIVES

COMPOSITIONAL IDEAS OF SPECIAL INTEREST

SIMPLE GRIDS

WALL AND FLOOR
DEFINED BY
PLANES

MAJOR LINES PLANNED
TO FLIRT WITH AXIS
"HOPPER-ESQUE"

3RD'S

3RD'S
&
5TH'S

DIAGONALS OF GRIDS –

USED OFF
THE GRIDS

COMPOSITION OBJECTIVES

TYPES OF COMPOSITION

TRADITIONAL ILLUSTRATION

MOST COMPOSITIONS HAVE BEEN FIGURES ARRANGED ON A RECTANGLE WITH SPACES DIVIDED BY THE BACKGROUND. VERY LITTLE FOREGROUND.

FILM COMPOSITION

3/4 ANGLES, OBJECTS AND FIGURES OVERLAP, SHOT THROUGH AND AMONG SCENES. ANGLE ON ANGLE.

BLICK COMPOSITION

EXAMPLES: PETER ARNO, AUSTRIAN ARTISTS.

"IN BETWEEN" FILM COMPOSITION. FRAGMENTS IDENTIFY THE WHOLE. THE CHARACTERS ARE DISTANCED. NOT FOCUSED ON THE FACES.

CIRCULAR COMPOSITION

SPHERE ON CIRCLE

CORNERS SACRIFICED

SECONDARY FIGURES BACKS TURNED. FACES HIDDEN.

GROUPS FOCUS

GROUPS - AN ACTIVE AND A PASSIVE ELEMENT

DIFFICULTY OF PLACING 2 FIGURES OF EQUAL IMPORTANCE IN FRAME.

TWO AGAINST ONE EASIER.

THREE TYPES OF GROUPS

① INTEREST FOCUSED ON IDEA INSIDE PICTURE.

② INTEREST FOCUSED ON OBJECT OUTSIDE PICTURE.

LIGHT TAKES PRECEDENCE OVER PLACE.

③ REPOSE, REVERIE, SUBJECTIVE FOCUS.

VIGNETTES

①

STANDARD

WHITE VIGNETTE IS STILL THE MOST UNIVERSAL WAY TO DEAL WITH TONE.
LIGHT-IN-FORM SHOULD BE MAINLY MID VALUE WITH EITHER DARK SPOTS OR LIGHT SPOTS

② SECOND WAY TO DEAL WITH VIGNETTE IS TO THINK OF VALUE 7, 8, 9, AND 10 SECTIONS WITHIN A MID RANGE WHITE VIGNETTE.

A DOUBLE VALUE SCHEME
LIGHT
X + LIGHT
DARK + LIGHT
X + DARK

O + LIGHT DARK + X

X PLUS DARK + LIGHT

X + LIGHT + DARK

DARK

TRY FOR IT

③ VALUE 9 OR 10-

BLACK OR COLOR-BLACK VIGNETTE

NICE SURPRISE

④ YELLOW OR VALUE 1 VIGNETTE
VIOLET OR VALUE 7 OR 8 VIGNETTE

SOMETHING SPECIAL

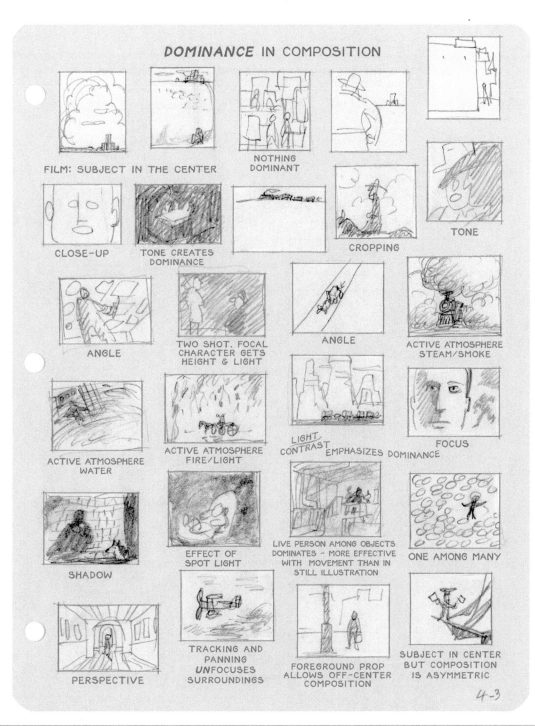

DOMINANCE IN COMPOSITION

FILM: SUBJECT IN THE CENTER

NOTHING DOMINANT

CLOSE-UP

TONE CREATES DOMINANCE

CROPPING

TONE

ANGLE

TWO SHOT. FOCAL CHARACTER GETS HEIGHT & LIGHT

ANGLE

ACTIVE ATMOSPHERE STEAM/SMOKE

ACTIVE ATMOSPHERE WATER

ACTIVE ATMOSPHERE FIRE/LIGHT

LIGHT CONTRAST EMPHASIZES DOMINANCE

FOCUS

SHADOW

EFFECT OF SPOT LIGHT

LIVE PERSON AMONG OBJECTS DOMINATES - MORE EFFECTIVE WITH MOVEMENT THAN IN STILL ILLUSTRATION

ONE AMONG MANY

PERSPECTIVE

TRACKING AND PANNING *UNFOCUSES* SURROUNDINGS

FOREGROUND PROP ALLOWS OFF-CENTER COMPOSITION

SUBJECT IN CENTER BUT COMPOSITION IS ASYMMETRIC

4-3

DOMINANCE IN COMPOSITION

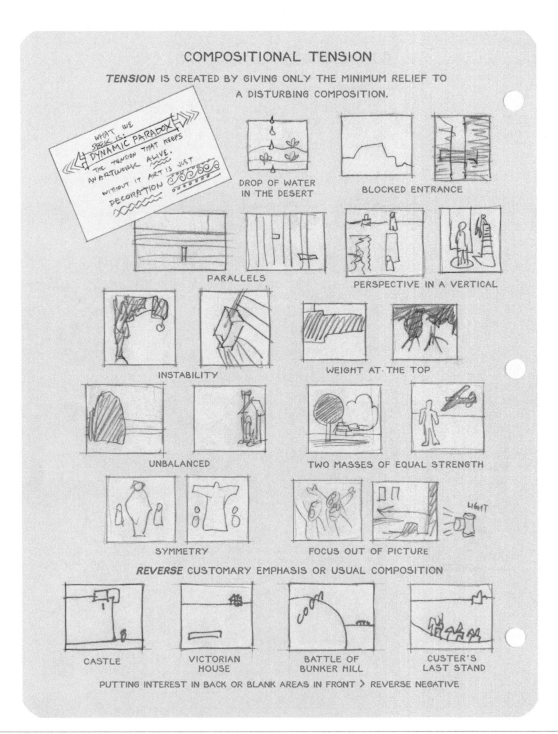

COMPOSITIONAL TENSION

TENSION IS CREATED BY GIVING ONLY THE MINIMUM RELIEF TO
A DISTURBING COMPOSITION.

WHAT WE SEEK IS: DYNAMIC PARADOX THE TENSION THAT KEEPS AN ARTWORK ALIVE. WITHOUT IT ART IS JUST DECORATION

DROP OF WATER IN THE DESERT

BLOCKED ENTRANCE

PARALLELS

PERSPECTIVE IN A VERTICAL

INSTABILITY

WEIGHT AT THE TOP

UNBALANCED

TWO MASSES OF EQUAL STRENGTH

SYMMETRY

LIGHT

FOCUS OUT OF PICTURE

REVERSE CUSTOMARY EMPHASIS OR USUAL COMPOSITION

CASTLE

VICTORIAN HOUSE

BATTLE OF BUNKER HILL

CUSTER'S LAST STAND

PUTTING INTEREST IN BACK OR BLANK AREAS IN FRONT > REVERSE NEGATIVE

DISTURBING COMPOSITION FOR PSYCHOLOGICAL EFFECT
(IN FILMS)

PARALLEL LINES WITHOUT VERTICAL OPPOSITION OR RELIEF

ENTRANCE STOPPED BY OPPOSING PLANE—(LOCKED-IN, CLAUSTROPHOBIC)

PERSPECTIVE OCCURRING IN A VERTICAL (DIFFICULTY OF ACCESS)

2 MASSES THE SAME SIZE IN DIFFERENT PLANES. (TENSION OF EQUAL STRENGTHS)

SINCE FILM COMPOSITION IS RESOLVED OVER A PERIOD OF TIME OR A NUMBER OF IMAGES IT IS POSSIBLE TO USE NEGATIVE OR "BAD" COMPOSITION TO CREATE TENSION IN THE PROPER PLACES.

FORMAL SYMMETRY FOR *POWER*--ORTHODOXY, CONTROL, LACK OF FREEDOM, AUTHORITARIAN SITUATIONS

SUBJECT OUTSIDE CIRCLE

DECORATIVE WHERE STRUCTURE IS PAINFULLY OBVIOUS

VIOLENT ACTION. BIG ACTION TOO CLOSE TO FIT IN THE FRAME

PROTRUSION MORE DISTURBING THAN INSERTION

DISTURBING COMPOSITIONS SLIGHTLY MITIGATED

FOUND IN: EDWARD HOPPER, HARVEY SCHMIDT, WAYNE THIEBAUD

VERTICAL PERSPECTIVE

CONTRARY DIRECTION

FLOATING WEIGHT

BARRIER

OPEN SPACES BENEATH YOUR FEET, GREAT DROP OR WATER BELOW (CRIB)

IMAGES OF FEAR AND HOPE

CONFINEMENT IN A LARGE EMPTY SPACE. (VULNERABLE FROM BEHIND)

SACRED PLACE VIOLATED OR CLEAN PLACE OR PLACE OF PLEASURE OR REFUGE

SEPARATION

SEPARATION (2)

LOVED ONE AS OBJECT IN STRANGE CIRCUMSTANCE (DEATH)

FOOD AREA VIOLATED

BEING PROJECTED THROUGH SOMEPLACE (BIRTH TRAUMA)

FOOD AREA VIOLATED (2)

DISMEMBERMENT

DISFIGUREMENT OF NOSE OR FACE

COMPOSITION FOR PSYCHOLOGICAL EFFECT

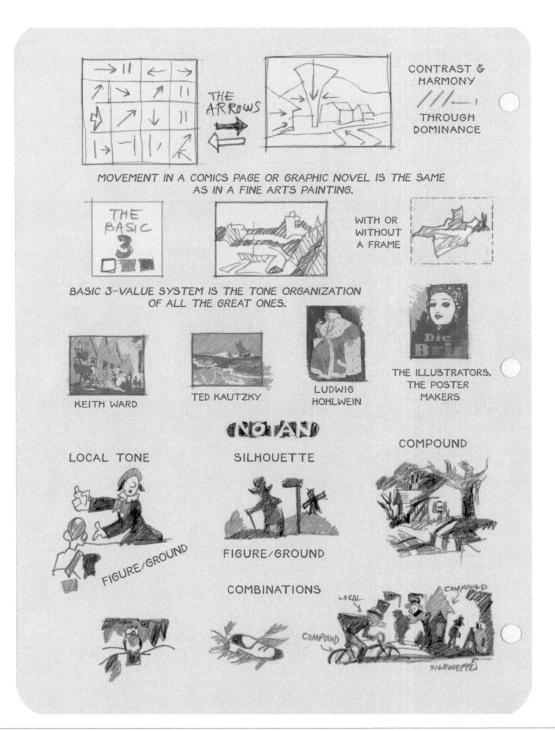

MOVEMENT IN A COMICS PAGE OR GRAPHIC NOVEL IS THE SAME
AS IN A FINE ARTS PAINTING.

THE ARROWS

CONTRAST &
HARMONY

THROUGH
DOMINANCE

THE BASIC 3

WITH OR
WITHOUT
A FRAME

BASIC 3-VALUE SYSTEM IS THE TONE ORGANIZATION
OF ALL THE GREAT ONES.

KEITH WARD

TED KAUTZKY

LUDWIG
HOHLWEIN

THE ILLUSTRATORS,
THE POSTER
MAKERS

NOTAN

LOCAL TONE

SILHOUETTE

COMPOUND

FIGURE/GROUND

FIGURE/GROUND

COMBINATIONS

LOCAL

COMPOUND

COMPOUND

SILHOUETTE

MOVEMENT, ORGANIZATION AND NOTAN

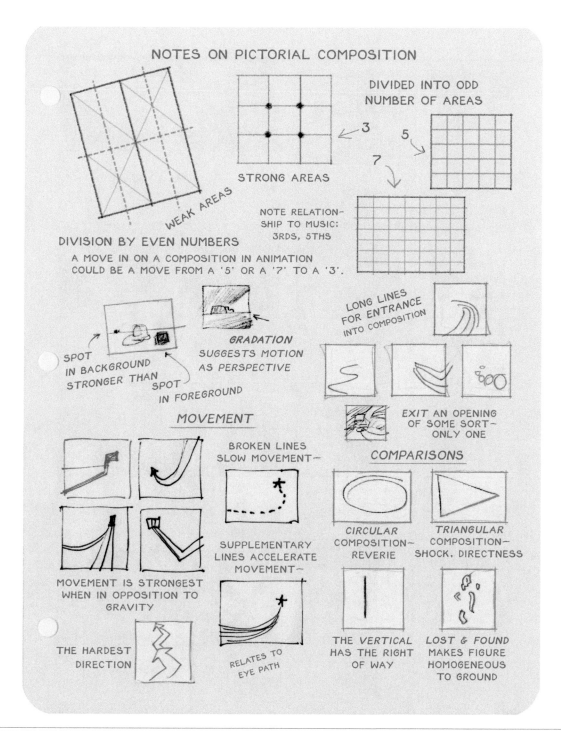

PICTORIAL COMPOSITION NOTES

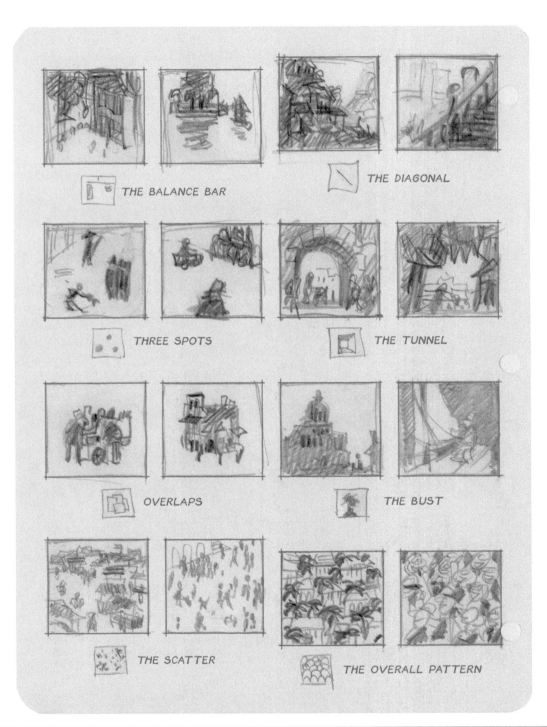

EXAMPLES OF COMPOSITIONAL METHODS...

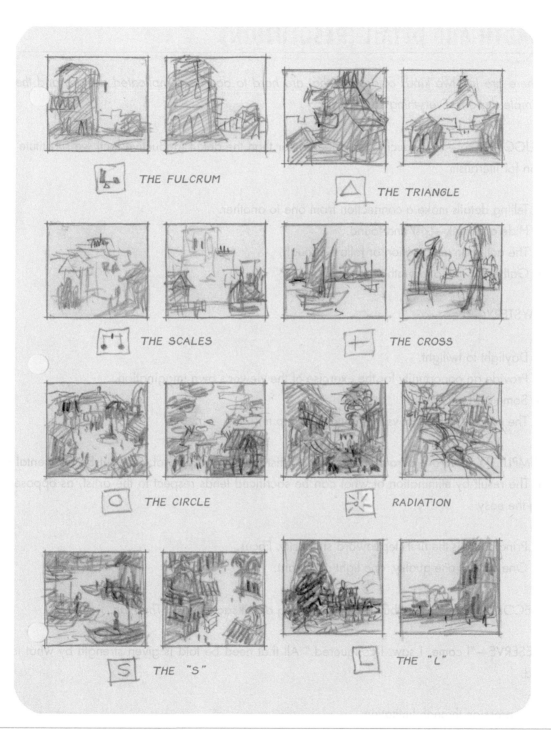

THE FULCRUM

THE TRIANGLE

THE SCALES

THE CROSS

THE CIRCLE

RADIATION

THE "S"

THE "L"

...BASED ON THE TEACHINGS OF EDGAR PAYNE

BREADTH AND DETAIL (RESOLUTION)

There are just two kinds of designs that are hard to do: the complicated designs and the simple designs. Everything else is easy.

SUGGESTION—In producing the *effect* rather than the detail (deductive fact) we substitute suggestion for literalism:

- Telling details make a connection from one to another.
- Hide and seek—Lost and found.
- The action in anticipation or follow-through.
- Gathering and aftermath.

MYSTERY—

- Daylight to twilight.
- Provide an opportunity for the exercise of the viewer's own imagination.
- Some part unseen.
- The cottage at twilight vs. the cottage at 3 p.m.

SIMPLICITY—We are attracted not by the artist's technique or problems but by his mental attitude. The result by elimination of what can be sacrificed lends respect to the artist, as opposed to doing the easy.

- Principality is the first step toward simplicity. Focus.
- One object, one quality, one light dominant.

DECORATION—Elegant but obvious arresting detail sacrificed to *The Plan.*

RESERVE—"I came. I saw. I conquered." All that need be told is given strength by what is left unsaid.

- Expression through limitation.
- The avoidance of "overacting."
- The rifle vs. the blunderbuss.

RELIEF—Particular items should not stand out so much as to jump off the canvas:

- Shadows flattened—rendering marked roundness of figures not so pronounced.
- Painting should express the envelopment of air.
- Outstanding figures in "limbo" are entities, not compositions.

FINISH—Not putting everything in, a matter of selection.

- Finish is the true relationship of values of shade and color. When these are properly adjusted the picture is finished.

THE "OAK" FORMULA FOR DYNAMIC PICTURE-MAKING

Close cropping means more, not less, white space.

"OAK" is an acronym for <u>O</u>verlap, <u>A</u>ngle, and "<u>K</u>"rop. (Crop, as in cutting off part of a picture.) It is a way to create action and space in your layout. Overlapping emphasizes and defines scale. Angle gives variety of viewpoint. Cropping draws the viewer closer into the scene and can create mystery by obscuring parts of it.

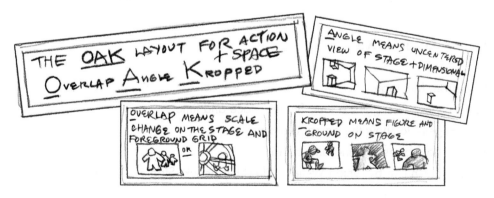

BLICK

"Blick" is defined as a look or glance. In film, illustration, comics and graphic novels it can be a frame that enhances action, speed and atmosphere—a fast glimpse into the story.

A blick is:

- Incomplete in itself.
- A part of a series or a single fragment.
- A clue to the content and meaning of the series.
- A scrap of information that contributes to milieu.
- It is secondary to the story line not primary.

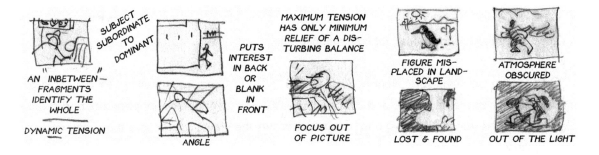

Examples of Blicks

Most common use: Montage

Railroads, towns—to suggest a tour. Shows space and time.

Calendar Pages—to show the passage of time.

Battle shots—to suggest fighting and travail.

Used effectively in film by Orson Welles, Alfred Hitchcock, Stanley Donen.

It must show up in thrillers a lot—

The eyes in the portrait; the silhouetted figure watching.

It is meaningless out of context.

People remember blicks more than anything in the pictures because they have to solve the clue. They have to put two and two together. They are *engaged* in a dialogue with the story!

A blick expands the storyline by expressing the milieu of the piece.

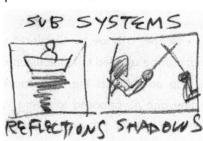

- It may express a system within a system of character:
 - A mood or psychological state.
 - Paranoia, shock, fear, joy, hunger.
 - Sleepiness, acrophobia, agoraphobia, claustrophobia.
- Or a system within a system of milieu—
 - Corruption, tyranny, laissez-faire, holiday spirit, celebration or workaday life.

- Or a system within a system outside the system of character—
 - Time, weather, rain and atmosphere; or the business of the non-involved… bystanders, observers, the self-involved, animals and birds.

The Style of a Blick

It is that of a glance, a snapshot, a telltale clue or detail. It may be a cropped view partially obscured.

It may be shot through a grid or some other foreground.

It resembles an in-between in animation—anticipation or a follow-through. It is not a key or contact drawing. It is a gathering or aftermath. It partakes of shadows, reflections and silhouettes.

The Composition of a Blick

It has instability. It is unbalanced and uncentered. It has maximum tension and only minimum relief of a disturbing imbalance. It contrasts to storyline pictures.

 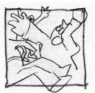

Blick as Related to Townscape

Townscape, a book by Gordon Cullen, presents many ideas regarding existing towns and cities that can be applied to fictitious ones you create for your film or story.

He emphasizes the importance of relationship—how a huge building seems to tower over a tiny one as opposed to being viewed among those of similar size. "Serial Vision" evokes the feeling of moving through a variety of spaces, as from path to street to courtyard. Each turning reveals a new vista as one proceeds from existing view to emerging view. "Place" is the emotional nature of your environment—being elevated or low, constricted or limitless, enclosed or outdoors. "Content" includes style and meaning—the ambiance and unique character of the location.

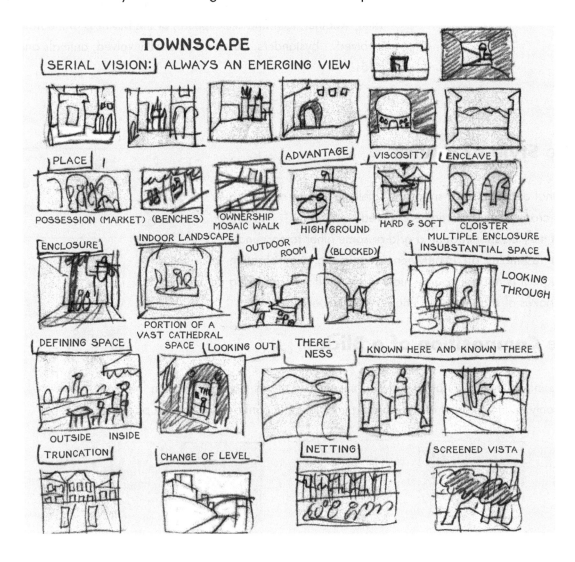

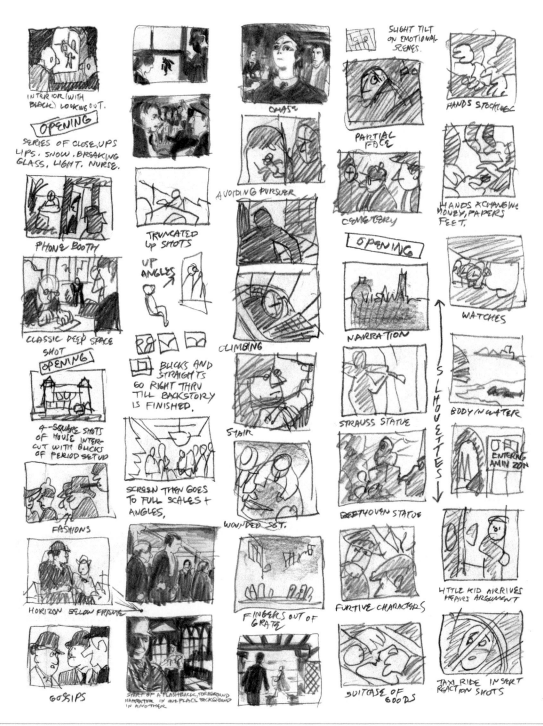

SKETCHES OF BLICK COMPOSITION FROM FILMS

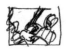

THE BLICK:

DEPICTS PART OF A SCENE. THE TELL-TALE.

WHAT ARE THE BLICK'S CHARACTERISTICS?

O.A.K.

OVERLAP ANGLE KROP

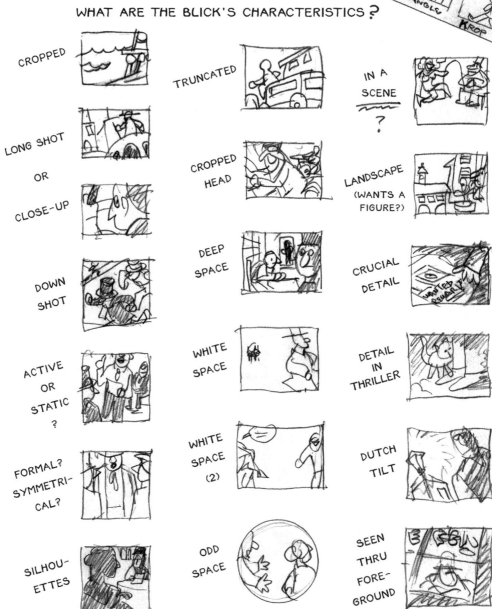

CROPPED

LONG SHOT OR CLOSE-UP

DOWN SHOT

ACTIVE OR STATIC ?

FORMAL? SYMMETRI-CAL?

SILHOU-ETTES

TRUNCATED

CROPPED HEAD

DEEP SPACE

WHITE SPACE

WHITE SPACE (2)

ODD SPACE

IN A SCENE ?

LANDSCAPE (WANTS A FIGURE?)

CRUCIAL DETAIL

DETAIL IN THRILLER

DUTCH TILT

SEEN THRU FORE-GROUND

SUMMARY OF BLICK DESIGN

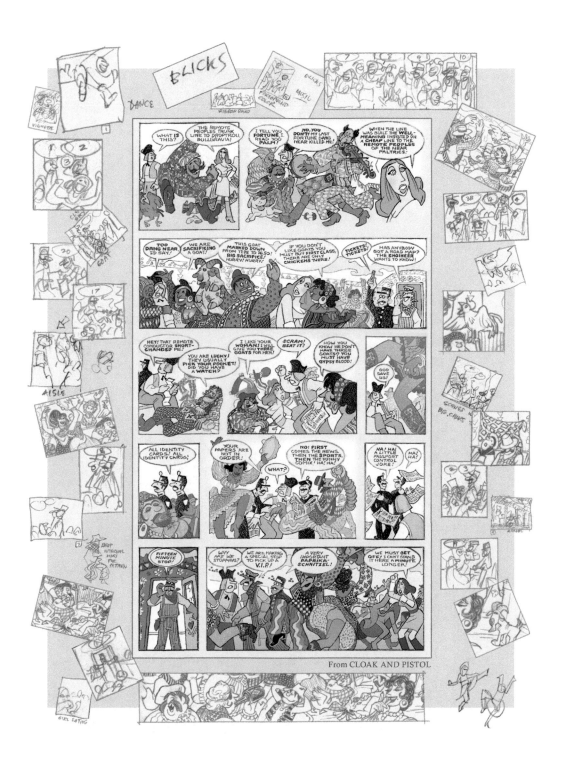

From CLOAK AND PISTOL

5

SHAPE, LINE AND TONE

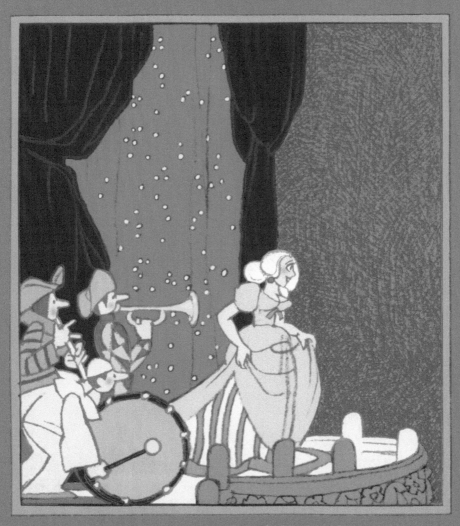

From CAPTAIN PISTOL'S PARADISE

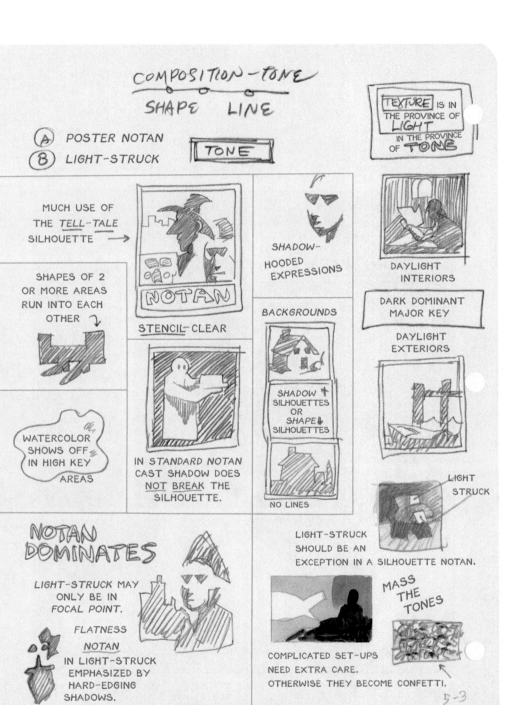

COMPOSITION - TONE

SHAPE — LINE

(A) POSTER NOTAN
(B) LIGHT-STRUCK

TONE

TEXTURE IS IN THE PROVINCE OF LIGHT IN THE PROVINCE OF TONE

MUCH USE OF THE *TELL-TALE* SILHOUETTE →

SHADOW-HOODED EXPRESSIONS

DAYLIGHT INTERIORS

SHAPES OF 2 OR MORE AREAS RUN INTO EACH OTHER ↘

NOTAN

STENCIL-CLEAR

BACKGROUNDS

DARK DOMINANT MAJOR KEY

DAYLIGHT EXTERIORS

WATERCOLOR SHOWS OFF IN HIGH KEY AREAS

IN STANDARD NOTAN CAST SHADOW DOES <u>NOT</u> <u>BREAK</u> THE SILHOUETTE.

SHADOW↑ SILHOUETTES OR SHAPE↓ SILHOUETTES

NO LINES

LIGHT STRUCK

NOTAN DOMINATES

LIGHT-STRUCK MAY ONLY BE IN FOCAL POINT.

FLATNESS <u>NOTAN</u> IN LIGHT-STRUCK EMPHASIZED BY HARD-EDGING SHADOWS.

LIGHT-STRUCK SHOULD BE AN EXCEPTION IN A SILHOUETTE NOTAN.

MASS THE TONES

COMPLICATED SET-UPS NEED EXTRA CARE. OTHERWISE THEY BECOME CONFETTI.

5-3

COMPOSITION — TONE

POSTER NOTAN

A PLANNED COMPOSITION WHERE VARIOUS OBJECTS ARE GROUPED TOGETHER IN TWO OR THREE TONAL PLANES.

THE GROUPING CREATES BOTH UNITY AND SEPARATION.

BLACK AND WHITE

BLACK AND WHITE SHOULD BE USED WITH DISCRETION.

AS STRONG FOCUS ELEMENTS —

JUST LIKE PURE CONTRASTING COLOR.

TONAL HARMONY

TONES ARRANGED TO HARMONIZE. CAN BE PATTERN

POSTERS HAVE IT

DARKS AND LIGHTS SCATTERED INTO SUPPORTING AREAS ARE AS DISHARMONIOUS AS RANDOM SPOTS OF RED OR OTHER STRONG COLOR.

DISCORD

* A SELECTION OF TONE SCHEMES

BLACK/MIDDLE LIGHT/WHITE

MIDDLE/LIGHT

DARK MIDDLE/LIGHT/WHITE

DARK MIDDLE LIGHT

DIFFERENT LIGHTS:
DAY
DUSK
NIGHT
FOG
LAMPLIGHT

A FEW MASSED TONES WORK BETTER THAN MANY BROKEN TONES.

(TWO!) MASSED LIGHTS MASSED DARKS

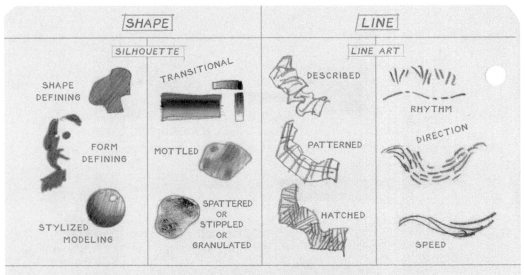

SHAPE	LINE
SILHOUETTE	LINE ART

SHAPE DEFINING

TRANSITIONAL

DESCRIBED

RHYTHM

FORM DEFINING

MOTTLED

PATTERNED

DIRECTION

STYLIZED MODELING

SPATTERED OR STIPPLED OR GRANULATED

HATCHED

SPEED

RESOLUTION IN SHAPE AND LINE

A SMALL OBJECT WITH HIGHLIGHT, LOCAL TONE AND SHADOW LOOKS FUSSY AND DETAILED WHERE A LARGE OBJECT DOESN'T.

CLOSENESS OF LINES ALTERS VALUE.

SOFT EDGES DEMAND ENOUGH VOLUME TO UNDERSTAND THE SHAPE.

TASTE DECIDES THE DEGREE OF RESOLUTION. GENERALLY THE *LARGEST* EFFECTIVE RESOLUTION IS PREFERRED.

TOO-SMALL RESOLUTION BECOMES ILLUSIONIST AND CLASHES WITH CARTOON-EXPRESSIONISM.

"SIGNATURE" LINE IS PREFERRED OVER —

CONVENTION (DECORATIVE) OR *DESCRIPTION* (REALISTIC).

(EXPRESSIONIST)

FOREGROUND — SOFT EDGE SHAPE, MINIMUM DEFINITION

BACKGROUND — 2 VALUE, LOW CONTRAST, LOW CHROMA, FLAT PATTERN INDICATION, NO DETAIL. SOFT EDGE DUE TO LOW CONTRAST.

MIDGROUND — FULL COLOR, FOCUS & DETAIL

RESOLUTION IN CLASSIC STYLE

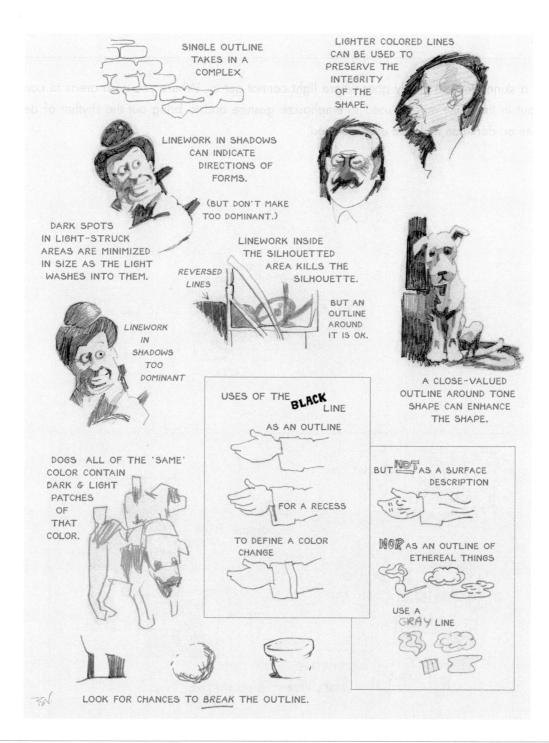

SINGLE OUTLINE TAKES IN A COMPLEX.

LIGHTER COLORED LINES CAN BE USED TO PRESERVE THE INTEGRITY OF THE SHAPE.

LINEWORK IN SHADOWS CAN INDICATE DIRECTIONS OF FORMS.

(BUT DON'T MAKE TOO DOMINANT.)

DARK SPOTS IN LIGHT-STRUCK AREAS ARE MINIMIZED IN SIZE AS THE LIGHT WASHES INTO THEM.

LINEWORK INSIDE THE SILHOUETTED AREA KILLS THE SILHOUETTE.

REVERSED LINES

BUT AN OUTLINE AROUND IT IS OK.

LINEWORK IN SHADOWS TOO DOMINANT

A CLOSE-VALUED OUTLINE AROUND TONE SHAPE CAN ENHANCE THE SHAPE.

USES OF THE **BLACK** LINE

AS AN OUTLINE

DOGS ALL OF THE 'SAME' COLOR CONTAIN DARK & LIGHT PATCHES OF THAT COLOR.

FOR A RECESS

BUT <u>NOT</u> AS A SURFACE DESCRIPTION

TO DEFINE A COLOR CHANGE

NOR AS AN OUTLINE OF ETHEREAL THINGS

USE A GRAY LINE

LOOK FOR CHANCES TO *BREAK* THE OUTLINE.

OBSERVATIONS ON LINE

LINE

Line is a skinny tone. It mostly goes where light cannot get in. Where you wish areas to connect, don't put in line. Line can be used to emphasize gesture and to bring out the rhythm of design. Light line on dark can make an effective area.

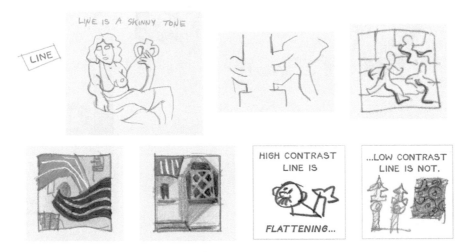

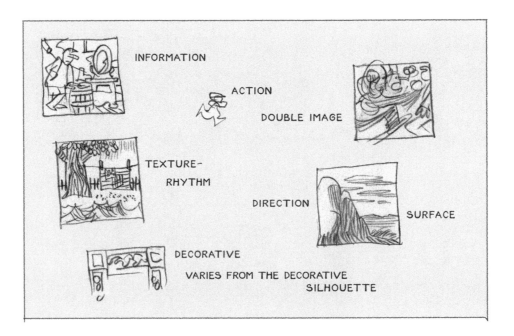

WHERE LINE CAN HELP

SILHOUETTE

Pure silhouette is any self-lined, unbroken tone of any value with a descriptive contour. It is a descriptive shape. Modified silhouette is a self-lined tone with gradation or mottling. Stylized silhouette is a tone outlined in a line of closely related value. It is similar to the dark edge of a puddled-on watercolor tone. It can also be soft edged or resembling a "brown-edged cookie." Silhouette implies—it makes something understood without expressing it directly. The effect is strengthened by inclusion of two or more tones in one tonal value (a conglomerate). Silhouette suggests an unequal distribution of light: indoors/outdoors, near/far (aerial perspective light), light/shadow or a cast shadow.

 The sense of silhouette is *destroyed* by:

- Contrasting outline
- Articulated outline
- Inclusion of pattern
- Not *losing* part of a form
- Inclusion of strong modeling
- Inclusion of a strong texture or interior drawing
- Shapes of unrelated local tone (indirect lighting)

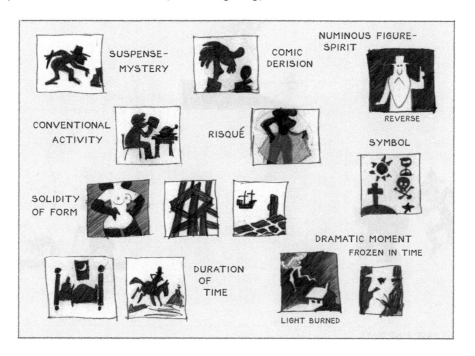

WHERE SILHOUETTE CAN HELP

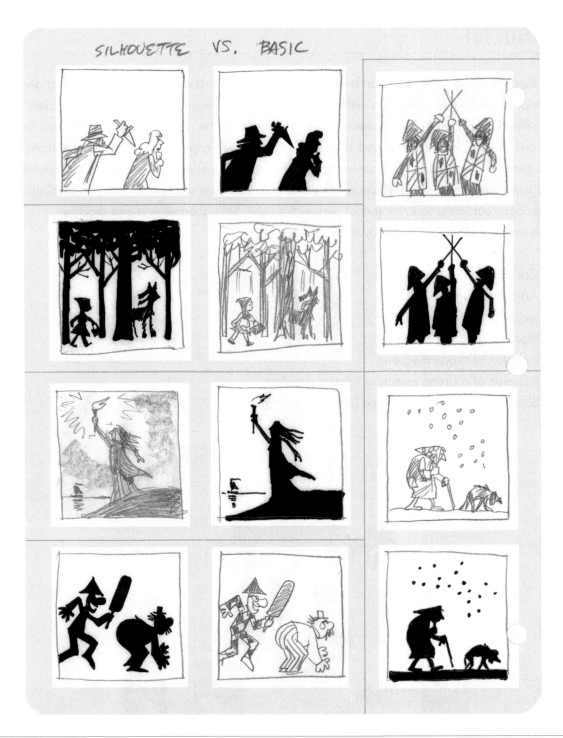

SILHOUETTE VERSUS BASIC RENDERING

TYPES OF TONAL TREATMENTS

LINE WITH BLACKS
AND SPOT SHADOWS

SHADOWED
FIGURE WITH
LOCAL TONES

SHADOWED FIGURE
WITH LOCAL TONES
AND RIM LIGHT

STRONG LIGHT
WITH CAST SHADOWS-
SHADOW IS ONE STEP
DARKER

LIGHT LOCALTONE
WHEN FIGURE IS TOO
SMALL FOR SPOT
SHADOWS

COMBINATION - SPECIAL
POSTER EFFECT-
PLANNED IN ADVANCE

"CHEATS"

FACE CHEAT
FOR CENTER
OF INTEREST

FACE CHEAT
FOR REFLECTED
LIGHT

DETAIL CHEAT
FOR LEGIBILITY

TYPES OF TONAL TREATMENT

HOW TONE DOMINATES COLOR

The following six panels, which depict characters from *Pistol's Pirates* at the Blue Lobster Inn, demonstrate the control of color areas through the organization of tones. Related tones can be massed together to create a strong pattern, emphasize a specific area or separate pictorial space into planes of foreground and background. Please see 4 and 5 Value Chart in Chapter 9.

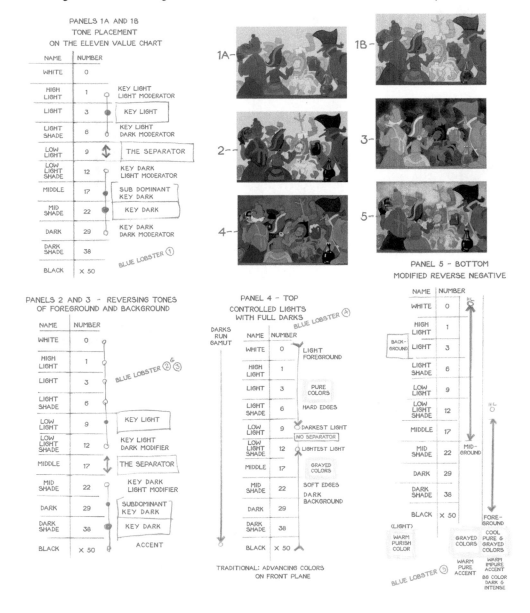

KEYS TO THE BLUE LOBSTER TONE/COLOR STUDIES

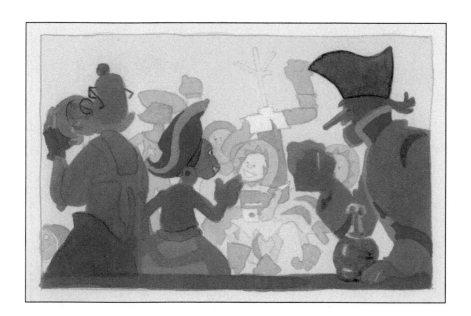

PANEL 1-A
Key light at "Light" tone, key dark at "Mid Shade"—Without lines

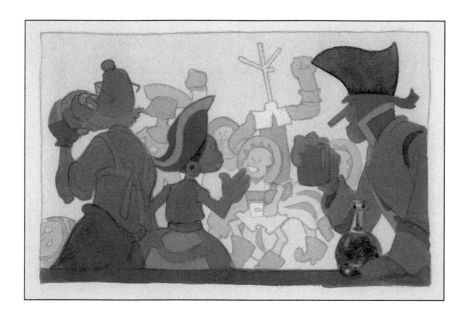

PANEL 1-B
Key light at "Light" tone, key dark at "Mid Shade"—With lines

TONE STUDIES 1

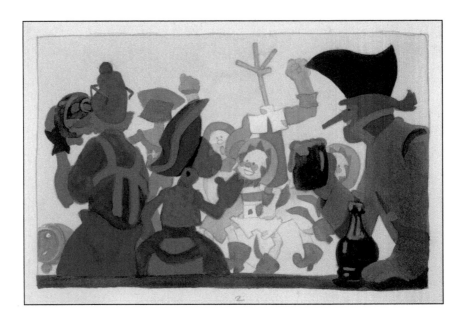

PANEL 2
Key light at "Low Light" tone, key dark at "Dark Shade" tone

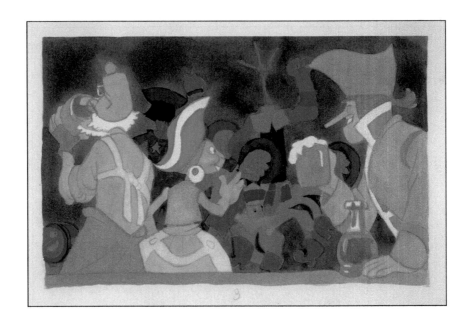

PANEL 3
Key light at "Low Light" tone, key dark at "Dark Shade," reversed foreground/background

TONE STUDIES 2

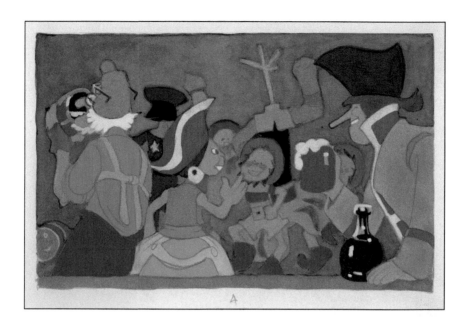

PANEL 4
Controlled lights with full darks—Pure colors and hard edges in "Light" tone, grayed colors and soft edges in "Middle" tone and background

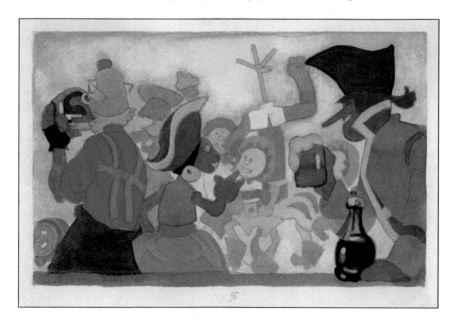

PANEL 5
Modified Reverse Negative—Background mainly "Light" tone with warm purish colors, mid-ground in grayed colors, foreground in "Middle" through black

TONE STUDIES 3

TRANSITION SHADING OF LIGHT SIDE

RIMLIGHT SHADOW-WHITES
ARE SAME VALUE AS SKY

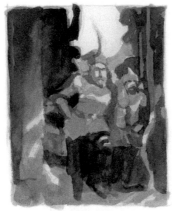

TRUE DAPPLED LIGHT
HEAD IN CLEAR

LIGHT
STRUCK

IN LIGHT IN SHADOW

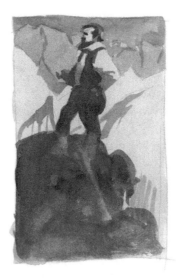

FIGURE CUT IN TWO

←
SILHOUETTE BODY
LIGHT-STRUCK
BUST & HEAD

SKETCHES AFTER
ILLUSTRATIONS
BY N. C. WYETH

↑ TRANSITIONAL SHADING
IN LIGHT SIDE

LIGHT STRUCK

LIGHT SHAPES DEFINE THE SUBJECT

HARD LINE IN LIGHT
SOFT EDGE IN
SHADOW

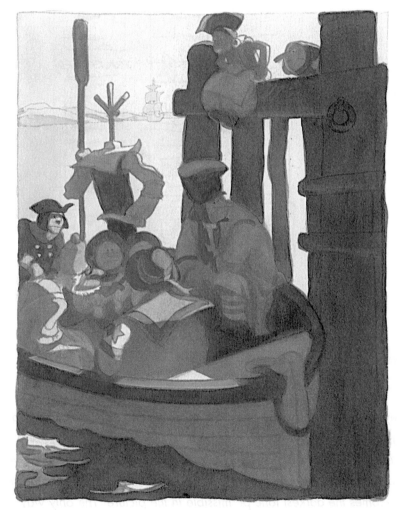

EXAMPLE USING
ORGANIZATION OF
TONES TO SUGGEST
LIGHT-STRUCK
SCENE →

RELATIONSHIP OF SHAPE AND TONE TO LIGHT

LIGHT QUALITY CREATED BY VALUE STEPS

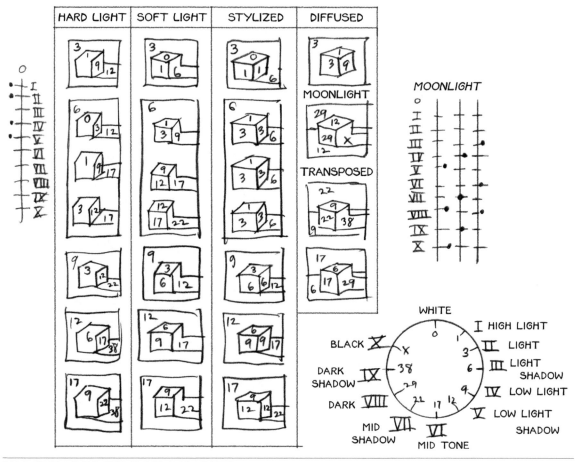

TONE KEY TO LIGHT QUALITY CREATED BY VALUE STEPS

The key to more is less. You see more by restricting your vision. By squinting, with dark glasses, through an aperture in a haze.

The effect of a haze is created by treating the shadows as if they were black and opaque, but instead of painting them black they're painted a tone which is lighter on the value scale. The tone then becomes the darkest tone permissible in the picture. The only way a tone can be darker is if it is out of the haze more—as in a fog. The nearest objects have the greatest contrast.

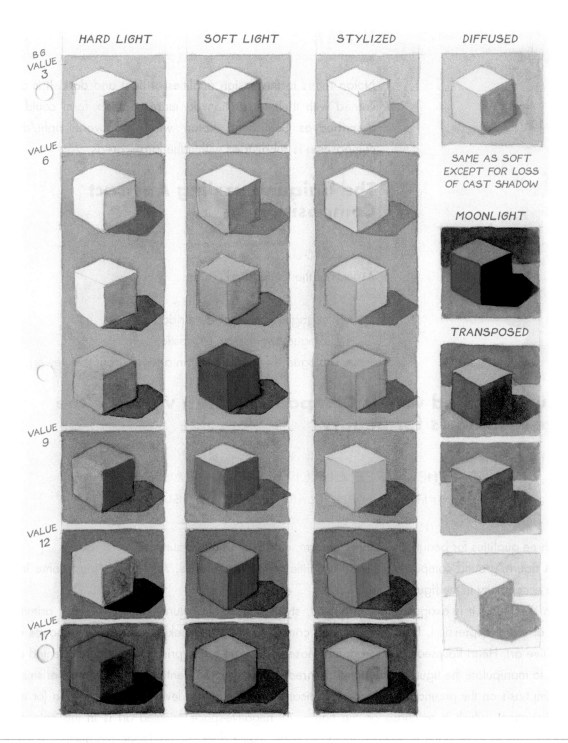

LIGHT QUALITY CREATED BY VALUE STEPS

MATHEWS. THE WAVE

NOTAN

Notan refers to the design qualities of light and dark. It is concerned with their interaction. Its more complex form could be described as Compound Notan, where an overall light/dark composition is subdivided within the larger areas.

The Unique Puzzling Abstract Composition

= COMPOUND NOTAN =

Aspects of the Compound Notan:

- It engages you as a visual riddle.
- Dialogue begins with a question.
- Dialogue is realized with an answer (from the viewer).

Figure/Ground versus Compound Notan vis-à-vis the Three Qualities for Beauty

THE THREE QUALITIES FOR BEAUTY
•CLARITY OF FORM •CLARITY OF TONE •SURPRISE

The three qualities for beauty are: clarity of form, clarity of tone and surprise.

A figure/ground composition gives very little scope for surprise. All surprise must come from some eccentricity in the figure or the ground.

In the figure it is exaggeration, treatment, stylization or caricature. This is the most primitive form of visual expression. It includes cartoon comics, cave art, Greek vases, pre-Renaissance art, primitive art, Henri Rousseau and Grandma Moses. The urge for surprise drives figure-oriented creators to manipulate the figure to the point of unrecognizability. Conventions become mannerisms.

Emphasis on the ground is level-two sophistication as opposed to level-one sophistication (or non-sophistication), which is emphasis on the figure. All negative-space oriented art is in this category: graphic arts that are done in reverse, inlays such as "pietre dure" works (stone marquetry), scratchboard, friskit, resist-ink, and anything considered "reverse negative." This is the area of strong "media-expressive" works such as Impressionism, pictures where "you must step back" to see the subject matter.

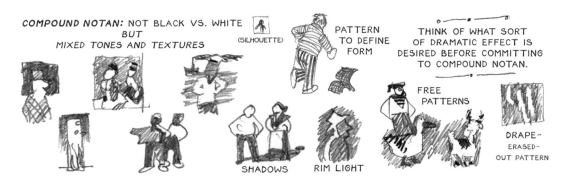

The puzzling abstraction of the compound notan automatically takes care of the "surprise" quality of beauty by its very nature.

Chiaroscuro, the arrangement of light and shade, launched puzzling abstraction. So many of the painters that have fascinated have been users of it—Rembrandt, Brueghel, the Baroque and Rococo artists, Gustav Klimt and Egon Schiele.

The Vienna Workshop (Wiener Werkstätte) and Art Deco have strong graphic treatments of it. Of the illustrators, N.C. Wyeth is the clearest user of it. Other examples are Edwin Austin Abbey, Howard Pyle, Frank Brangwyn, Dean Cornwell and many others.

The value of it is: distortion need *not* be used for the purpose of surprise—thus allowing beauty to be included in art. Art has no need to be ugly. It need not be brutal or crude to achieve an effect. It can be charming, elegant and sophisticated with no loss of power.

The appeal of the compound notan (besides the fact that it takes care of the artist–viewer dialogue) may be the pre-conscious "hunter's eye." The hunter gets a mental synapse electrical charge when he picks out the bunny in the grass or the stag in the brush. The puzzling abstraction *snaps* into figure/ground. This is *discovery*! Figure/ground understanding is mere recognition.

A GRILL OVER FIGURE GROUND ENHANCES THE LOST AND FOUND COMPOUND NOTAN.

The added dimension of movement makes compound notan/puzzling abstraction "de rigueur" for animation.

LOCAL TONE NOTAN

PURE COLORING BOOK –
BLACK LINES.

COLORING BOOK WITH SHADOW
AREAS.

SELF-LINED COLORING BOOK
·MASSED LIGHTS + MASSED DARKS
ARE VERY EFFECTIVE IN LOCAL
TONE.

PATCHWORK LIGHTING NOTAN

1 TONE STEP WITHIN EACH AREA.
2 TONE STEPS FROM 1 AREA TO
THE NEXT.

COMBINATION PATCHWORK &
INDIRECT LIGHT. 2 TONE STEPS
WITHIN EACH AREA

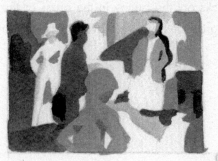

COMBINATION PATCHWORK AND
DIRECT LIGHT.

5-7

STYLES OF NOTAN 1

● HARLEQUIN NOTAN

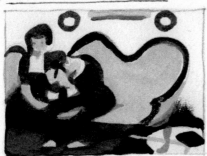

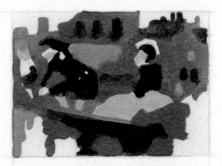

DARKS MASSED TOGETHER —
SPOTTED WITH TELL-TALE WHITES
5 TONE STEPS APART.

DARKS AVERAGE 5 TONE STEPS
FROM LIGHTS. — A MINIMUM OF
3 TONE STEPS.

● INDIRECT LIGHT NOTAN — ↓

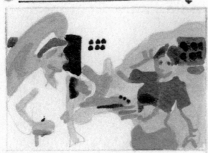

FRONT-LIT. LOCAL TONES UNMODIFIED
EXCEPT FOR MINIMAL SHADOWS.
PURE LOCAL TONE NOTAN HAS NO
MINIMAL SHADOWS.

TRADITIONAL ILLUSTRATION
MINIMAL SHADOWS. SHADOWS ON
LIGHTS AVERAGE 3 TONE STEPS.

GLARE. MINIMAL SHADOWS FORCED
TOWARD PURE LOCAL TONE.

POSTERIZED. TONES FORCED TOWARD
TWO MAIN TONES.

5-8

STYLES OF NOTAN 2

● DIRECT LIGHT CHIAROSCURO

RARE AND DIFFICULT. 3 OR MORE TONE STEPS FROM LIGHT TO SHADE. NEITHER TOTALLY DOMINATES.

STRONG REFLECTED LIGHT

6 TONE STEPS FROM DARK TO LIGHT ON DARK AREAS. 1 STEP ON LIGHT AREAS. WITH SOME SHADOW LINING →

AERIAL PERSPECTIVE. PLANE 1: 3 TONE STEPS FROM LIGHT TO SHADE. PLANE 2: 2 STEPS. PLANE 3: 1 STEP.

● LIGHTSTRUCK CHIAROSCURO

5 STEPS OR MORE BETWEEN LIGHTSTRUCK AND DARK. THE DIFFERENCE BETWEEN LIGHTSTRUCK AND HARLEQUIN.

LIGHT AREA

COMBINATION LIGHTSTRUCK AND LOCAL TONE NOTAN.

● STYLIZED

LIMITED KEY. LINE AROUND MAIN FORMS. COMBINATION LOCAL TONE, PATCHWORK, INDIRECT LIGHT. 1 STEP.

5-9

NOTAN AND LIGHTING

THE CONVENTIONS OF DEEP SPACE MUST BE ACKNOWLEDGED...

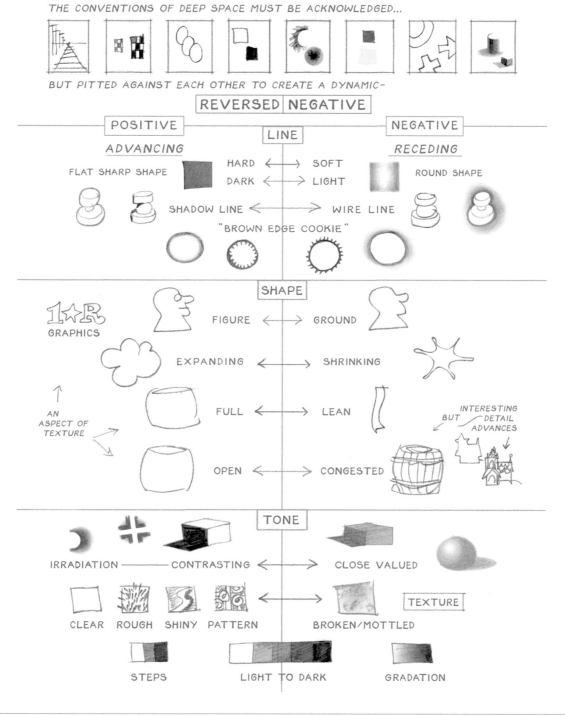

BUT PITTED AGAINST EACH OTHER TO CREATE A DYNAMIC—

REVERSED NEGATIVE

POSITIVE	LINE	NEGATIVE
ADVANCING		RECEDING

FLAT SHARP SHAPE HARD ⟷ SOFT ROUND SHAPE
 DARK ⟷ LIGHT

SHADOW LINE ⟷ WIRE LINE

"BROWN EDGE COOKIE"

SHAPE

1☆R GRAPHICS FIGURE ⟷ GROUND

EXPANDING ⟷ SHRINKING

↑ AN ASPECT OF TEXTURE FULL ⟷ LEAN INTERESTING BUT DETAIL ADVANCES

OPEN ⟷ CONGESTED

TONE

IRRADIATION ——— CONTRASTING ⟷ CLOSE VALUED

CLEAR ROUGH SHINY PATTERN BROKEN/MOTTLED TEXTURE

STEPS LIGHT TO DARK GRADATION

REVERSED NEGATIVE

IDEALS FOR REVERSED NEGATIVE WORK

OVERLAPPING DIMINISHING PLANES
THAT DON'T RECEDE

LIGHT AND SHADE THAT CREATES
ONLY SHAPE AND NOT FORM

PERSPECTIVES THAT
DON'T RECEDE

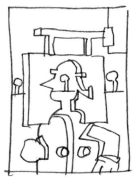

FIGURES THAT ARE REALLY
HOLES IN THE GROUND

FIGURES THAT ARE ONLY SUPPORTS
FOR DECORATION DESIGNS

GROUNDS
BY
MASKING

IDLE PASTIMES THAT ARE
VISUALLY FORMALIZED
INTO ICONS OF ETERNITY

AUTHORITATIVE DETAIL THAT IS
HUNG ON CLEARLY BOGUS
OBJECTS

ELABORATE DRAFTSMANSHIP IS
UNSUPPORTED BY TONE OR COLOR

FULSOME RENDERING IS
UNSUPPORTED BY DRAFTSMANSHIP

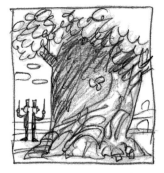

FOCAL EVENTS THAT ARE
DENIED THEIR IMPORTANCE

TECHNIQUES OF ILLUSION ARE USED BUT FOILED.

IDEALS FOR REVERSE NEGATIVE

6

COLOR

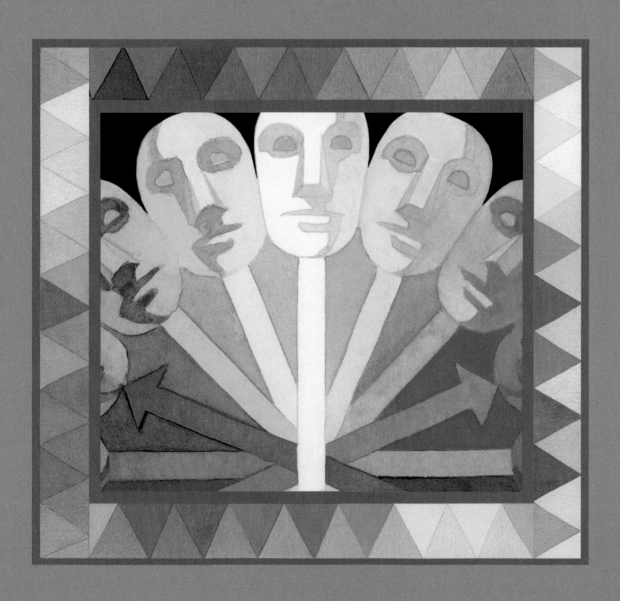

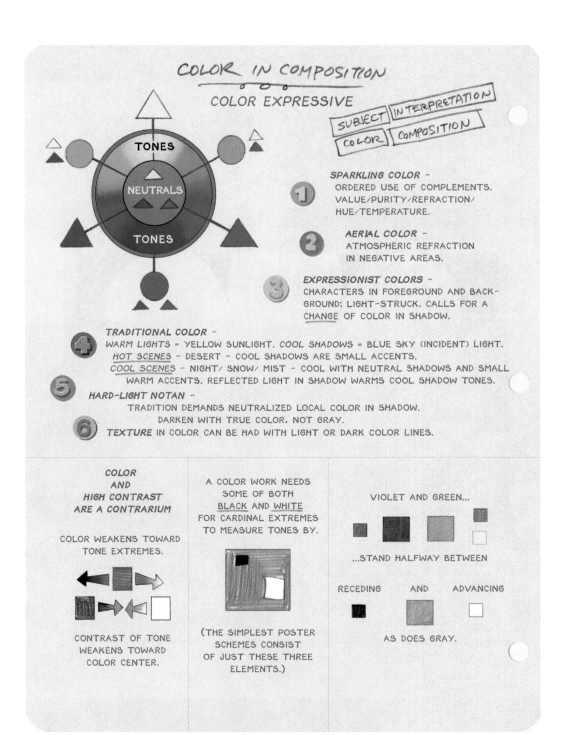

COLOR IN COMPOSITION

COLOR EXPRESSIVE

SUBJECT	INTERPRETATION
COLOR	COMPOSITION

TONES

NEUTRALS

TONES

① *SPARKLING COLOR* –
ORDERED USE OF COMPLEMENTS.
VALUE/PURITY/REFRACTION/
HUE/TEMPERATURE.

② *AERIAL COLOR* –
ATMOSPHERIC REFRACTION
IN NEGATIVE AREAS.

③ *EXPRESSIONIST COLORS* –
CHARACTERS IN FOREGROUND AND BACK-
GROUND; LIGHT-STRUCK. CALLS FOR A
CHANGE OF COLOR IN SHADOW.

④ *TRADITIONAL COLOR* –
WARM LIGHTS = YELLOW SUNLIGHT. *COOL SHADOWS* = BLUE SKY (INCIDENT) LIGHT.
HOT SCENES – DESERT – COOL SHADOWS ARE SMALL ACCENTS.
COOL SCENES – NIGHT/ SNOW/ MIST – COOL WITH NEUTRAL SHADOWS AND SMALL
WARM ACCENTS. REFLECTED LIGHT IN SHADOW WARMS COOL SHADOW TONES.

⑤ *HARD-LIGHT NOTAN* –
TRADITION DEMANDS NEUTRALIZED LOCAL COLOR IN SHADOW.
DARKEN WITH TRUE COLOR, NOT GRAY.

⑥ *TEXTURE* IN COLOR CAN BE HAD WITH LIGHT OR DARK COLOR LINES.

*COLOR
AND
HIGH CONTRAST
ARE A CONTRARIUM*

COLOR WEAKENS TOWARD
TONE EXTREMES.

CONTRAST OF TONE
WEAKENS TOWARD
COLOR CENTER.

A COLOR WORK NEEDS
SOME OF BOTH
BLACK AND WHITE
FOR CARDINAL EXTREMES
TO MEASURE TONES BY.

(THE SIMPLEST POSTER
SCHEMES CONSIST
OF JUST THESE THREE
ELEMENTS.)

VIOLET AND GREEN...

...STAND HALFWAY BETWEEN

RECEDING AND ADVANCING

AS DOES GRAY.

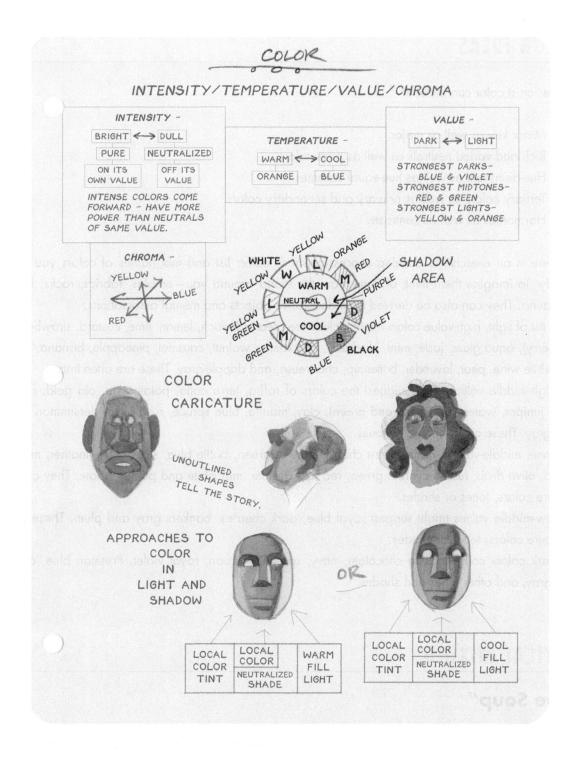

COLOR

INTENSITY/TEMPERATURE/VALUE/CHROMA

INTENSITY –

BRIGHT ←→ DULL

PURE NEUTRALIZED

ON ITS OWN VALUE OFF ITS VALUE

INTENSE COLORS COME FORWARD – HAVE MORE POWER THAN NEUTRALS OF SAME VALUE.

TEMPERATURE –

WARM ←→ COOL

ORANGE BLUE

VALUE –

DARK ←→ LIGHT

STRONGEST DARKS– BLUE & VIOLET
STRONGEST MIDTONES– RED & GREEN
STRONGEST LIGHTS– YELLOW & ORANGE

CHROMA –

YELLOW

RED ←→ BLUE

SHADOW AREA

WHITE YELLOW YELLOW ORANGE RED
YELLOW W L M PURPLE
WARM L M D
NEUTRAL
COOL
YELLOW GREEN L GREEN M BLUE B VIOLET BLACK

COLOR CARICATURE

UNOUTLINED SHAPES TELL THE STORY.

APPROACHES TO COLOR IN LIGHT AND SHADOW

OR

| LOCAL COLOR TINT | LOCAL COLOR / NEUTRALIZED SHADE | WARM FILL LIGHT |

| LOCAL COLOR TINT | LOCAL COLOR / NEUTRALIZED SHADE | COOL FILL LIGHT |

COLOR IDEAS

Expressionist color can include:

- Minor key as well as major.
- Rich and varied neutrals as well as pure colors.
- Hue-dominant as well as hue-equal schemes.
- Tertiary colors as well as primary and secondary colors.
- Harmonies as well as contrasts.

Here is an exercise to develop expressionism in color: list and mix names of colors you can identify. To imagine them think of items from the world around you—edibles, fabrics, rocks, flora and fauna. They can also be derived from decorative objects and mental associations.

A list of light, high-value colors might include ice creams (peach, lemon, lime, custard, strawberry, raspberry), aqua glass, jade, mint, blueberry, blackberry, walnut, caramel, pineapple, banana, canvas, white wine, pear, lavender, buttercup, chartreuse, and dapple-gray. These are often tints.

High-middle values might suggest the colors of raffia, terra cotta, potato skin, old gold, rose, sage, juniper, watermelon (pink and green), clay, manila, blue spruce, rust, olive, persimmon and steel gray. These could be tints or tones.

Some middle-value examples are cherries, bottle green, bottle blue, slate blue, heather, maraschino, olive drab, russet, cypress green, red fox, granite, malachite and pomegranate. They could be pure colors, tones or shades.

Low-middle values might suggest royal blue, dark cherries, bankers gray and plum. These are also pure colors, tones or shades.

Dark colors could include chocolate, navy, spruce, maroon, royal violet, Prussian blue, charcoal gray, and other tones and shades.

OPTICAL MIXING

"The Soup"

Some artists make a neutral watercolor wash of complements such as orange and blue and use it to unify colors. ("Stock" is more like it!) Instead of pre-mixing it, *overlay* it as in the method of a sky

overlay of blue over orange. Color hatching sometimes works in shadow if tones are close for special effect. Color hatching for optical mix in a lit textured area is excellent!

Choice of Colors for a Mix

- Should be equal in intensity, or:
- Should be equal in value.
- Color choices should be made from the Color Triangle: hue, tint, tone or shade.
- For shadows consider three colors in shadow: a local hue, an incident light hue and a darkness hue. (For example: Darkness hue can be a color one or two steps down the color wheel so a yellow shadow would be orange with cool incident light such as lemon, resulting in a sienna hue. Blue shadow would be purple and a cool incident light mixed to a "navy" blue. A red shadow could include purple and magenta, equaling a plum color.)
- Merged shadows can vary in color and temperature in recognition of obscured local colors. The techniques of broken color and mottling can aid this effect.

Some Color Mixtures for Painting the Sky

The following are used for the overlay method. The first mixture is painted on and allowed to dry. A second color wash is added using the strong blue.

- Wash of Yellow Ochre and Rose Madder, Cobalt Blue painted over it.
- Cadmium Yellow and Vermilion mix/Cobalt Blue.
- Aureolin and Viridian mixture/Cobalt Violet.
- Black and Burnt Sienna mixture/Ultramarine Blue.
- Light Red and Emerald Green/Cobalt Blue.
- Raw Sienna and Rose with overlay of Manganese Blue.

Useful Colors

Burnt Sienna or Venetian Red functions as a brownish red in shadowed areas.
Burnt Sienna plus White gives a good smoky brownish red.
Raw Sienna functions as gold in shadow.
A flat warm tone can be made from Vermilion and Lamp Black or Indian red.
Shadowed yellow can be mixed from Yellow Ochre and Burnt Sienna or from warm Sepia.

Some greens mixed from color:

Cadmium Yellow Deep, Phthalocyanine Blue, Winsor Violet (for leaf green).
Cerulean Blue and Cadmium Lemon.
Ultramarine Blue plus Cadmium Lemon or Cadmium Yellow Medium.
Phthalocyanine Blue plus Cadmium Lemon or Cadmium Yellow Medium (plus limited amount of
 Alizarin Crimson).
Any yellow other than Lemon goes olive in the mix.
In superimposing color, yellow over blue is brighter than blue over yellow.

Colored Neutrals—As both mixed primaries and mixed secondaries produce gray, any color
mixed with *black* can produce a neutral.

The color *of* light *takes precedence over all other color!*

COLOR ADVICE FROM EDGAR PAYNE

- Two parts of a secondary are needed to neutralize one part primary.
- Rarely can a picture employ only analogous pure colors for harmony.
- All pure colors create activity. All muted colors rest.
- An artistic inequality of complements with a dominant color, shade or tint is a good plan.
- Mixing a dominant tone and injecting it in various colors is called the "soup" method and
 creates harmony.
- A "toner" can be made with Indian Red, Ultramarine Blue and Yellow.
- Any strong color affects its surroundings and should modify them in a picture.
- "Soup" can be any neutralized color: warm, cool, brown, russet.
- Little pure color exists outdoors.
- Outdoor color is much more intense than paint.
- Any color combination can be transposed by keeping the relationship true
 (i.e., intensity-darkness-warmth).
- Color is only one aspect. Drawing and value are important.
- Color is visual and easier studied than disguised principles.

Broken color replaces "soup"—for atmosphere.

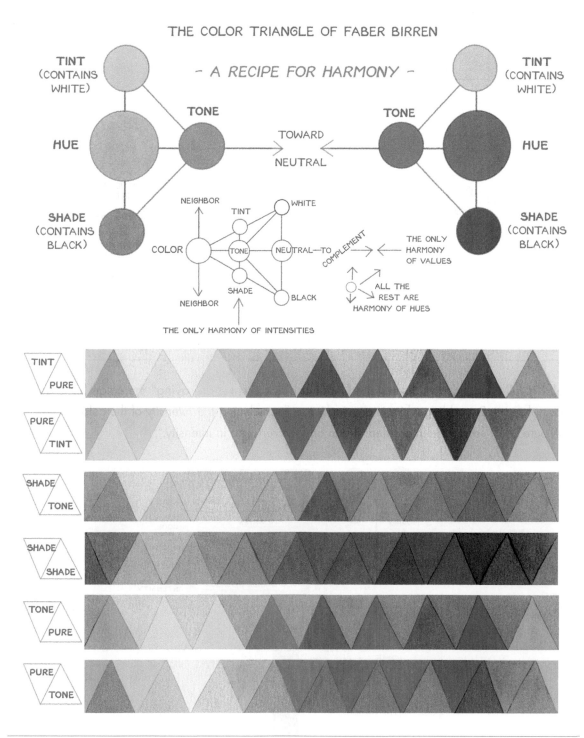

COLOR ANALYSIS OF FABER BIRREN

CHARTING THE HUE, VALUE, TEMPERATURE AND INTENSITY OF A COLOR

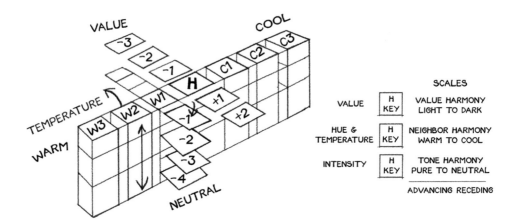

		SCALES
VALUE	H / KEY	VALUE HARMONY LIGHT TO DARK
HUE & TEMPERATURE	H / KEY	NEIGHBOR HARMONY WARM TO COOL
INTENSITY	H / KEY	TONE HARMONY PURE TO NEUTRAL
		ADVANCING RECEDING

NEUTRALIZING A COLOR/CHANGING VALUE

A color is full intensity at its given value. Adding black is called "graying" the color. So is adding the complement. But adding white is graying it too (by reducing the *intensity* of the color!).

A pure color cannot be intensified. It can only be reduced in intensity.

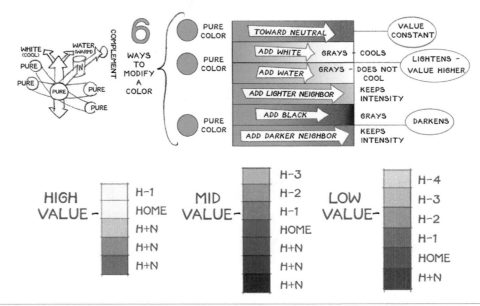

HOME VALUE—Intensity lessens going up or down from home value.

COLOR vs TONE CONTRARIUM

TONE AT THE ENDS –

COLOR AT THE MIDDLE →

– OF VALUE SCALE

A

'A' DOES NOT HAVE THE SILHOUETTE VALUE OF 'B'.

B

✻NOTE: LINE IS KEPT IN DARK VALUE AREAS

BUT COLOR LINE GOES WHERE IT WILL

'C' DOES NOT HAVE THE SAME SPACIAL QUALITY OF 'D'.

C

D

BOTH LINE AND COLOR ARE SACRIFICED TO TONE

 OR TONE IS SACRIFICED TO COLOR AND LINE →

TASTE AND STYLE WILL DETERMINE WHERE AND WHAT TO SACRIFICE.

BUT A MAXIMUM OF COLOR IS ACHIEVED IN A HALFTONE COMPOSITION

MINIMUM LIGHTS MINIMUM DARKS

RELATIONSHIP OF COLOR AND TONE

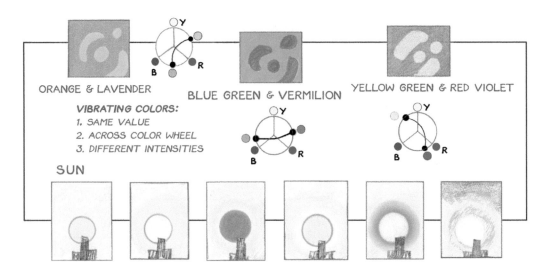

ORANGE & LAVENDER

BLUE GREEN & VERMILION

YELLOW GREEN & RED VIOLET

VIBRATING COLORS:
1. SAME VALUE
2. ACROSS COLOR WHEEL
3. DIFFERENT INTENSITIES

SUN

VIBRATING COLORS

Neutral Colors

Create more lively and varied "grays" by mixing them from color instead of adding black. Here are some useful combinations:

A "navyish" blue—Winsor Blue, Payne's Gray and Alizarin Crimson.

Warm shadow—Cadmium Orange and Winsor Violet.

A rich gray—Winsor Blue, Alizarin Crimson and Raw Umber.

Enlivened cool gray—Payne's Gray, Alizarin Crimson and Burnt Umber.

Neutral "Red"—Alizarin Crimson, Burnt Umber, Payne's Gray and Winsor Violet.

Neutral "Green"—Payne's Gray, Raw Umber and Winsor Blue.

Reddish Gray—Raw Sienna and Winsor Violet.

Super Black—Payne's Gray, Alizarin Crimson and Winsor Blue.

Red Black—Payne's Gray and Alizarin Crimson.

Blue Black—Payne's Gray and Winsor Blue or Ultramarine Blue.

Green Black—Payne's Gray and Winsor Green.

Yellow Black—Lamp Black and Indian Yellow.

Silvery—Alizarin Crimson and Winsor Green.

Gray Green—Payne's Gray and Indian Yellow.

"Cooper's" Gray I—Winsor Violet, Raw Sienna, Payne's Gray and Burnt Umber.

"Cooper's" Gray II—Payne's Gray and Burnt Umber warmed with Alizarin Crimson and cooled with Winsor Blue.

COLOR AND THE PICTURE PLANE

MOTTLED
COLOR

*SOPHISTICATED
(COMPLEX)
TREATMENTS –
THEY MOVE
THROUGH TWO
PLANES.
THEY HAVE
RHYTHM.*

WHITE–YELLOW–RED–BLUE–GRAYED

OVERLAY

ALSO
SPATTER
AQUAPASTO

USE
GOUACHE-
WASH

INTERCHANGE

TAKES ONE
SHAPE THROUGH
SEVERAL PLANES

PUTS PATTERN
INTO AREAS
THAT DON'T
REALLY HAVE IT.

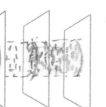

A NIMBUS OF SOLID
ATMOSPHERE THRU PLANES

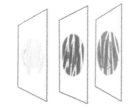

BROKEN COLOR
ALLOWS
COMPLEMENTS TO
REFLECT WITHOUT
NEUTRALIZING OR
MUDDY COLOR.

BROKEN COLOR
IS
LOOSE PATTERN

ONE SHAPE
ON SEVERAL
PLANES

MONDRIAN HAS SPACE

PATTERN

STRUCTURAL

OR SURFACE

AND BROKEN
MIXTURES ARE
BRIGHTER THAN
BLENDED
MIXES.

OR PATTERN
IS FORMAL BROKEN COLOR.

THE COLOR SCALE

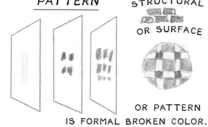

READS
THROUGH
THE PICTURE
PLANE.
SUGGESTS II
PICTURE PLANES.
EXCEPTION
* A PURE COLOR PUSHES AHEAD OF
ITS VALUE PLANE.

CHOOSING TONE STRIPES IS
CHOOSING SPACE PLANES.
GENERALLY, ONE WAY OR
ANOTHER LIGHT COMES FORWARD–
LIGHT OVER DARK
PURE OVER TEXTURED
PURE OVER GRAYED.

COLOR AND THE PICTURE PLANE

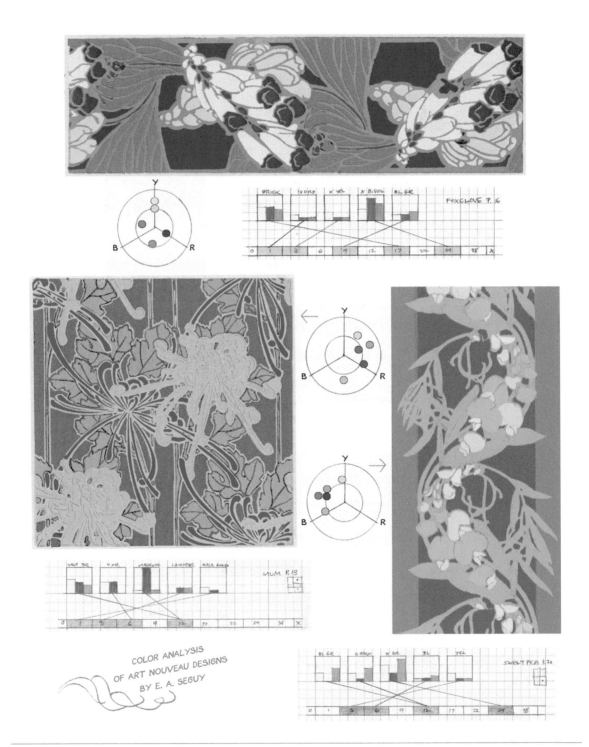

ANALYSIS OF ART NOUVEAU COLOR SCHEMES
Art by E. A. Seguy from Full-Color Floral Designs in the Art Nouveau Style, *Dover Publications*

ART NOUVEAU COLOR SCHEMES

The Art Nouveau style originated at the turn of the twentieth century and derived its inspiration from plant forms. It is known for dramatic curved lines and unusual and subtle color schemes. This approach to color can be adapted to modern subjects.

Some characteristics:

HUE—No more than half the color wheel is used in many cases.

VALUE—Schemes consist of first and second dominant tones, a middle tone and two accents. The first and second dominants are most commonly midrange light values and middle tones. Middle tones and accents range from high light to dark shade and are least seen in midrange light to the middle of the value scale.

TONE STEPS—These are most commonly placed one or two steps apart in the first and second dominant tones. They may also be placed three and even four steps apart.

INTENSITY—Varying the intensity of the dominant colors retains their relationship and provides harmony and richness. The Color Triangle and Color Wheel can be helpful in discovering vibrant combinations.

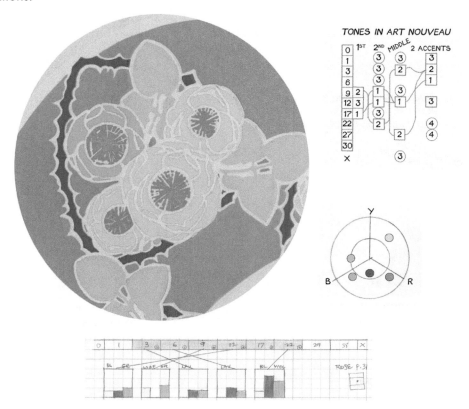

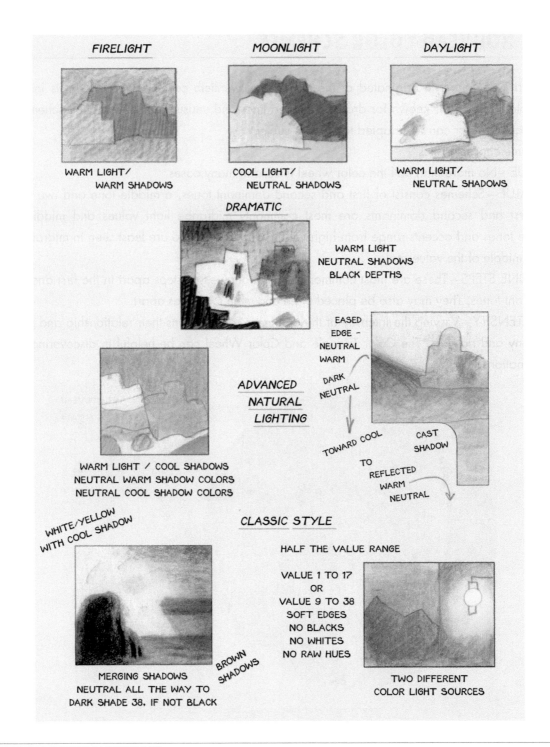

FIRELIGHT

MOONLIGHT

DAYLIGHT

WARM LIGHT/
WARM SHADOWS

COOL LIGHT/
NEUTRAL SHADOWS

WARM LIGHT/
NEUTRAL SHADOWS

DRAMATIC

WARM LIGHT
NEUTRAL SHADOWS
BLACK DEPTHS

ADVANCED
NATURAL
LIGHTING

EASED
EDGE –
NEUTRAL
WARM

DARK
NEUTRAL

TOWARD COOL

CAST
SHADOW

TO
REFLECTED
WARM

NEUTRAL

WARM LIGHT / COOL SHADOWS
NEUTRAL WARM SHADOW COLORS
NEUTRAL COOL SHADOW COLORS

WHITE/YELLOW
WITH COOL SHADOW

CLASSIC STYLE

HALF THE VALUE RANGE

VALUE 1 TO 17
OR
VALUE 9 TO 38
SOFT EDGES
NO BLACKS
NO WHITES
NO RAW HUES

BROWN
SHADOWS

MERGING SHADOWS
NEUTRAL ALL THE WAY TO
DARK SHADE 38, IF NOT BLACK

TWO DIFFERENT
COLOR LIGHT SOURCES

THEMATIC COLOR FOR BACKGROUNDS

WHEN PLANE TURNS TOWARD LIGHT IT NEED NOT CHANGE VALUE BUT IT MUST CHANGE TEMPERATURE.

THE 'TRUE' HUE IS IN THE RAKING HALFTONE.

WARM COLORS IN WARM LIGHT GET MORE INTENSE. OTHERS GRAY. COOL COLORS IN COOL LIGHT GET MORE INTENSE. OTHERS GRAY.

OUTDOOR

WARM LIGHT COOL SHADOW

INDOOR

COOL LIGHT WARM SHADOW

1. AN OBJECT IS COLORED IN THE LIGHT BY THE COLOR OF THE LIGHT.
2. IT IS COLORED IN THE SHADOW BY THE COLOR OF THE SKY.
3. IT MAY BE COLORED IN LIGHT OR SHADOW BY THE COLOR OF THE GROUND.
THE POWER OF THESE LIGHT SOURCES IS:

1. LIGHT – STRONG
2. SKY – PERVASIVE
3. GROUND – WEAK

LIGHT SKY OR ENCLOSURE

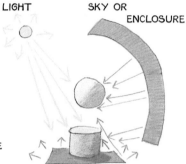

GROUND OR REFLECTOR

WHITES AND BLUES WARM AT A DISTANCE

THE EFFECT OF LIGHT AND ATMOSPHERE ON COLOR

ALL COLOR AREAS IN A PICTURE WHICH ARE THE SAME VALUE SEEM RELATED TO EACH OTHER REGARDLESS OF THEIR CHROMA.

COLORS OF LIKE INTENSITIES RELATE.

COLORS OF LIKE CHROMA RELATE.

MAXIMUM CONTRAST WHEN ALL THREE ARE DIFFERENT.

COLOR COMPOSITION SHOULD BE DONE WITH THREE TONES.

① A FULL RANGE OF MID VALUE COLORS. ANY COLORS
& NEUTRALS

② ACCENTS OF DARK AND LIGHT.
& NEUTRALS

③ ACCENT COLORS
LIGHT: YELLOWS OR PASTELS
DARK: BLUES OR SHADES

COLOR PRINCIPLES

TRIANGULATION – PRINCIPLE ACCENT USED IN THREE POINTS

COMPLEMENTS IN THE FOCAL POINT

MOSAIC OF HARMONIES

COLOR AND COMPOSITION

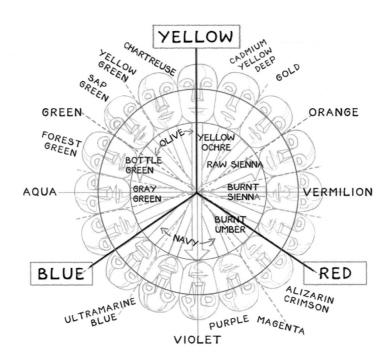

Key to "Around the Color Wheel Shadowing" chart

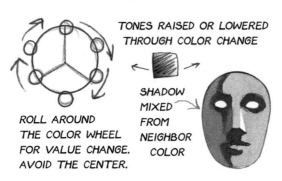

ROLL AROUND
THE COLOR WHEEL
FOR VALUE CHANGE.
AVOID THE CENTER.

TONES RAISED OR LOWERED
THROUGH COLOR CHANGE

SHADOW
MIXED
FROM
NEIGHBOR
COLOR

ALL COLORS ARE NEIGHBORS AS LONG AS
YOU GO AROUND THE COLOR WHEEL.
HUE HARMONY IS MAINTAINED WHILE GOING
FOR DARKS IN THIS WAY,
THAT IS WHY COLOR
CHARTS ARE HARMONIOUS BUT PICTURES
ARE NOT THE JUMPS FROM BLUE
TO GREEN TO RED ARE
CONTRAST NOT
HARMONY!

DISCONNECTED COLORS!!

Tracing paper overlay used to determine color schemes and
color neighbors on chart.

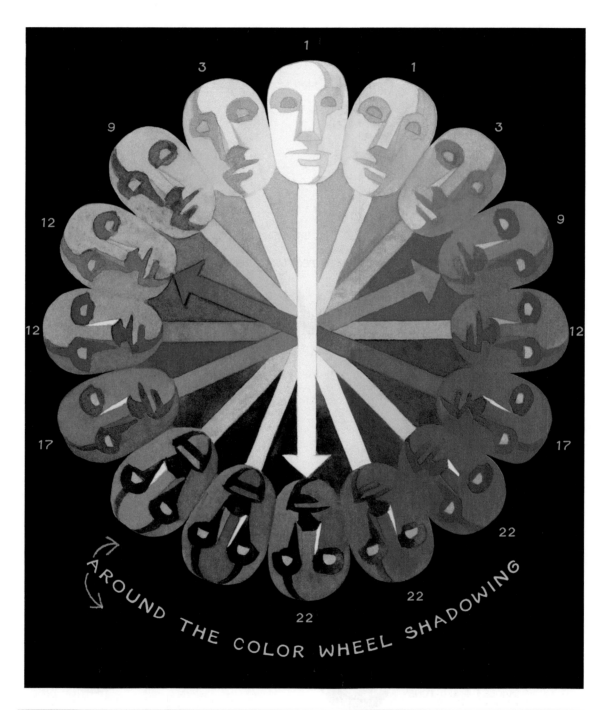

FOR RICHER COLOR—Mix light and shadow areas from neighboring color instead of adding white or black.

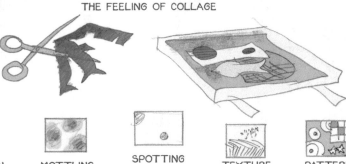

FINDING INSPIRATION FOR COLOR SCHEMES

THE FEELING OF COLLAGE

GRADATION MOTTLING SPOTTING TEXTURE PATTERN

POSTERS, WOODBLOCK PRINTS, ARCHITECTURAL RENDERINGS –

- FLAT SHAPES
- APPROPRIATE TONE
- LINEWORK

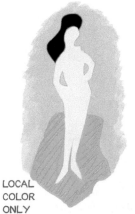

LOCAL
COLOR
ONLY

SHADED OR
GRADIENT SHAPES

COLORS FROM FOLK ART –

SCHEME: A COOL PURE COLOR PLAYED
AGAINST A WARM ANALOGOUS
TONE –

- ALIZARIN & BURNT SIENNA
- EMERALD & OLIVE
- LEMON & BURNT OCHRE
- LAVENDER & MAROON
- AQUA & BURNT VIOLET
- PALE GOLD & OLIVE
- PALE VERMILION
 & MAGENTA TONE
- VIOLET & RED TONE

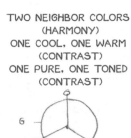

TWO NEIGHBOR COLORS
(HARMONY)
ONE COOL, ONE WARM
(CONTRAST)
ONE PURE, ONE TONED
(CONTRAST)

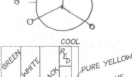

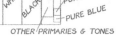

GREEN WHITE BLACK RED PURE YELLOW
PURE BLUE

COOL

OTHER PRIMARIES & TONES

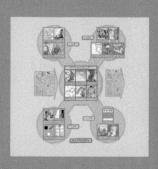

7

RENDITION

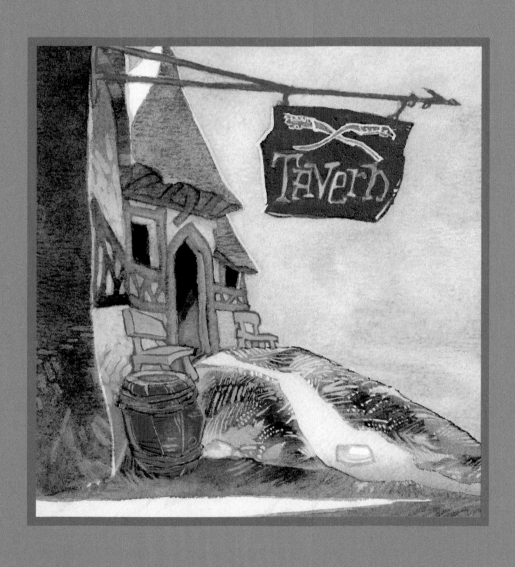

RENDITION

SIGNATURE

| LINE | FORM |
| TONE | COLOR |
COMPOSITION

COMPLEMENTARY

1. LINE — CONSISTENCY PLAYED AGAINST ACCENTS

2. FORM — SUBJECTIVE DISTORTION

3. TONE — LIGHT-STRUCK COMBINED WITH POSTER NOTAN

4. COLOR — COLOR EXPRESSIVE

5. COMPOSITION — GRID DYNAMIC TENSION RHYTHM & FLOW

6. SHAPES — SIGNATURE SHAPES IN POSTER NOTAN

MEDIA EXPRESSIVE

→ DESIGN FOR WATERCOLOR'S SIGNATURES

EASED OUT SHAPES IN VIGNETTES

DRAWN BUT NOT PAINTED AREAS
LIGHTLY TONED VS. FULLY TONED

WET IN WET
SPLATTER
PUDDLING
WEALTH OF HIGH KEY COLOR
MOTTLING & GLAZE MOTTLE
GLAZING
SPOT SHADOWS

COLOR PENCILS

COLOR HATCHED AREAS

HIGHLIGHT LINES

EXPRESSIONIST COLOR IN LINE

DARK SHAPES WITH COLOR LINE DRAWING-

PENCIL TEXTURE

RED/BLUE OUTLINE ON COMPLEMENTS

RESIST-INK

SIGNATURE

THE ARTIST'S NATIVE INDIVIDUALITY

ORGANIC 'UNDRAWABLE'
THINGS-

FOAM	BARK
CLOUDS	MOSS
WATER	FOLIAGE
SMOKE	STONES
FIRE	DRAPERY
EXPLOSIONS	

-ARE THE PROVINCE OF
SIGNATURE FORMS.

ART LIVES IN THE SIGNATURE.

 AN ABSTRACT PASSAGE OF PURE SIGNATURE IS THE DELIGHT OF A DRAWING:
A CADENZA OF PERSONALITY. BRINGING THE UNKNOWABLE INTO THE SHARP
FOCUS OF AN INDIVIDUAL UNIQUE EYE.

 THE GEOMETRIC IS NOT ONLY THE FOIL FOR THE
ORGANIC SIGNATURE. IT GIVES THE STAMP OF
AUTHENTICITY TO THE SIGNATURE: BEING AS
"UNINTERPRETED" AND "FACTUAL" AS POSSIBLE.

STYLES WHICH DON'T UNDERSCORE THIS CONTRAST OF ORGANIC SIGNATURE
AND MECHANICAL GEOMETRY ARE FLACCID.

COMPLEMENTS

ORGANIC SIGNATURE AND GEOMETRIC STRICTNESS
ARE COMPLEMENTS OF FORM.

TO DRAW IN
SIGNATURE STYLE
IN THE PROPER
LINE COLORS... →

...BASIC
COLOR AND
TONE MUST
BE PRE-
PLANNED →

WEIGHT, VOLUME
TEXTURE,
IMMUTABLE-
PERMANENCE-
AS ONE WITH
THE ENVIRONMENT

SOFTNESS VALUED.

CHILD'S VIEW

ADULT'S VIEW

ABSTRACT,
SYMBOLISTIC IN
CONTRAST,
FLEXIBLE, CHANGING,
MANIPULATABLE.

SHARPNESS VALUED.

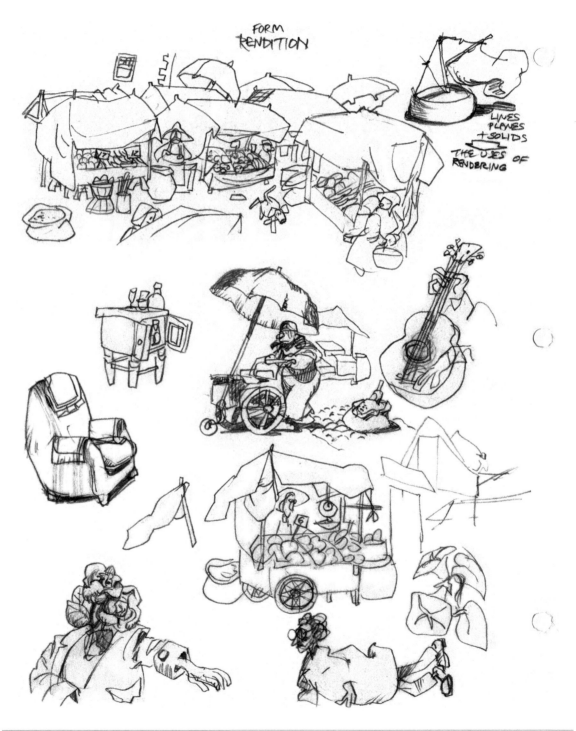

FORM RENDITION

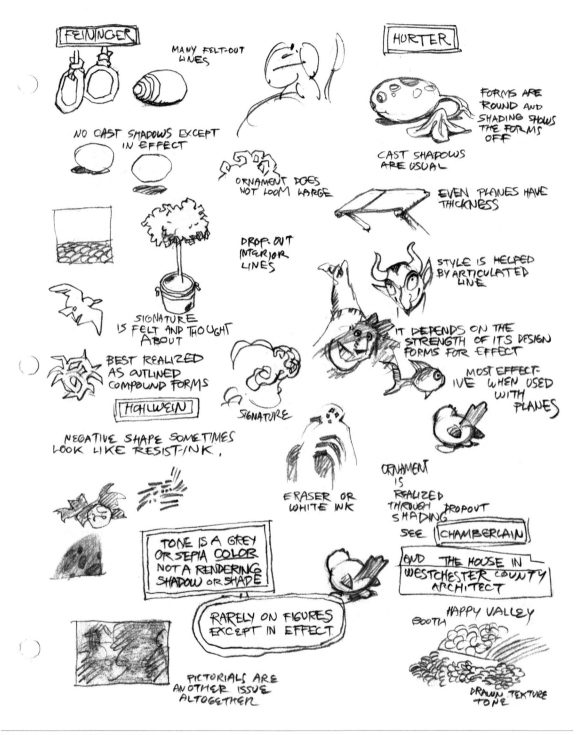

FEININGER

MANY FELT-OUT LINES

HURTER

FORMS ARE ROUND AND SHADING SHOWS THE FORMS OFF

NO CAST SHADOWS EXCEPT IN EFFECT

CAST SHADOWS ARE USUAL

ORNAMENT DOES NOT LOOM LARGE

EVEN PLANES HAVE THICKNESS

DROP-OUT INTERIOR LINES

STYLE IS HELPED BY ARTICULATED LINE

SIGNATURE IS FELT AND THOUGHT ABOUT

IT DEPENDS ON THE STRENGTH OF ITS DESIGN FORMS FOR EFFECT

BEST REALIZED AS OUTLINED COMPOUND FORMS

MOST EFFECTIVE WHEN USED WITH PLANES

HOHLWEIN

SIGNATURE

NEGATIVE SHAPE SOMETIMES LOOK LIKE RESIST-INK,

ORNAMENT IS REALIZED THROUGH DROPOUT SHADING

ERASER OR WHITE INK

SEE CHAMBERLAIN

TONE IS A GREY OR SEPIA COLOR NOT A RENDERING SHADOW OR SHAPE

AND THE HOUSE IN WESTCHESTER COUNTY ARCHITECT

RARELY ON FIGURES EXCEPT IN EFFECT

HAPPY VALLEY BOOTH

PICTORIALS ARE ANOTHER ISSUE ALTOGETHER

DRAWN TEXTURE TONE

INSPIRATION FROM OTHER ARTISTS

STYLES OF EDGES

EFFECT

EDGE

OBJECT ON SURFACE

1 4 10 13 16

HARD EDGE & ENHANCED CONTRAST EDGE

OBJECT SLIGHTLY RECESSED

7

'BROWN-EDGE COOKIE'

BAS-RELIEF OR BAS-RECESS

LIGHT ADVANCING TO SURFACE

2 9 *COLORED LIGHT* 15 *DIM OR COLORED LIGHT* 18

SPREADING OUT EDGE (MOSTLY FROM LIGHT)

DEEP RECEDING RECESS

6 8 12

SOFTENING-IN EDGE TO DARKNESS

NEUTRAL RECESS

5 11

SPREADING-OUT EDGE FROM DARKNESS

LIT RECESS

3 14 17

SOFTENING-IN EDGE TO LIGHTNESS

VARIOUS METHODS OF HANDLING EDGES

EDGES

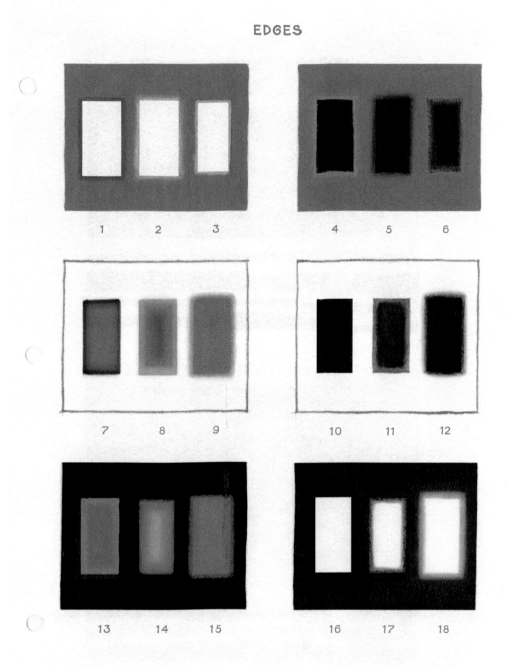

EXAMPLES OF EDGE STYLES

EXAMPLES OF EDGE TREATMENT 1

EDGE TREATMENT WITH COLOR

SKETCH FOR
WARM/COOL &
LIGHT/DARK ACCENTS

ELEMENT ①

SIGNATURE LINE
& FORM

ELEMENT ②

SELF LINE WITH
ACCENT

ELEMENT ③

REVERSE NEGATIVE
TREATMENT

*THE CRUX OF THE PROBLEM IS HOW TO KEEP SIGNATURE SHAPE—
WHETHER FLAT – REVERSED?*

COLOR LINES BY
PLANES RATHER THAN
LOCAL COLOR.
(WITH ACCENTS)

SELF-LINED
SHAPES ACROSS
OTHER SHAPES

UNLINED
← KEEPS
SILHOUETTE

ANSWER
IT COMES BACK TO
SILHOUETTE

SHAPES
STRONGER
THAN ANY
LINE WORK

LIGHT LINE IN
COLOR ACCORDING
TO
LIGHT

SHAPES
OUTLINED ONE
TONE DARKER

REASON TO PRESERVE
THE SILHOUETTE

LIGHTER THAN
DARKEST VALUE
LINES LAY DOWN
IN BACKGROUND

MORE
INTERESTING THAN GRAY

PROCEDURE:

① DETERMINE TONE
NOTAN

② DETERMINE
REVERSE NEGATIVE
COLOR NOTAN

③ DRAW WITH
APPROPRIATELY
TONED PENCIL

IF UNCERTAIN
CAN START WITH
ALL GRAY

CONSIDER VARIOUS
COLOR LINE

BROWN & GRAY
ARE ALL-PURPOSE

RENDITION NOTES

TRANSPARENT AND OPAQUE WATERCOLOR TECHNIQUES

1. XEROX ON TONED PAPER—Work out notan on a toned paper. Xerox your pencil drawing onto a gray charcoal paper and then paint over it.

2. TONED PAPER—Work out color notan on a color toned paper. Either drop in an ink wash on white or use a colored charcoal paper and use it as a support for your painting.

3. LIFTED OUT (Washing down)—After laying in a strong wash scrub it out with a stiff brush—for maximum grain. This can be done over a completed painting. Aquapasto can be added. (Example: cartoon showing procession of Pilgrims in the snow encountering a New Year's Eve partyer in stocks exclaiming "Hap—py New Year!" printed in *Playboy* magazine.)

4. "TINT YOUR OWN"—Lay down a tint over the whole picture before starting. Vignette area can be left out to allow for luminosity of white paper in focal area.

5. TWO COLORS OF INK—Brushed on: black and brown, blue and brown or other combination.
 Could be used with opaque wash to "vague" out the detail in the darkest parts.

6. SAME-COLOR LINE AND TONE—Brushed on ink where *line becomes tone* and *tone becomes line*. Effective when colors are used. Line is done first then tones are filled in with same color.

7. GRADED SHADOWS—"Puddle" on a light gray tone using a lot of water. Create variations of color and value by mingling in darker tones of green and brown.

8. MULTICOLOR LIFT OUT—Patchwork shadow patterns are painted in strongly. Then highlights are scrubbed out with bristle brush. Use various colors.

9. UNIFYING WASH—Full detail is painted over the whole picture. Then a cool gray is set over the middle ground to unify it.

10. SCRATCH OUT—This works best in conjunction with "rough-edged" washes. A sharp instrument such as stick, razor, or Exacto knife can be used to scrape out areas.

11. AQUAPASTO—Aquapasto is a thickening gel that adds body to the paint, allowing for opaque-over-transparent effects. It can be used to simulate the look of resist-ink or woodblock prints. It is similar to methods used in "The Trans-Siberian Express" animated commercial for Count Pushkin Vodka. This is a good technique for background images such as trees, cottages, rivers and mountains.

12. SCRAPING THE PAPER—When this is done before painting it takes wash differently. Can be interesting with plate watercolor paper.

13. GRANULAR WASH—Using one color at a time with a lot of water. Shift paper to make wash run up and down. This works with pigments that deposit a random amount of sediment such as Ultramarine Blue, Manganese Blue, Cobalt Blue, Cobalt Violet, Rose Madder, Burnt Umber, Raw Umber and Cobalt Green. It can also be done with gouache.

14. GRANULATED OVERPAINTING—To add an interesting and unifying texture wash granulated gray over an area or whole picture. Underpainting will be more fixed after two or three days.

15. WIPING OUT—Adding glycerin keeps surface wet longer. It also aids wiping out when dry. Used as an underpainting it keeps the surface damp. It can be put over ink tints.

16. COLORED PAPER WITH GOUACHE WASH—This combination provides a great range from opaque on down to tint. Thin gouache can be used like transparent watercolor. Light can be painted on dark.

17. MONOCHROMATIC—Simple monochromatic work reproduces with great strength. The printing process and juxtaposition of colors creates optical variations.

18. PROCEDURE—Notan established on tone paper by:
 A. Dropping in the second lightest value (light sky).
 B. Dropping in darkest tones such as dark trees.
 C. Adding accents of color light plus body tone (opaque watercolor) in a complement popped in.

19. VERY SOFT EDGES—Create this effect by wiping out wet opaque areas.

20. FINAL TONE—Add an overall coat of thin gouache over painting. It doesn't necessarily have to be white; a light gray or warm color gives a nice effect. It softens the existing drawing.

21. SOAKED PAPER—Apply a coat of gouache over soaked paper, then wipe out the effects. Try both wet and dry blotters. It is "drawing in washable wash." A tone over it may or may not obscure it according to taste.

DRAWING IN WASH-ABLE WASH

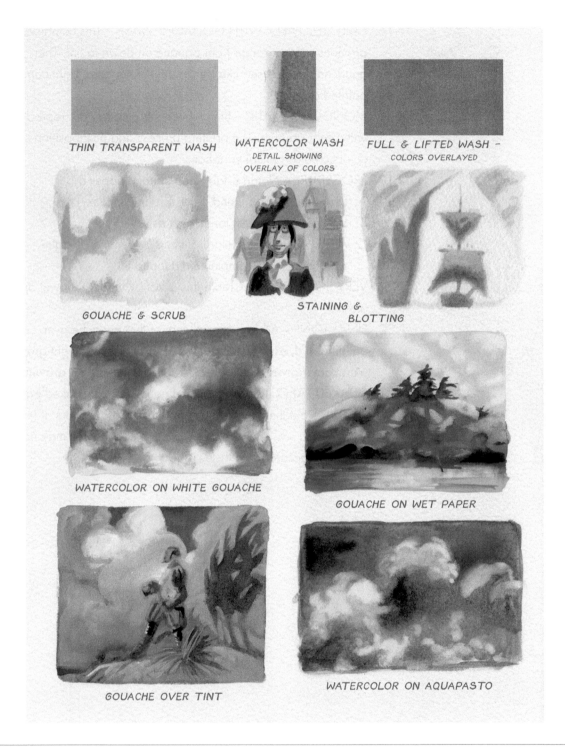

THIN TRANSPARENT WASH

WATERCOLOR WASH
DETAIL SHOWING
OVERLAY OF COLORS

FULL & LIFTED WASH –
COLORS OVERLAYED

GOUACHE & SCRUB

STAINING &
BLOTTING

WATERCOLOR ON WHITE GOUACHE

GOUACHE ON WET PAPER

GOUACHE OVER TINT

WATERCOLOR ON AQUAPASTO

EXAMPLES OF WATERCOLOR TECHNIQUES

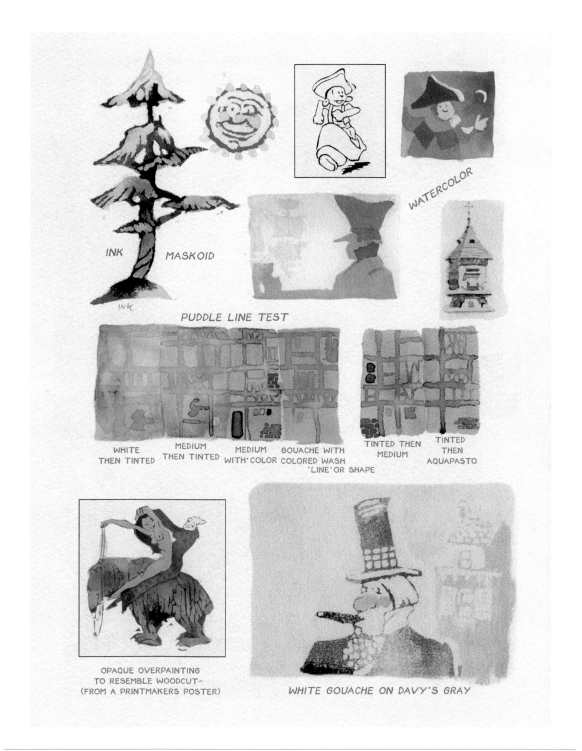

INK MASKOID

WATERCOLOR

PUDDLE LINE TEST

WHITE THEN TINTED MEDIUM THEN TINTED MEDIUM WITH·COLOR GOUACHE WITH COLORED WASH 'LINE'OR SHAPE TINTED THEN MEDIUM TINTED THEN AQUAPASTO

OPAQUE OVERPAINTING TO RESEMBLE WOODCUT- (FROM A PRINTMAKERS POSTER)

WHITE GOUACHE ON DAVY'S GRAY

INK, MASKOID, WATERCOLOR AND GOUACHE TECHNIQUES

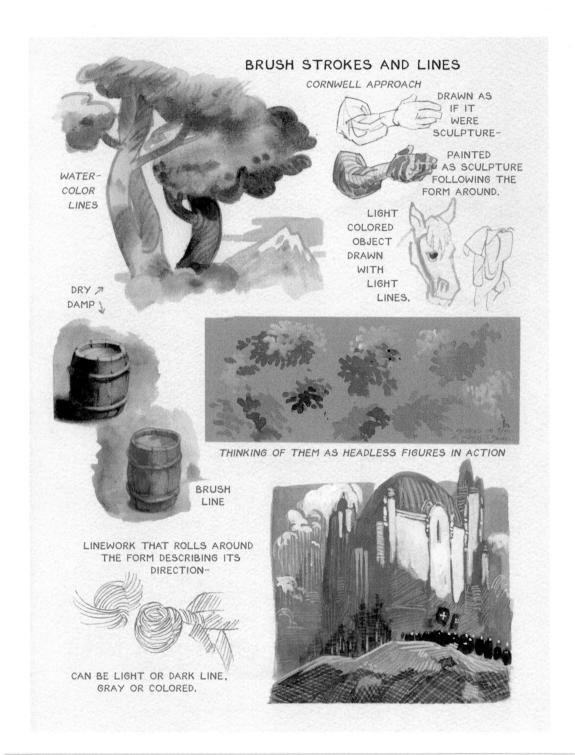

BRUSH STROKES AND LINES

CORNWELL APPROACH

DRAWN AS IF IT WERE SCULPTURE—

PAINTED AS SCULPTURE FOLLOWING THE FORM AROUND.

WATER-COLOR LINES

LIGHT COLORED OBJECT DRAWN WITH LIGHT LINES.

DRY ↗
DAMP ↘

THINKING OF THEM AS HEADLESS FIGURES IN ACTION

BRUSH LINE

LINEWORK THAT ROLLS AROUND THE FORM DESCRIBING ITS DIRECTION—

CAN BE LIGHT OR DARK LINE, GRAY OR COLORED.

PAINT HANDLING—BRUSH STROKES AND LINES

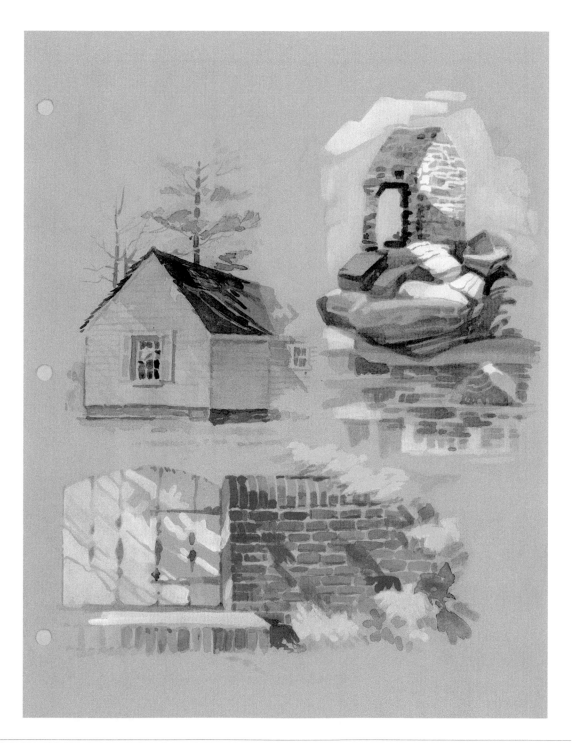

TRANSPARENT AND OPAQUE PAINT HANDLING ON TONED PAPER

This method demonstrates the range of paint application. Thin transparent washes allow the background color to show through. Thick application obscures it and is useful for highlights.

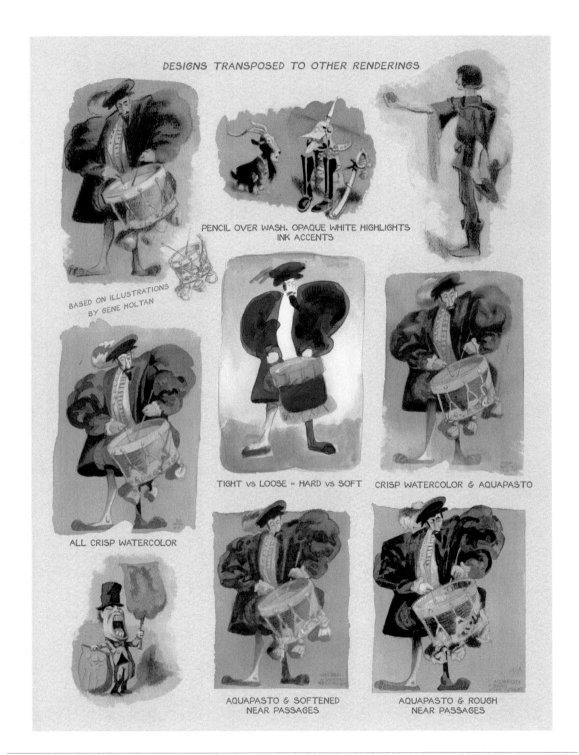

DESIGNS TRANSPOSED TO OTHER RENDERINGS

PENCIL OVER WASH. OPAQUE WHITE HIGHLIGHTS
INK ACCENTS

BASED ON ILLUSTRATIONS
BY GENE HOLTAN

TIGHT vs LOOSE = HARD vs SOFT CRISP WATERCOLOR & AQUAPASTO

ALL CRISP WATERCOLOR

AQUAPASTO & SOFTENED
NEAR PASSAGES

AQUAPASTO & ROUGH
NEAR PASSAGES

DESIGNS TRANSPOSED TO OTHER RENDERINGS
These sketches, based on the work of Gene Holtan, explore the possibilities of translating pen-and-ink drawings into other techniques.

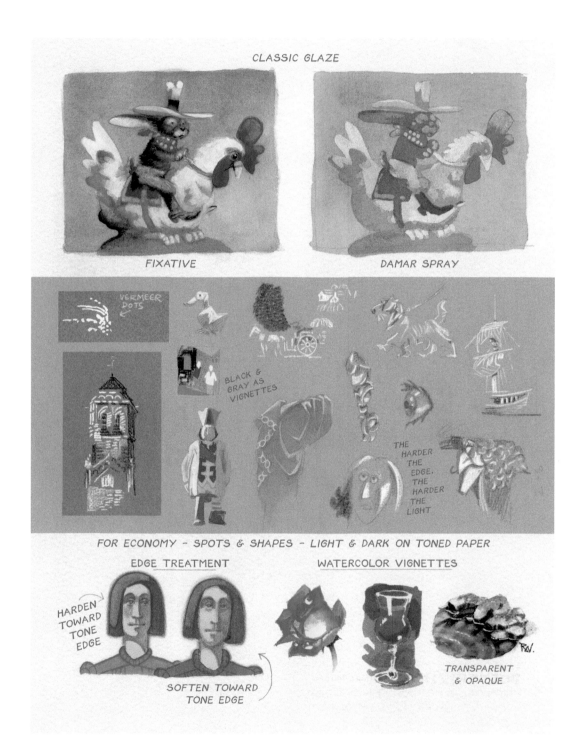

CLASSIC GLAZE

FIXATIVE

DAMAR SPRAY

VERMEER DOTS

BLACK & GRAY AS VIGNETTES

THE HARDER THE EDGE, THE HARDER THE LIGHT

FOR ECONOMY - SPOTS & SHAPES - LIGHT & DARK ON TONED PAPER

EDGE TREATMENT

WATERCOLOR VIGNETTES

HARDEN TOWARD TONE EDGE

SOFTEN TOWARD TONE EDGE

TRANSPARENT & OPAQUE

ADDITIONAL RENDERING STYLES INCLUDING GLAZING AND TONED PAPER

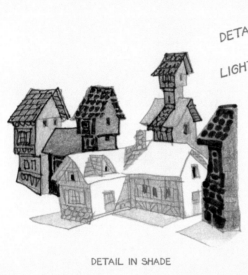

DETAIL RELATED TO LIGHT AND SHADOW

DETAIL IN SHADE

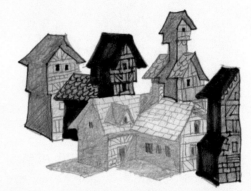

DETAIL IN LIT SIDE

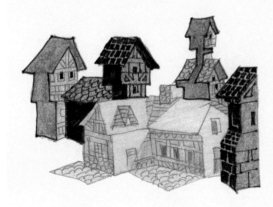

DETAIL IN MID TONES

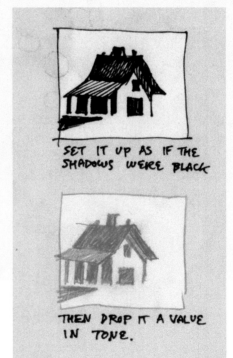

SET IT UP AS IF THE SHADOWS WERE BLACK

THEN DROP IT A VALUE IN TONE.

POSTERIZING IS DECIDING WHICH VALUES TO PULL →←TOGETHER AND WHICH VALUES TO PUSH ←→ APART.

ABOUT LIGHT SOURCES

SOURCE OF DIRECT ○ SUN LIGHT

SOURCE OF INCIDENT ○ LIGHT

AREAS IN SHADOW...

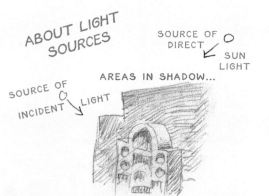

...ARE THE EXACT SAME AS AN AREA IN DIFFUSED LIGHT. THE LIGHT IS DIRECT <u>INCIDENT</u> LIGHT FROM ANOTHER DIRECTON THAN THE SUN LIGHT. SHADOWS ARE SOFT BUT CONSISTENT JUST LIKE THE NORTH LIGHT IN A STUDIO.

CAST SHADOWS

NEAR CAST SHADOW

DARKEST HERE

BUT SOFTENED HERE

DIRECTION OF REFLECTED LIGHT

FAR CAST SHADOWS ALL ONE VALUE FUZZY EDGES

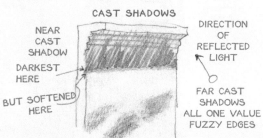

SILHOUETTED OBJECT IN SHADOW

AGAINST THE SKY: FLAT. NO SOFT EDGE

AGAINST OBJECT: WITH TONE SOFTENED EDGES

AN OBJECT PARTLY IN SUNLIGHT PARTLY IN SHADOW-

-PART IN SUNLIGHT FOLLOWS RULES OF DIRECT LIGHT. PART IN SHADOW FOLLOWS RULES OF NORTH LIGHT.

DOES LINE GO IN THE LIGHT OR SHADOW ?

ANSWER LINE IS A SURFACE SHADOW. THE OBJECT SHOULD NOT BE LIT 50/50. THE OBJECT SHOULD BE LIGHT-STRUCK.

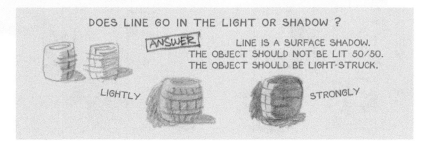

LIGHTLY

STRONGLY

RENDERING LIGHT AND SHADOW

ARTISTRY vs. ROUTINE CONVENTION

SAMUEL CHAMBERLAIN (RURAL FRANCE)	vs.	ARCHITECTURAL DRAWING

MORE SIGNATURE STYLIZATION		LITERAL
DRAWS NEGATIVE SPACES 		DRAWS POSITIVES
SIGNATURE		ROUTINE MARKS
SOFT AND SHARP		ALL THE SAME LINE
FORCED EDGES EMPHASIZE SHADOWS		SHADOWS FLAT
		SECONDARY DETAILS ARE MERELY INDICATED WITH CONVENTIONAL MARKS.
EVERYTHING IS <u>DRAWN</u> WITH STYLE		
SUNLIGHT		SOFT LIGHT

After a drawing by Saml, Chamberlain

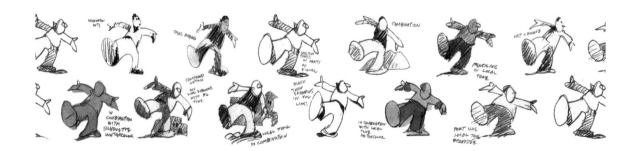

ARTISTRY VERSUS ROUTINE CONVENTION

8

THE PROCESS

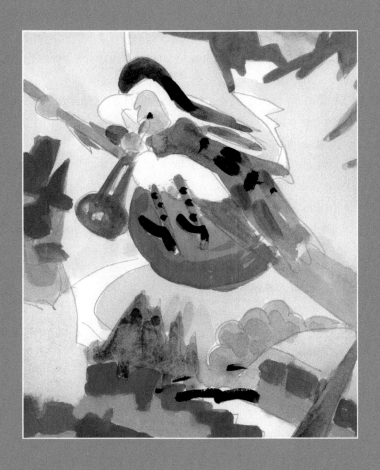

HOW DOES THE CREATIVE MAN CREATE?

1. **He sees:** He lifts the beaded curtain of accumulated values, accepted by the generality, and looks at nature naked. He sees the construct of the natural universe, the construct of society, the construct of man's mind and the construct of his own creativity (his godliness). He sees the eye he sees with. This is his talent.

2. **He organizes:** He unscrambles the multitude of images he sees and puts them in categories. This makes them accessible and useful and keeps them from getting lost, and conserves his precious time. This is his knowledge. His library.

3. **He synthesizes:** He takes the images he wants to blend out of his library and puts them in the tumbler of his unconscious where they turn over and over until the positive and negative jigsaw-parts snap together. If they don't, he tries another combination until they do. These are his ideas.

4. **He works:** He takes the idea and gives it physical form, adjusting the idea to the material and the material to the idea, keeping the intention always in mind. As he does this he continues seeing, organizing and synthesizing allalong the way, to the end. This is his craft.

5. **He finishes:** He becomes a critic. He brings the work out with polishing, sharpening, subduing till it takes on its own identity. If it doesn't, he goes back into the steps again. This is his integrity.

 WORKING NOTES FROM THE STUDIO

> • COLOR • VALUE • PATTERN • SILHOUETTE • TECHNIQUE • COMPOSITION (TRANSITIONS) •

- COLOR—Look at Art Nouveau, then Art Deco. List all the colors that are nowadays avoided or dismissed—the sullied yellows and the "muddy" colors in combination. Tints, tones and shades of bright colors always seen pure: vermilion, cobalt blue, orange. Find a range of grays and "blacks" and "whites." Use them in combination with pure earth colors: siennas, umbers, and bistre olives. Find new brights for accent colors: lightened Prussian, German poster blue, red neither yellowish nor purplish, tube greens, rose. Find new glazing combinations, not just blue and umber. Use analogous glazes, tertiary glazes. Try to find a way to use the "distasteful" glazes (blue over orange) by modifying the purity of one or the other (yellow over blue), (red over green) or by juxtaposing them in the right place or by using them as accents.*

- VALUE—Compose the value scheme as an overall silhouette pattern—so it could almost be reduced to pure black-and-white shapes. Plan the extremes with colors from the opposite ends of the value scale: 1, 2, 3 for white; 7, 8, 9, X for black. Middle values 4, 5, 6 can be used if surrounded by either high key or low key. Midtones look like darks enclosed in low keys. Strong silhouette gestalt allows the use of *value* harmony in colors, the most versatile and satisfying form of harmony, much better than chroma or intensity harmonies.*

All sorts of simultaneous contrast and "irradiation" (influence and vibration) become possible with close value colors.

- PATTERN—Use pattern to define form. You can express a form *without* the limiting requirements of chiaroscuro. Not necessarily in the very obvious black-and-white polka-dot robes of Maxfield Parrish but with close-valued pattern.

Use textures and pattern to contradict the strong figure/ground statement of a powerful notan. Light lines create pattern more than dark ones.

- TECHNIQUE—(Plate finish paper.) Kid finish paper is much easier to lay on controlled exact-value washes and smooth transitions than is plate paper. If that is part of the compositional scheme then choose it. Otherwise the dark edges puddling and textured glazing is much more effective on plate paper. Add aquapasto to your glazes. Glazes of gouache and aquapasto give a delightful velvety look. A color can be stepped up from a dark by either

adding white (cools it), adding water (maintains its chroma) or by running it up the color wheel toward yellow (warms it). A glaze looks good on just about everything. Plan it.
- COMPOSITION—It is very difficult to create a strong gestalt composition that cuts across figure and ground; that is not predicated on figure and ground. Grouping of objects is an obvious way but try to break the gestalt across the group: compound notan. A large object can be made to shade into a transitional change from dark to light. It takes a lot of planning to keep the paradox and not just make it too confusing.

Moving a light object from Value 1 to Value 5 helps. Do this with either transitional shading or steps of value. But it is not a true compound notan; the object still remains a "light object."

Compound notan suggests some sort of lighting effect: cast shadows, reflection. Think in those terms.

*COLOR & VALUE—There is a theory that the complement of a color is not just its hue but also its intensity and value. In other words: A pure orange, full intensity, value 3 would have its complement, not full intensity blue but a low intensity blue of value 6 or 7—a bright light orange versus a dull dark blue.

WHAT IS PART OF WHAT? *WHEN IS IT BEST DONE?*

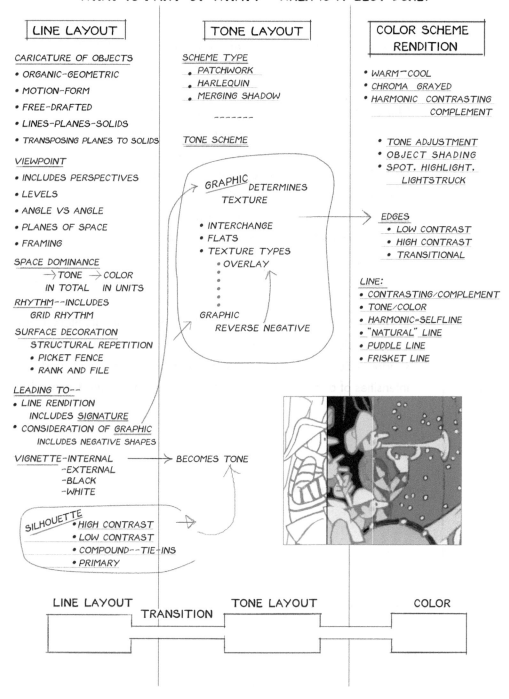

LINE LAYOUT	TONE LAYOUT	COLOR SCHEME RENDITION

CARICATURE OF OBJECTS
- ORGANIC-GEOMETRIC
- MOTION-FORM
- FREE-DRAFTED
- LINES-PLANES-SOLIDS
- TRANSPOSING PLANES TO SOLIDS

VIEWPOINT
- INCLUDES PERSPECTIVES
- LEVELS
- ANGLE VS ANGLE
- PLANES OF SPACE
- FRAMING

SPACE DOMINANCE
→ TONE → COLOR
IN TOTAL IN UNITS

RHYTHM--INCLUDES
GRID RHYTHM

SURFACE DECORATION
STRUCTURAL REPETITION
- PICKET FENCE
- RANK AND FILE

LEADING TO--
- LINE RENDITION
 INCLUDES SIGNATURE
- CONSIDERATION OF GRAPHIC
 INCLUDES NEGATIVE SHAPES

VIGNETTE-INTERNAL
 -EXTERNAL
 -BLACK
 -WHITE
→ BECOMES TONE

SILHOUETTE
- HIGH CONTRAST
- LOW CONTRAST
- COMPOUND--TIE-INS
- PRIMARY

SCHEME TYPE
- PATCHWORK
- HARLEQUIN
- MERGING SHADOW

TONE SCHEME

GRAPHIC DETERMINES
 TEXTURE
- INTERCHANGE
- FLATS
- TEXTURE TYPES
 - OVERLAY
 -
 -
 -
 -
GRAPHIC
 REVERSE NEGATIVE

- WARM⌐COOL
- CHROMA GRAYED
- HARMONIC CONTRASTING
 COMPLEMENT

- TONE ADJUSTMENT
- OBJECT SHADING
- SPOT. HIGHLIGHT.
 LIGHTSTRUCK

EDGES
- LOW CONTRAST
- HIGH CONTRAST
- TRANSITIONAL

LINE:
- CONTRASTING/COMPLEMENT
- TONE/COLOR
- HARMONIC=SELFLINE
- "NATURAL" LINE
- PUDDLE LINE
- FRISKET LINE

LINE LAYOUT	TONE LAYOUT	COLOR

TRANSITION

LESSONS FROM "THE PAISLEY WHALE"

LINE

TO DIRECT
THE EYE.

Please see full cartoon in Chapter 11 Gallery, page 299: "Does it have to be white, Captain? Would you consider something in a paisley?"

1. DESIGN IN SPACE—Shapes progress from large in foreground to smaller in background to create depth. Curves and angles lead the eye to the center of interest.
2. METHOD—Pencil and watercolor, beginning with complete line drawing. Paint thick white for frisket and thin white to enhance lifting and emphasize edges. The paint naturally gravitates toward the edge of the shape as it dries.

OVERLAP

EDGES

OVERLAP

TO CREATE
PLANES.

3. COLOR—Characters in shadows in flat (subdued) local colors. Characters in light designed for light and dark pattern. Can be in both. Skin tone in shadow—Burnt Umber plus Ultramarine Blue. Complements and different intensities of analogous colors vibrate when they are the same values.

Burnt Umber plus Ultramarine Blue

COLOR

FOR
FOCUS.

Color scheme tertiary—Prussian Blue, Yellow Ochre, Indian Red

Other possibilities: Alizarin Crimson, Lemon Yellow, Grayed Cobalt Blue

Ultramarine Blue, Cadmium Yellow, Indian Red

4. TONES—Tones conceived as mosaics of various sizes and shapes. Some of them fused with others in places.

Great variety is possible inside a given tone, for example the clouds or the rowers.

Complements are best for contrast in close tones. A pure color can be used inside shadow if it corresponds to type of light in shadow (blue and red, etc.).

Light shining through may reverse tone. Bottom tones the same.

Try using three tone magic markers to solve tonal problems.

5. LINES—Lines or "No Lines" could be conceived as loose fits and tight fits.

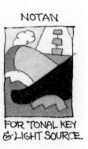
NOTAN
FOR TONAL KEY & LIGHT SOURCE.

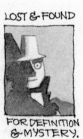
LOST & FOUND
FOR DEFINITION & MYSTERY.

VIGNETTE
FOR VARIETY

WORKING NOTES FOR CARTOONS, ILLUSTRATIONS AND ANIMATION

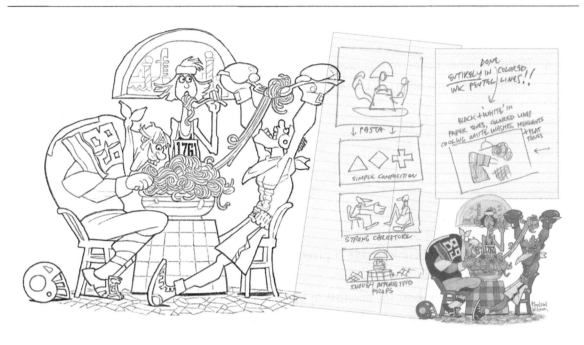

Article about athletes loading up on carbohydrates. Please see Gallery Chapter 11, page 287.

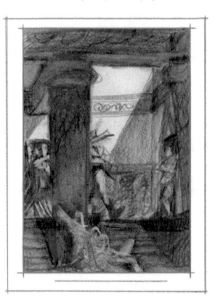
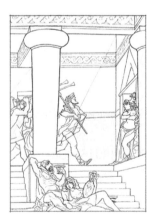

Value study, color sketch and drawing for a cartoon

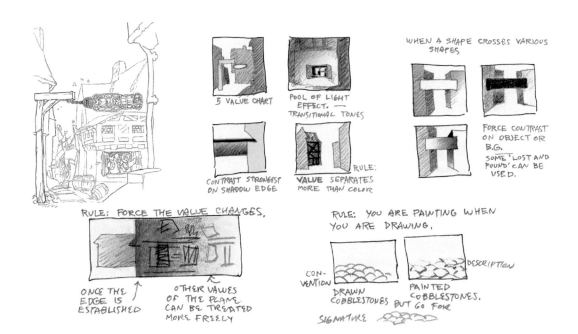

Ideas and rules for cartoons

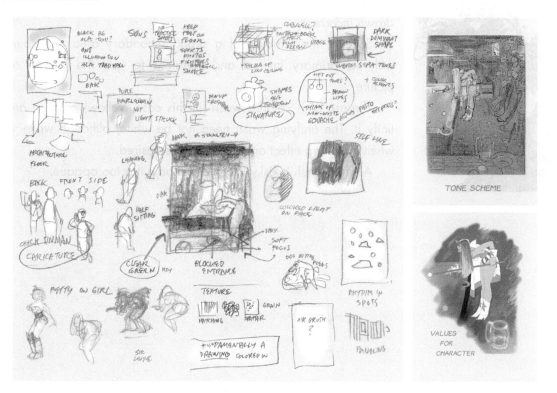

Development sketches for setting, characters, color and values

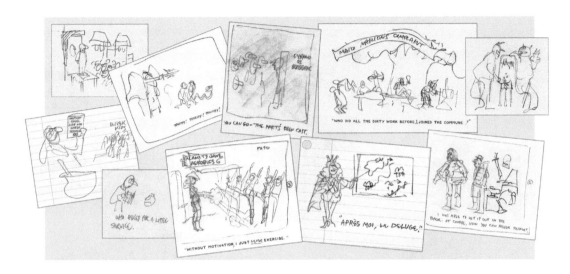

Cartoon concepts begin with thumbnail sketches.

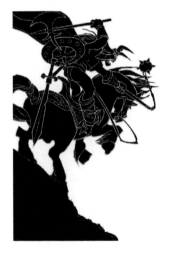

Again, the discovery that a picture you can't paint is one that is drawn incorrectly.

Second, the difficulty of a strong secondary area that competes with the primary interest and threatens to split the interest of the picture.

The use of a colored wash (in this case, yellow) over an area to unify it. The unifying wash need not be white, although white works when a cooling effect or chalky effect is desired.

A white wash is risky in reproduction if it is too opaque.

LARGE FLAT AREA WITH
SOFT EDGE BORDERS

Problem: a large light blue area in the sky had to be absolutely flat to contrast with the central figure's texture. Also it had to blend off at top and bottom. The area was too big for chalks—the chalk color was too limited and wouldn't cover. Solution: Gouache spritzed on with a toothbrush, with frisket mask on characters, etc.

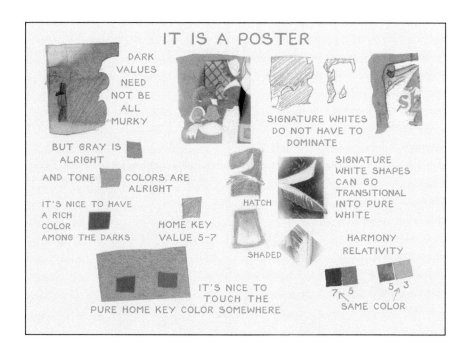

Notes From Farm and Woods Background for Animation

1. Aquapasto well mixed with loose dark tone:
 Makes light easier to lift out.
 Avoids the coolness of white underpainting.
 Extra darks can still be added.
2. Combination of Rendering and Poster Treatment: Poster treatment in far objects mostly.
 Rendering in near objects. <u>But not necessarily</u>.
3. Colors in Neutral Area (night scene) mixed from the primaries: Neutrals mixed out of
 primaries (Prussian Blue, Purple Lake and Cadmium Yellow Deep) are mixed to the
 appropriate amounts of warm or cool or yellowish or whatever, regardless of resulting hue.
 Greenness, redness, blueness become irrelevant. Local color is irrelevant.
 Pure blues in night scene glow because they are contrasted with neutrals.
 The contrasting warm dark is a mixture of Blue and Vermilion, with Vermilion dominant.

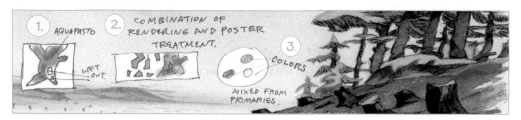

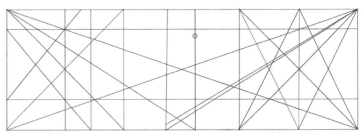

© Disney

COMPOSITIONAL GRID--Grid lines aid in postioning picture elements for the most dynamic arrangement. The dot marks the focal point of the ring on horse's bridle.

ELLIPSE GUIDES--
Used for tambourines,
earrings and bangles.

PENCIL STUDIES OF
DANCERS

COLOR SCHEME--
A limited palette is created
by selecting a range
on the color
wheel

© Disney

CONCEPT ART FOR
WALT DISNEY'S
THE HUNCHBACK OF
NOTRE DAME

A panoramic scene invokes the
chaotic merriment of a street
fair in medieval Paris.

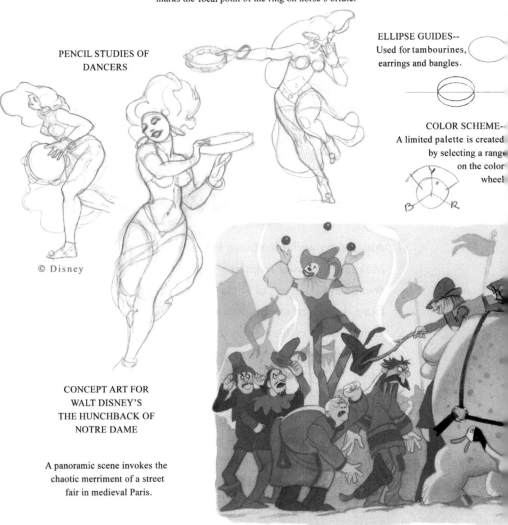

CONCEPT ART FOR WALT DISNEY'S "THE HUNCHBACK OF NOTRE DAME"
© Disney

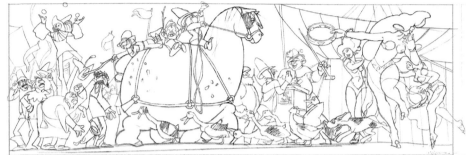

PRELIMINARY LINE DRAWING--The entire scene is sketched in.

© Disney

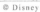

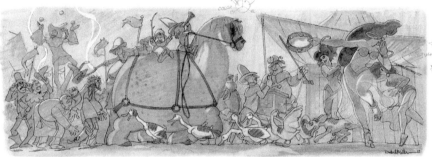

© Disney

VALUE STUDY--Gray tones and black and white accents define a value pattern. The direction of light for each area is indicated, emphasizing a difference betweeen the outdoors and the inside of the tent.

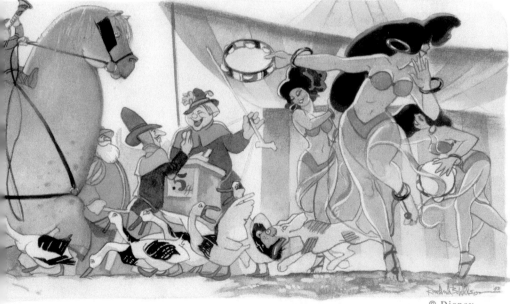

© Disney

CONCEPT ART FOR WALT DISNEY'S "THE HUNCHBACK OF NOTRE DAME"

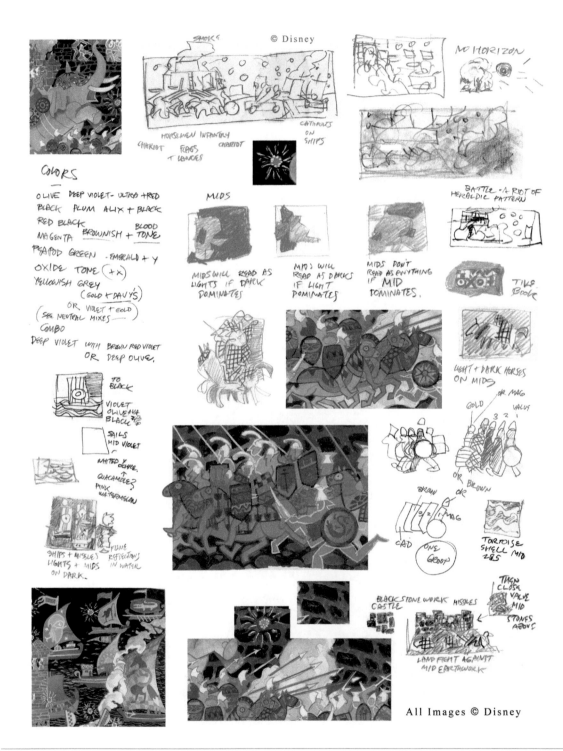

© Disney

All Images © Disney

WALT DISNEY'S ATLANTIS—DEVELOPMENT NOTES FOR BATTLE OF ATLANTIS 1

(clearing)

© Disney

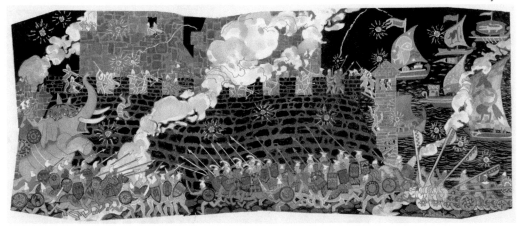

CONCEPT ART FOR WALT DISNEY'S ATLANTIS --A mural visually describes the pageantry of the battle of Atlantis.

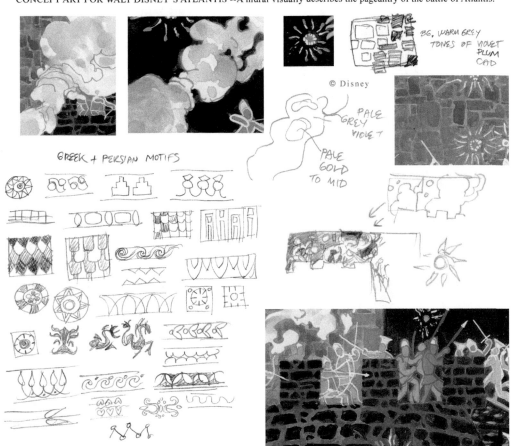

BG, WARM GREY
TONES OF VIOLET
PLUM
CAD

© Disney

PALE
GREY
VIOLET

PALE
GOLD
TO MID

GREEK + PERSIAN MOTIFS

WALT DISNEY'S ATLANTIS—DEVELOPMENT NOTES FOR BATTLE OF ATLANTIS 2
© Disney

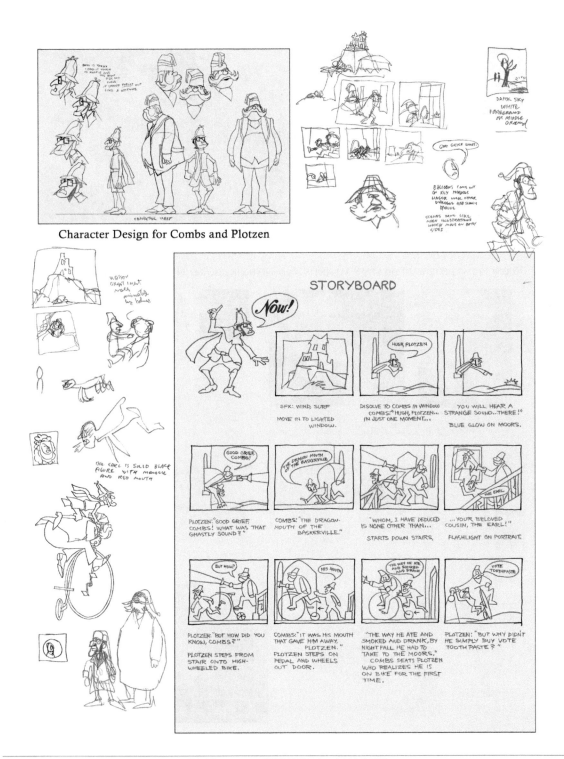

Character Design for Combs and Plotzen

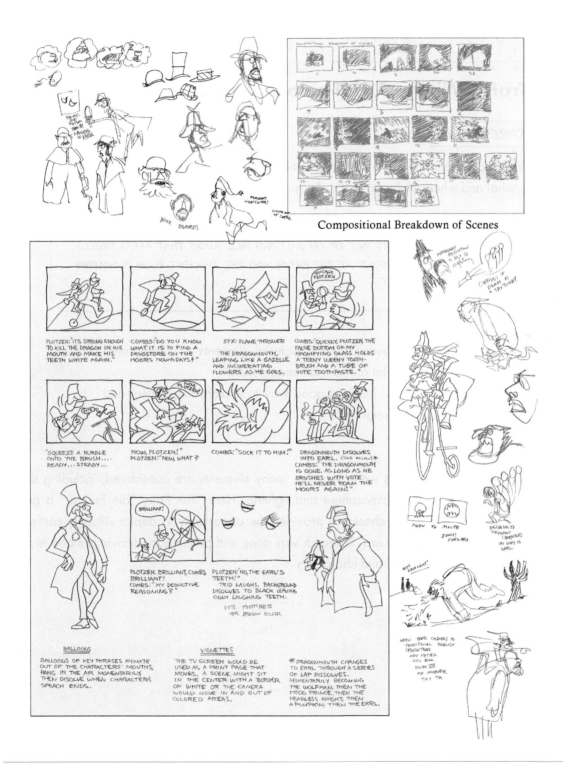

Compositional Breakdown of Scenes

PLOTZEN: "IT'S STRONG ENOUGH TO KILL THE DRAGON IN HIS MOUTH AND MAKE HIS TEETH WHITE AGAIN."

COMBS: DO YOU KNOW WHAT IT IS TO FIND A DRUGSTORE ON THE MOORS NOWADAYS?"

SFX: FLAME THROWER

THE DRAGONMOUTH, LEAPING LIKE A GAZELLE AND INCINERATING FLOWERS AS HE GOES.

COMBS: "QUICKLY, PLOTZEN. THE FALSE BOTTOM OF MY MAGNIFYING GLASS HOLDS A TEENY WEENY TOOTH-BRUSH AND A TUBE OF VOTE TOOTHPASTE."

"SQUEEZE A NURDLE ONTO THE BRUSH.... READY...STEADY...

NOW, PLOTZEN!" PLOTZEN:"NOW, WHAT?

COMBS: "SOCK IT TO HIM!"

DRAGONMOUTH DISSOLVES INTO EARL. (SEE BELOW)* COMBS:" THE DRAGONMOUTH IS GONE. AS LONG AS HE BRUSHES WITH VOTE HE'LL NEVER ROAM THE MOORS AGAIN!"

PLOTZEN: BRILLIANT, COMBS BRILLIANT! COMBS:" MY DEDUCTIVE REASONING?"

PLOTZEN: "NO, THE EARL'S TEETH!" TRIO LAUGHS, BACKGROUND DISSOLVES TO BLACK LEAVING ONLY LAUGHING TEETH.

VOTE TOOTHPASTE THE DRAGON KILLER

BALLOONS

BALLOONS OF KEY PHRASES ANIMATE OUT OF THE CHARACTERS' MOUTHS, HANG IN THE AIR MOMENTARILY THEN DISSOLVE WHEN CHARACTERS SPEACH ENDS.

VIGNETTES

THE TV SCREEN WOULD BE USED AS A PRINT PAGE THAT MOVES. A SCENE MIGHT SIT IN THE CENTER WITH A BORDER OF WHITE OR THE CAMERA WOULD MOVE IN AND OUT OF COLORED AREAS.

*DRAGONMOUTH CHANGES TO EARL THROUGH A SERIES OF LAP DISSOLVES. MOMENTARILY BECOMING THE WOLFMAN, THEN THE FROG PRINCE, THEN THE HEADLESS KNIGHT, THEN A PUMPKIN, THEN THE EARL.

DEVELOPMENT ART FOR AN ANIMATED COMMERCIAL—PHIL KIMMELMAN AND ASSOCIATES

STEP BY STEP THROUGH THE FLOWCHART SYSTEM

The Traffic Witch—A Full-color Cartoon

INTERPRETATION | **THE ACT**

In the case of a cartoon the entire act is contained in the caption. This is the "script" and contains the who, what and where of the story. It's almost like a one-act play.

> "THERE'S A TWO-CART PILE-UP ON GALLOWS HILL. AVOID THAT AREA! TROLLS ARE CAUSING A SLOWDOWN AT THE BRIDGE AND THE TWILIGHT RUSH IS SHAPING UP ABOUT AS USUAL!"

Much of the information needed for the pictorial elements is incorporated into the gag line. There is still a lot of room for imagination.

Making small thumbnail sketches is a good way to explore the content and experiment with a unique interpretation.

THE SCENE

In this step, the stage is set. As we have seen, many elements are considered, including the setting, viewpoint, time, season, atmosphere and lighting. Here "The Fairy Tale Period," a generic storybook "timeless" time, was chosen. It provided the opportunity to depict villages, castles and townspeople from an imaginary era. Research was done and preliminary drawings made to create the scenery, architecture, props, and characters.

CARICATURE

All witches are not created equal. Characters can have variety. It's possible to create a "repertory company" of stock characters and choose the type that fits the current situation.

COMPOSITION | VALUES

A value study is done even before color is decided in order to place the emphasis where you want it in the picture. This is important to draw the eye to your subject, to "pay off" the gag line in a cartoon or to add punch to a storyboard. It doesn't have to be "realistic"—in fact, reserving black and white to highlight your center of interest can be useful.

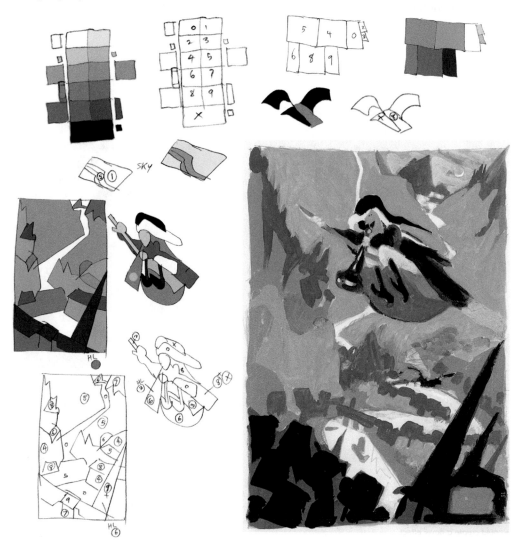

REVERSE NEGATIVES

The river and the witch's hair are designed to be white so that dynamic shapes are formed where foreground objects intersect.

⟦ *COMPOSITION* ⟧ PRELIMINARY COLOR STUDIES

COLOR SKETCHES help to avoid clichés by previewing different color schemes. Instead of the usual dark night and orange moon, other colors can suggest a different time of day when the interesting landscape details are visible. Hints about the color can be derived from the gag line.

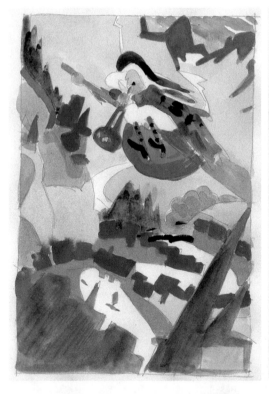 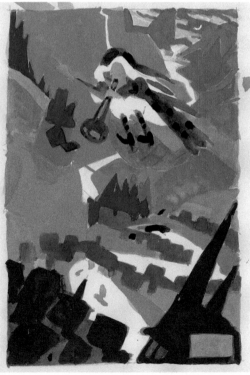

The cartoon plays on the idea of reporters who broadcast traffic conditions from a helicopter. Since they are active during commuting times, such as early evening, a sunset view with a bright sky and deep shadows could create a novel effect.

Muted colors based on a tertiary color scheme set the mood for "the twilight rush is shaping up about as usual". Intermixing colors creates a soft harmonious atmosphere.

RENDITION

Finally a drawing containing everything is made as a basis for the finished painting. It is done with pencil on tracing paper in order to be visible when placed on a light box to be transferred to watercolor paper.

When redrawing the final image, the key is to instill "signature," your individual style, rather than simply tracing. Everything is solved so now it can be drawn with a confidence, verve and energy that will reflect through to the final piece.

Even after the watercolor is added, the pencil drawing remains a visual element in the finished art and should be approached as such. For example "self-line," using a color pencil outline similar to the final color, creates a different effect than a black or graphite outline. It serves to unify the object within its own local color range.

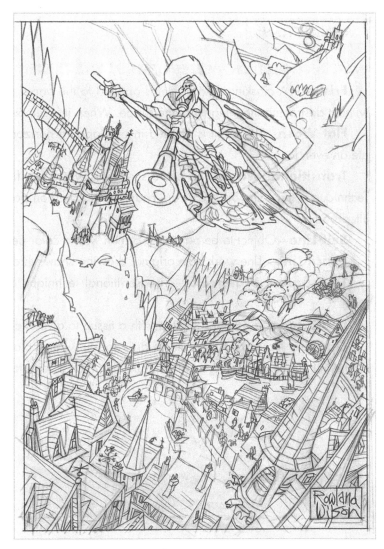

Final Pencil Rendering on Tracing Paper

Example of "self line" drawn onto watercolor paper. Transparent watercolor washes are then painted directly over the line work.

RENDITION

WATERCOLOR TECHNIQUES USED IN *THE TRAFFIC WITCH*

Frisket—A masking fluid or film is applied to the paper so that a wash can be painted over it without destroying the integrity of the shape. When it is removed the watercolor paper shows.

Flat Wash—The paint is applied in overlapping horizontal strokes from the top down to create an even tone.

Transitional Wash—The entire surface is wet down first and sufficient paint colors mixed. Technique is the same but colors are changed at transition point. It helps to work very quickly on a tilted board.

Self-Line—Object to be painted is drawn with a color pencil similar to local color.

Pencil Line—Line work from original drawing shows through to describe details.

Transparent Watercolor—The traditional technique of glazing with individual washes of color.

Lift Technique—Paint is blotted with a tissue to give effect of foliage or variation in texture.

Opaque Accent—After paint is dry, opaque watercolor (gouache) can be used to highlight light-struck areas. A small amount of pigment can be added to suggest warm or cool light.

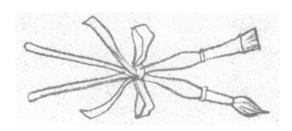

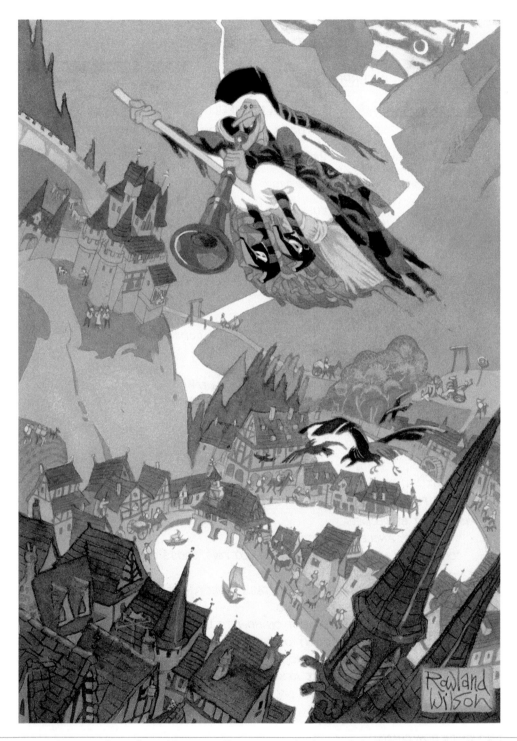

"There's a two-cart pile-up on Gallows Hill, avoid that area! Trolls are causing a slowdown on the bridge and the Twilight Rush is shaping up about as usual!"

GOING THROUGH THE FLOW CHARTS
APPLYING IT TO THE CARTOON OR GRAPHIC NOVEL

PAGE ONE	INTERPRETATION

VISUAL GOALS TO ACHIEVE IN THE GRAPHIC NOVEL		
1. EXCELLENCE IN PICTORIALS	MISE EN SCÈNE	SETS
2. SOLID CARICATURE IN CHARACTERS	STARS	CHARACTER DESIGN
3. INTERESTING GRAPHICS	ENTER-TAIN-MENT	SPLASH PAGES & SONGS
4. COMEDY POSING / STRONG DRAMA / IMAGERY	ACTION !	POSES DRAMATIZATION
5. OVERALL PAGE DESIGN		DESIGN & WHITE SPACE
6. CINEMATIC CONTINUITY		PAGE LAYOUT
7. STORYBOARD LOOK		UNIQUE STYLE (COLOR HATCH)

DETERMINED IN ADVANCE

- THE ACT
- THE SETTING
- SOME SET DRESSING
- TIME, SEASON, ATMOSPHERE
- WEATHER, LIGHT
- PLAYERS
- COSTUMES
- CARICATURE

TO BE DETERMINED

- ADDITIONAL SET DRESSING
- VIEWPOINT(S)
- SOME PROPS
- BUSINESS - GESTURE

PAGE TWO	COMPOSITION

FOR COMEDY AND IN GENERAL

COMPOSING WITH CHARACTERS

FIGURES COMFORTABLE IN THE PANEL

BECOMES A PART OF CONTINUITY

- OVERLAP
- FOCUS
- PERSPECTIVE
- SILHOUETTE
- RHYTHM
- DOMINANCE

COMPOSE AS SPREAD

CONSIDER HOW 2 PAGES LOOK NEXT TO EACH OTHER

PAGE THREE	RENDITION

DETERMINED AFTER RESOLVING ABOVE AREAS. MEDIA EXPRESSES THE SUBJECT.

CONCLUSION:

ACTION, CHARACTERS AND SETTINGS ARE ALL PREDETERMINED

WHAT MUST BE DECIDED:

- VIEWPOINT: ANGLE AND DISTANCE.
- CONTINUITY: HOLDING CAMERA, JUMP CUTTING, CROSS CUTTING, TRACKING, SUBJECTIVE CUTTING.
- FOCAL POINT: ON WHAT? SCENE, DETAIL, OBJECT, ACTION, CHARACTER, CHARACTERS BY IMPORTANCE.
- EMOTIONAL EFFECT: JUDGEMENT ON HOW TO UNDERSCORE THE IMPORTANT STORY POINTS, THE POINT OF DECISION AND ACTION, THE TURNING POINTS.
- FRAME STYLING: FULL BACKGROUND/NO BACKGROUND, VIGNETTE, SILHOUETTE, INDICATED BACKGROUND, ATMOSPHERE SHOT, STYLIZED SHOT.
- PAGE STYLING: FOCUSING AND BALANCING THE WHOLE. DESIGNING THE SPREAD ACROSS DOUBLE PAGES.

OPUS CHECKLIST

☐ 1. Does the composition have open space; white space?

☐ 2. Does the composition have a clearly dominant area?

☐ 3. Does the tone scheme contain both black and white?

☐ 4. Does the composition have rhythm?

☐ 5. Does the subjective-distortion have an organic as well as a geometric form?

☐ 6. Does the lighting define an atmosphere?

☐ 7. Are the proportions right?

☐ 8. Does the composition have a clear movement?

☐ 9. Does the drawing have consistent resolution?

☐ 10. Does the composition have an ambiguous area? Subject to the dialogue of interpretation? Enough "lost" in the lost and found?

☐ 11. Does the composition have principality? One object, one quality, one light dominating?

☐ 12. Is there contrast of hard and soft?

☐ 13. Have you left out as much as possible?

☐ 14. Is the picture seen from the standpoint of a witness? Is it "what the witness saw"?

☐ 15. Are there obscured details? Does it avoid the "arranged" look?

☐ 16. Is the lighting as stylized as the drawing? Is the rendering stylized, not realistic?

☐ 17. Is everything caricatured: anatomy, proportions, surroundings, expression, and treatment?

☐ 18. Is the color subjective?

☐ 19. Are the negatives reversed? Is the pictorial space composed of flat layers of shapes?

☐ 20. Are the edges working?

☐ 21. Are the composition's tones grouped/bunched together?

☐ 22. Do the silhouette groups contain several various shapes?

☐ 23. Is at least one tone value skipped as a separator?

☐ 24. Is the texture adequate (such as scratchy contrasted with smooth)?

☐ 25. Is the texture in the right place tonally?

☐ 26. Does it express its media?

☐ 27. Does it refer to non-visual realities? (Wind. Smell. Sound. Taste. Feelings.)

☐ 28. Does it contain a system within a system?

☐ 29. At the finish, are all the tones properly adjusted?

☐ 30. Does the subjective distortion have "Art Brut" as well as "Art Élégant"?

☐ 31. Does the focal point of contrast have a feeling of crescendo? (Dark, darker, darkest. Light, lighter, lightest.)

☐ 32. Does it demonstrate Artistic Self-Determination? It must be allowed that each work can break the rules to its own purpose.

9

STUDIO POSTERS AND CHARTS

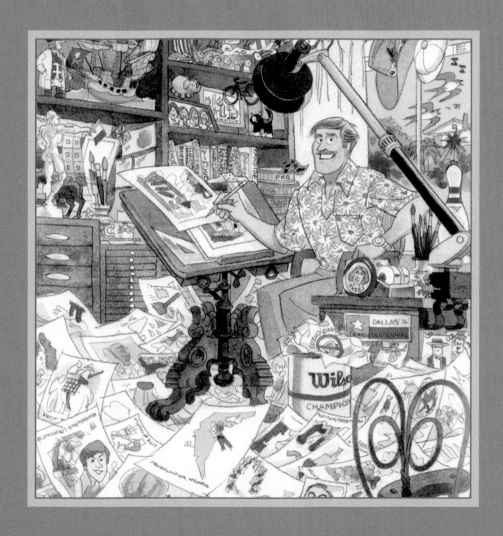

ELEMENTS OF NOTAN/GESTALT 1

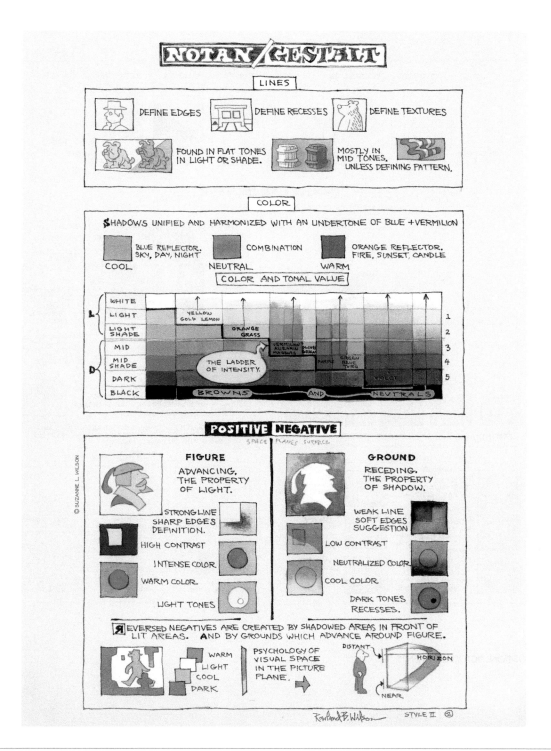

ELEMENTS OF NOTAN/GESTALT 2

COMPOSITION

LINE	OVERLAP	BROKEN PERSPECTIVE	ANGLE	COLOR	NOTAN	LOST & FOUND	VIGNETTE
TO DIRECT THE EYE.	TO CREATE PLANES.	TO CREATE LEVELS.	FOR VIEWPOINT.	FOR FOCUS.	FOR TONAL KEY & LIGHT SOURCE.	FOR DEFINITION & MYSTERY.	FOR VARIETY.

Describe a little, **imply** a lot.

LIGHT PERSPECTIVE

90°

HIGHLIGHT LIGHT HALF TONE (RAKING LIGHT) SHADOW REFLECTED LIGHT

TONAL KEY

FRAME — DIMINISHED COLOR TEXTURE DETAIL.

BACKDROP — DIMINISHED COLOR TEXTURE DETAIL.

FOCAL AREA — FULL COLOR TEXTURE DETAIL.

DEFINITION IN FRAME AND BACKDROP DO NOT DEPEND ON LINE BUT IS SEEN BY CONTRAST: WARM — COOL COMPLEMENTS DARK — LIGHT.

A SINGLE OBJECT CAN EXIST IN FRAME, FOCAL-AREA, BACKDROP.

PLUS GRAY

PLUS GRAY AND/OR WHITE

PLAIN PAPER

LIGHT AND SHADE SHOULD BE DEFINED WITHIN THE ASSIGNED KEY TONE OF FRAME, FOCAL AREA, BACKDROP.

RESOLUTION: CONSISTENCY OF RESOLUTION: ONLY A GIVEN AMOUNT OF DESCRIPTION WITHIN AN AREA TO AVOID 'THE COLLAGE EFFECT.'

TEXTURE

SLICK NORMAL FORMIC SURFACE

FORM TAKES PRECEDENCE OVER TEXTURE AND COLOR.

LINES

PURPOSE:
① TO DEFINE EDGES OF TONE, COLOR OR OF HARD SHADOWS. LINES BREAK UP AROUND CURVES.
② DON'T. LINES DO NOT BELONG IN THE LIGHT IN A REVERSED NEGATIVE OR HIGH CONTRAST STYLE.
③ DO. LINES IN HALF-TONE OR SHADE DEFINE FORM OR SURFACE TEXTURE.

TYPES:
BLACK BRINGS AN OBJECT FORWARD.

GRAY IS SUBORDINATE TO TONE. CREATES LOST & FOUND.

WHITE DEFINES EDGES IN LIT TONES.

© SUZANNE L. WILSON

FORM

| EXPRESSIVE DRAWING OF THE NEGATIVE SPACES. | CONGESTION VS. OPEN SPACES | PINCHED SHAPES VS. FULL. |
| PLANES, VOLUMES, LINES. | ORGANIC AND GEOMETRIC. | HARMONY & RHYTHM THRU REPETITION. |

Tavern

Rowland B. Wilson

COMPOSITION: PICTORIAL ELEMENTS

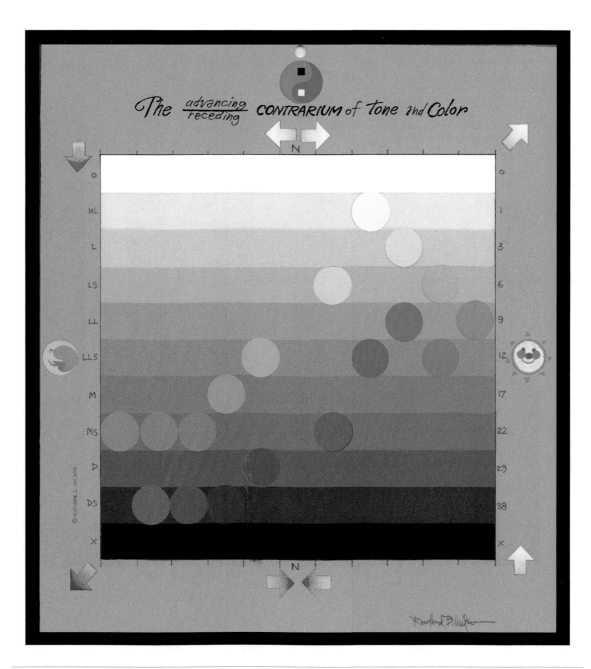

THE ADVANCING/RECEDING CONTRARIUM OF TONE AND COLOR

◇ #1

◇ #2
ADJUSTED

◇ #3

◇ #4

◇ #5

◇ #6

SHADOW CHART 1
1ST INTENSITY
DIFFUSED LIGHT

0	1
1	3
3	6
6	9
9	12
12	17
17	22
22	29
29	38
38	X

SHADOW CHART 2
2ND INTENSITY
HAZY SUNLIGHT

0	6
1	9
3	12
6	
9	17
12	22
17	29
22	38
29	38
38	

SHADOW CHART 3
3RD INTENSITY
FULL SUNLIGHT

	0	6	
1	1	9	LIMIT OF REFLECTED LIGHT
2	3	12	
3	6	17	
4	9	22	
5	12	30	
6	17	38	
7	22	X	
8	30		
9	38		

SHADOW CHART 4
4TH INTENSITY
GLARE

0	9	
1	12	LIMIT OF REFLECT LIGHT
3	17	
6	22	
9	30	
12	38	
17	X	
22		
30		
38		

SHADOW CHART 5
5TH INTENSITY
LIGHT IN DUSK

0	12
1	17
3	22
6	30
9	38
12	X
17	
22	
30	
38	

SHADOW CHART 6
6TH INTENSITY
LIGHT IN DARKNESS

0	17
1	22
3	30
6	38
9	X
12	
17	
22	
30	
38	

SHADOW CHARTS RANGING IN INTENSITY FROM DIFFUSED LIGHT TO LIGHT IN DARKNESS

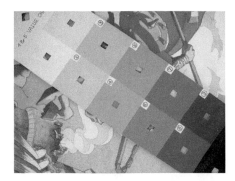

Holes cut in the centers of the squares make it possible to assess the value of a color in the image.

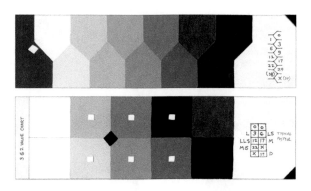

5 & 6 Value Chart and 3 & 2 Value Chart

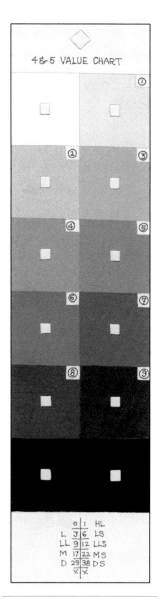

4 & 5 Value Chart

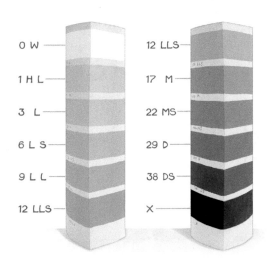

Charts painted on heavy folded paper

Many published value charts group the grays too close together at the beginning and end of the scale. The object is to create a discernible difference between each step. The 4 & 5 Value Chart shows two steps between each grade. These were made with animation cel paint and the numbers indicate their numerical listing.

VALUE CHARTS

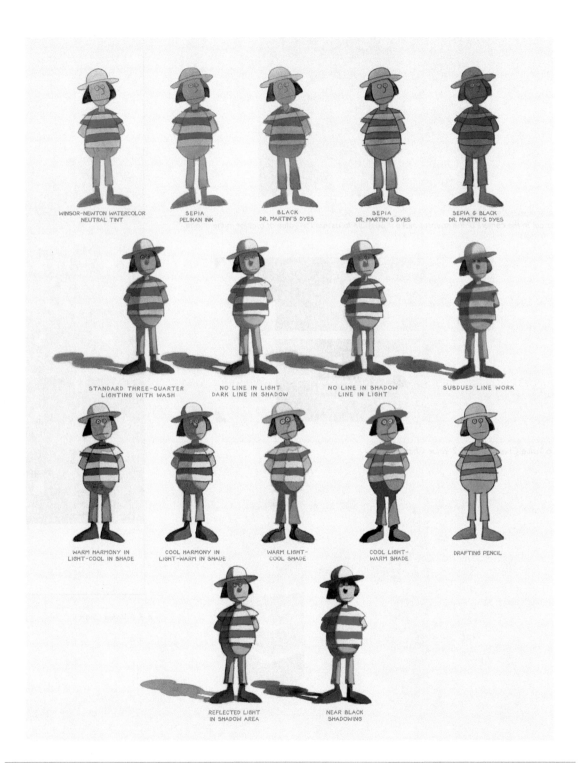

VARIOUS TECHNIQUES AND LIGHTING EFFECTS 1

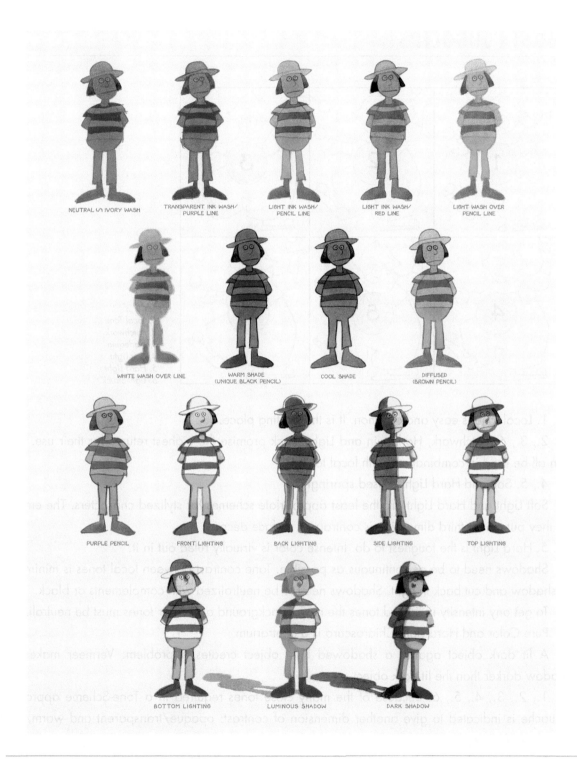

NEUTRAL UN IVORY WASH

TRANSPARENT INK WASH/
PURPLE LINE

LIGHT INK WASH/
PENCIL LINE

LIGHT INK WASH/
RED LINE

LIGHT WASH OVER
PENCIL LINE

WHITE WASH OVER LINE

WARM SHADE
(UNIQUE BLACK PENCIL)

COOL SHADE

DIFFUSED
(BROWN PENCIL)

PURPLE PENCIL

FRONT LIGHTING

BACK LIGHTING

SIDE LIGHTING

TOP LIGHTING

BOTTOM LIGHTING

LUMINOUS SHADOW

DARK SHADOW

VARIOUS TECHNIQUES AND LIGHTING EFFECTS 2

THE SIX JUGGLERS

1. Local Tone
2. Patchwork
3. Harlequin
4. Soft Light
5. Hard Light
6. Light-Struck

1. Local tone is easy and common. It is the starting place.

2., 3., 6. Patchwork, Harlequin and Light-Struck promise the highest returns for their use. They can all be used in combinations with local tone.

4., 5. Soft and Hard Light is used sparingly.

Soft Light and Hard Light are the least appropriate schemes for stylized characters. The emphasis they put on the third dimension is contrary to surface décor.

5. Hard Light is the toughest to do. Intense color is virtually ruled out in it.

Shadows need to be as continuous as possible. Tone contrast between local tones is minimized in shadow and cut back in light. Shadows need to be neutralized with complements or black.

To get any intensity in lighted tones the major background and other tones must be neutralized.

Pure Color and Hard Light Chiaroscuro is a contrarium.

A lit dark object against a shadowed light object creates a problem. Vermeer makes the shadow darker than the lit dark object.

1., 2., 3., 4., 5., 6. Because of the many close tones required in a Tone-Scheme approach, gouache is indicated to give another dimension of contrast: opaque/transparent and warm/cool (plus use of white).

Merging shadow with light tie-ins is 3 (Harlequin) and 6 (Light-Struck) together and pushed into a (compound-form) Compound-Notan Patchwork.

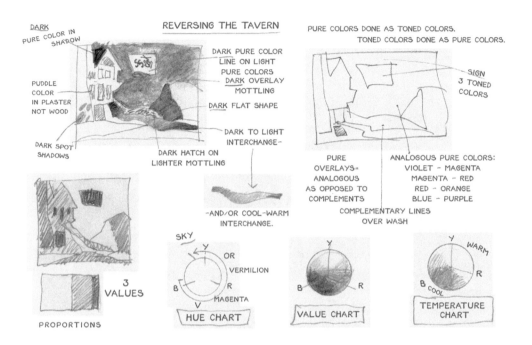

THE TAVERN

The Tavern paintings illustrate a number of techniques such as color hatching, paint texture, opaque accents, mottling, and various watercolor washes. They also demonstrate color ideas and reversed negative shapes.

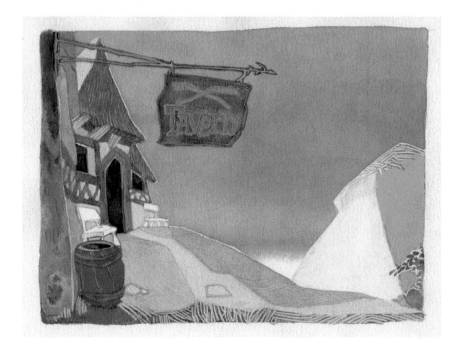

Another interpretation of The Tavern

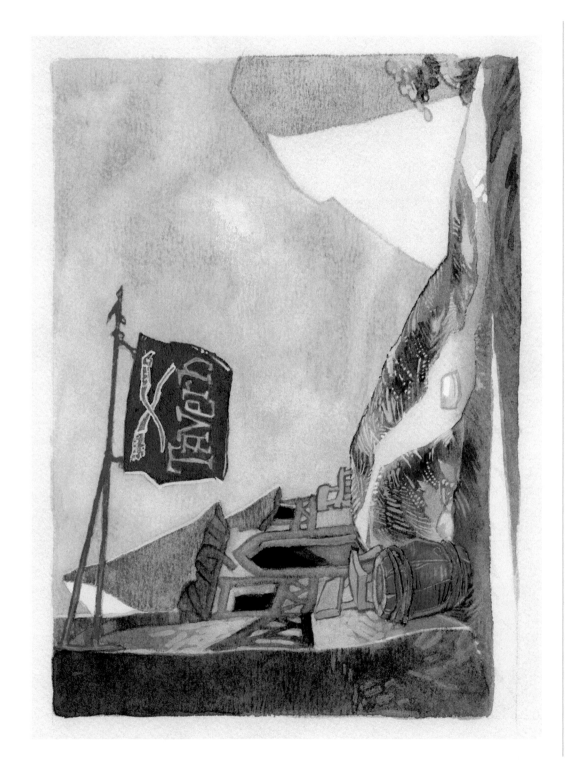

THE TAVERN—A STUDY IN TECHNIQUES, COLOR AND NEGATIVE SHAPES

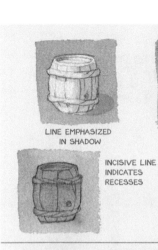

LINE EMPHASIZED
IN SHADOW

LINE IN LIGHT
AREAS ONLY

DARK AND LIGHT ACCENT
IN LIGHT AREAS;
SIMPLE TONES IN SHADOW

EMPHASIS ON CONTOUR
OUTLINE

INCISIVE LINE
INDICATES
RECESSES

LINE TREATMENTS FOR LIGHT AND SHADOW

WHITE LINE
PICKS UP
EDGES

3 VARIATIONS USING ULTRAMARINE & VERMILION MIXTURES

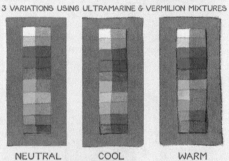

OPAQUE COOL WASH WARM WASH COOL WASH NEUTRAL COOL WARM

TONAL WATERCOLOR WASHES FOR SHADOW AREAS

LIMITED PALETTE COLOR SCHEMES

BURNT SIENNA/ORANGE/BLUE

BLUE/RED/UMBER

UMBER/ORANGE/BLUE

BURNT SIENNA/GREEN/BLUE

UMBER/ORANGE/GREEN

SAMPLES OF LIGHTING AND COLOR

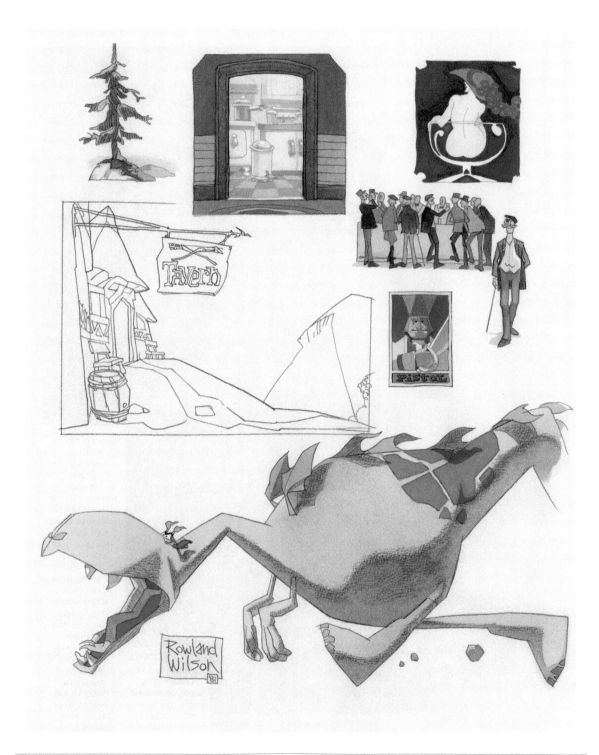

VISUAL REMINDERS OF GESTALT, VALUES, NEGATIVE SHAPES, REVERSE NEGATIVES, COMPLEMENTARY COLORS AND CARICATURE

LIGHT LIGHT SHADE MIDDLE MID SHADE DARK DARK SHADE

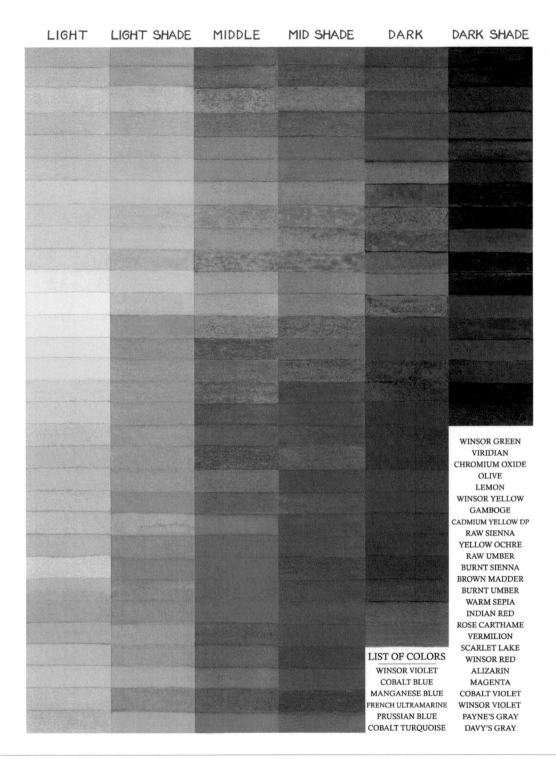

WINSOR GREEN
VIRIDIAN
CHROMIUM OXIDE
OLIVE
LEMON
WINSOR YELLOW
GAMBOGE
CADMIUM YELLOW DP
RAW SIENNA
YELLOW OCHRE
RAW UMBER
BURNT SIENNA
BROWN MADDER
BURNT UMBER
WARM SEPIA
INDIAN RED
ROSE CARTHAME
VERMILION
SCARLET LAKE
LIST OF COLORS **WINSOR RED**
WINSOR VIOLET **ALIZARIN**
COBALT BLUE **MAGENTA**
MANGANESE BLUE **COBALT VIOLET**
FRENCH ULTRAMARINE **WINSOR VIOLET**
PRUSSIAN BLUE **PAYNE'S GRAY**
COBALT TURQUOISE **DAVY'S GRAY**

VALUE CHART OF POPULAR WATERCOLORS

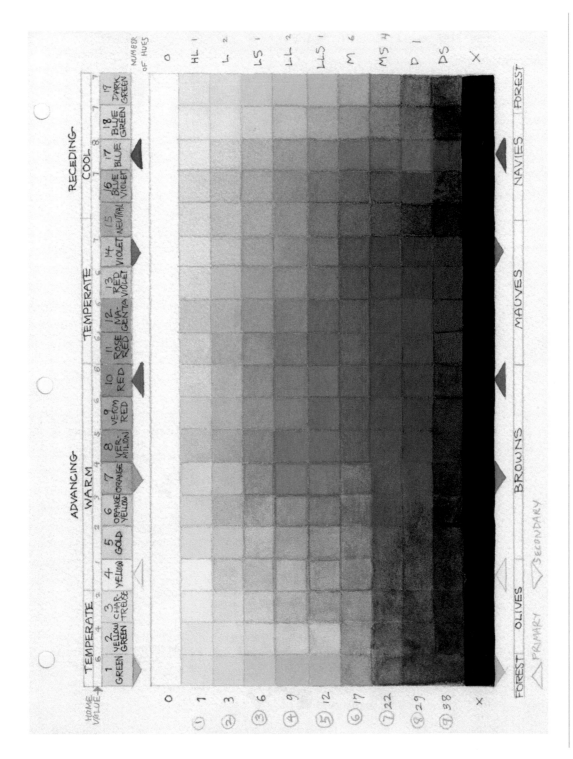

DIAGRAM OF COLOR TEMPERATURE

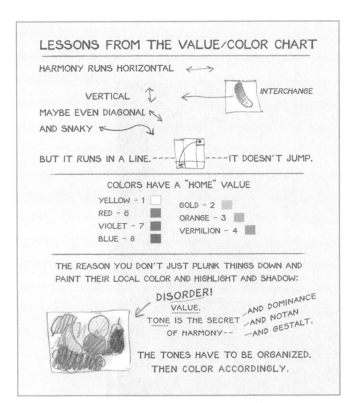

LESSONS FROM THE VALUE/COLOR CHART

HARMONY RUNS HORIZONTAL ⟷

VERTICAL ↕ ← INTERCHANGE

MAYBE EVEN DIAGONAL ↘

AND SNAKY ↶

BUT IT RUNS IN A LINE.------- IT DOESN'T JUMP.

COLORS HAVE A "HOME" VALUE

YELLOW - 1 GOLD - 2
RED - 6 ORANGE - 3
VIOLET - 7 VERMILION - 4
BLUE - 8

THE REASON YOU DON'T JUST PLUNK THINGS DOWN AND
PAINT THEIR LOCAL COLOR AND HIGHLIGHT AND SHADOW:

DISORDER!
VALUE.
TONE IS THE SECRET —AND DOMINANCE
 —AND NOTAN
OF HARMONY-- —AND GESTALT.

THE TONES HAVE TO BE ORGANIZED.
THEN COLOR ACCORDINGLY.

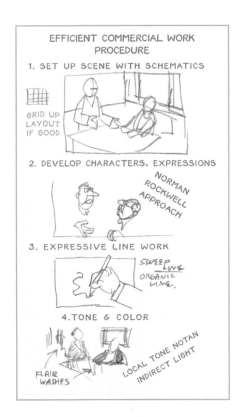

EFFICIENT COMMERCIAL WORK PROCEDURE

1. SET UP SCENE WITH SCHEMATICS

GRID UP LAYOUT IF GOOD

2. DEVELOP CHARACTERS. EXPRESSIONS

NORMAN ROCKWELL APPROACH

3. EXPRESSIVE LINE WORK

SWEEP LINE
ORGANIC LINE.

4. TONE & COLOR

FLAIR WASHES

LOCAL TONE NOTAN
INDIRECT LIGHT

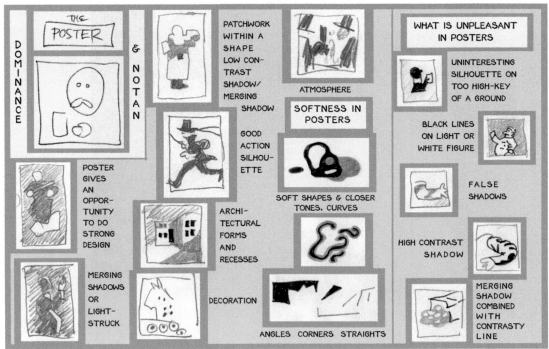

THE POSTER

DOMINANCE & NOTAN

POSTER GIVES AN OPPORTUNITY TO DO STRONG DESIGN

MERGING SHADOWS OR LIGHT-STRUCK

PATCHWORK WITHIN A SHAPE LOW CONTRAST SHADOW/ MERGING SHADOW

GOOD ACTION SILHOUETTE

ARCHITECTURAL FORMS AND RECESSES

DECORATION

ATMOSPHERE

SOFTNESS IN POSTERS

SOFT SHAPES & CLOSER TONES. CURVES

ANGLES CORNERS STRAIGHTS

WHAT IS UNPLEASANT IN POSTERS

UNINTERESTING SILHOUETTE ON TOO HIGH-KEY OF A GROUND

BLACK LINES ON LIGHT OR WHITE FIGURE

FALSE SHADOWS

HIGH CONTRAST SHADOW

MERGING SHADOW COMBINED WITH CONTRASTY LINE

ABOUT POSTERS

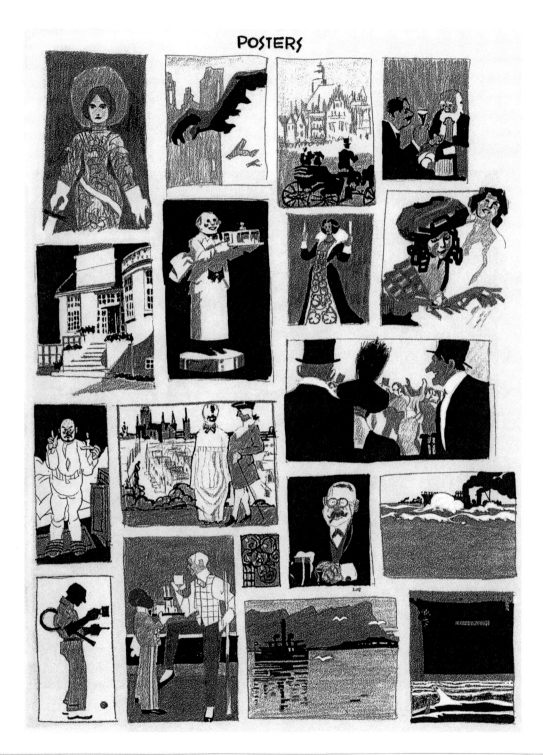

STUDIES FROM POSTERS DEMONSTRATING STRONG VALUE PATTERNS

SIMPLIFY. POSTERIZE STYLIZE

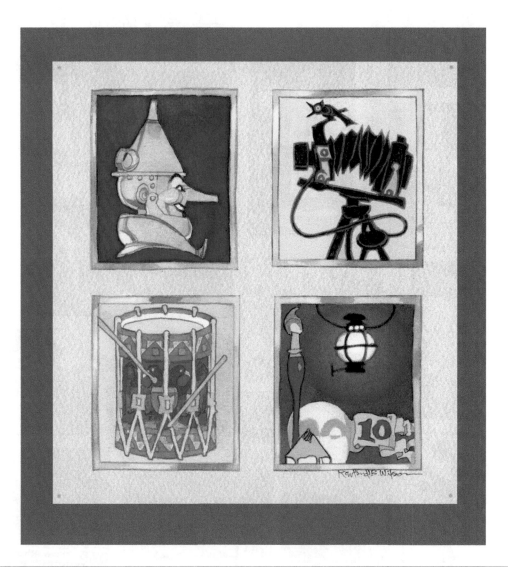

LOGO DESIGNS FROM THE FLOW CHARTS

10

MISCELLANEOUS NOTES

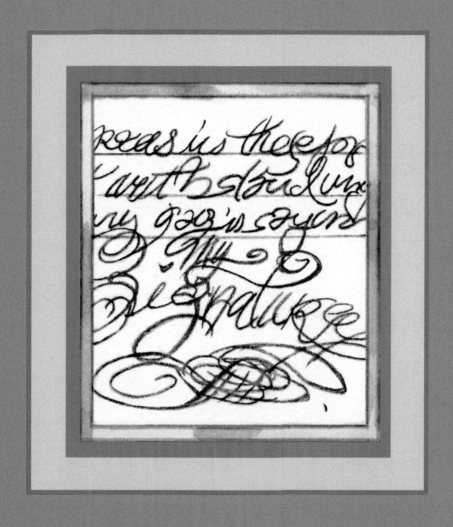

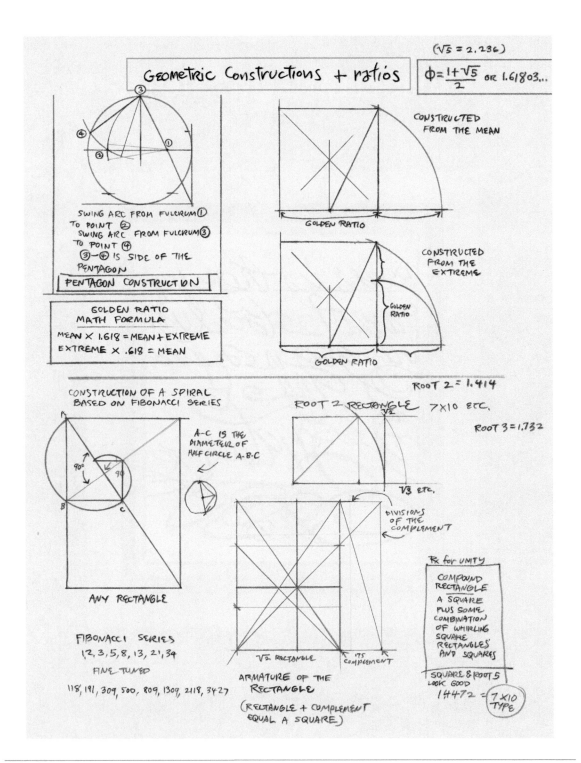

Geometric Constructions + ratios

$(\sqrt{5} = 2.236)$

$\Phi = \dfrac{1+\sqrt{5}}{2}$ or $1.61803...$

SWING ARC FROM FULCRUM ①
TO POINT ②
SWING ARC FROM FULCRUM ③
TO POINT ④
③—④ IS SIDE OF THE
PENTAGON

PENTAGON CONSTRUCTION

GOLDEN RATIO
MATH FORMULA
MEAN × 1.618 = MEAN + EXTREME
EXTREME × .618 = MEAN

CONSTRUCTED FROM THE MEAN

GOLDEN RATIO

CONSTRUCTED FROM THE EXTREME

GOLDEN RATIO

GOLDEN RATIO

CONSTRUCTION OF A SPIRAL
BASED ON FIBONACCI SERIES

A–C IS THE DIAMETER OF
HALF CIRCLE A-B-C

$90°$ $90°$

B C

ANY RECTANGLE

FIBONACCI SERIES
1,2,3,5,8,13,21,34
FINE TUNED
118, 191, 309, 500, 809, 1309, 2118, 3427

ROOT 2 = 1.414

ROOT 2 RECTANGLE 7X10 ETC.
√2

ROOT 3 = 1.732

√3 ETC.

DIVISIONS
OF THE
COMPLEMENT

√2 RECTANGLE ITS COMPLEMENT

ARMATURE OF THE RECTANGLE
(RECTANGLE + COMPLEMENT
EQUAL A SQUARE)

Rx for UNITY

COMPOUND
RECTANGLE
A SQUARE
PLUS SOME
COMBINATION
OF WHIRLING
SQUARE
RECTANGLES'
AND SQUARES

SQUARE & ROOT 5
LOOK GOOD
1.4472 = 7X10 TYPE

GEOMETRIC CONSTRUCTIONS AND RATIOS 1

Geometric Constructions + ratios ②

TO FIND A PROPORTIONATE AREA –

3

| A |

2

| B |

EXAMPLE: B TO HAVE 3 TIMES THE AREA OF A.

SQUARE ONE SIDE, MULTIPLY BY PROPORTION, DIVIDE BY SQUARE ROOT–

2 X 2 = 4 X 3 = 12 $\sqrt{}$ = 3.46

$\sqrt{5}$ 2.236

ϕ = PHI = 1.618

ϕ = GOLDEN SECTION

ϕ 1.618

$\sqrt{5}$ MEANS A SQUARE CONSTRUCTED ON THE LONG SIDE OF
THE RECTANGLE IS EQUAL IN AREA TO 5 SQUARES
CONSTRUCTED ON THE SHORT SIDE OF THE RECTANGLE.

1

5

CIRCUMFERENCE OF
A CIRCLE:

C = π ɸ π = 3.14

D

① DRAW THE PICTURE FRAME WITH THE MAIN FREEHAND PERSPECTIVE ANGLES.

→ TO VP. 2

TO VP. 1

DERIVING 3 POINT PERSPECTIVE FROM A FREEHAND DRAWING.

(EXAMPLE A)

③ FIND A RIGHT ANGLE (90°) BETWEEN THE THREE VANISHING POINTS, SHORTEN OR LENGTHEN THE VANISHING POINTS IF NECESSARY, TWIST THE PICTURE FRAME ACCORDINGLY.

VP.-1

90°

VP. 2

↓ TO VP. 3

② EXTEND THE MAIN PERSPECTIVE ANGLES TOWARD THEIR VANISHING POINTS.

VP.-1 VP. 2
45° 45°
90°
GROUND

TO ESTABLISH A GRID

④ LOCATE A 45° DEGREE TRIANGLE BETWEEN THE HORIZON VANISHING POINTS. ITS APEX (90°) ESTABLISHES THE GROUNDLINE. THE PICTURE FRAME MUST BE ABOVE THE GROUND LINE TO AVOID PERSPECTIVE ERROR. PERSPECTIVE ERROR IS ANY HORIZONTAL ANGLE 90° OR LESS

90° LESS LESS

VP. 3

DERIVING 3-POINT PERSPECTIVE FROM A FREEHAND DRAWING

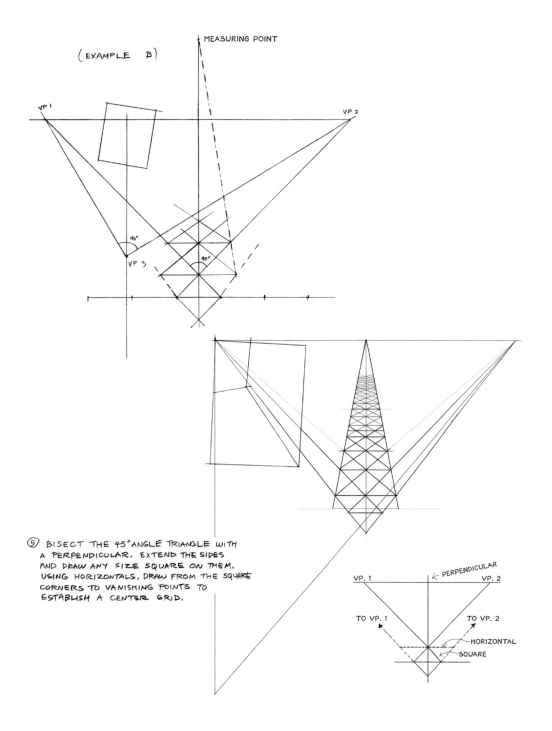

(EXAMPLE B)

MEASURING POINT

VP 1

VP 2

90°

VP 3

90°

⑤ BISECT THE 45° ANGLE TRIANGLE WITH
A PERPENDICULAR. EXTEND THE SIDES
AND DRAW ANY SIZE SQUARE ON THEM.
USING HORIZONTALS, DRAW FROM THE SQUARE
CORNERS TO VANISHING POINTS TO
ESTABLISH A CENTER GRID.

VP. 1 PERPENDICULAR VP. 2

TO VP. 1 TO VP. 2

HORIZONTAL

SQUARE

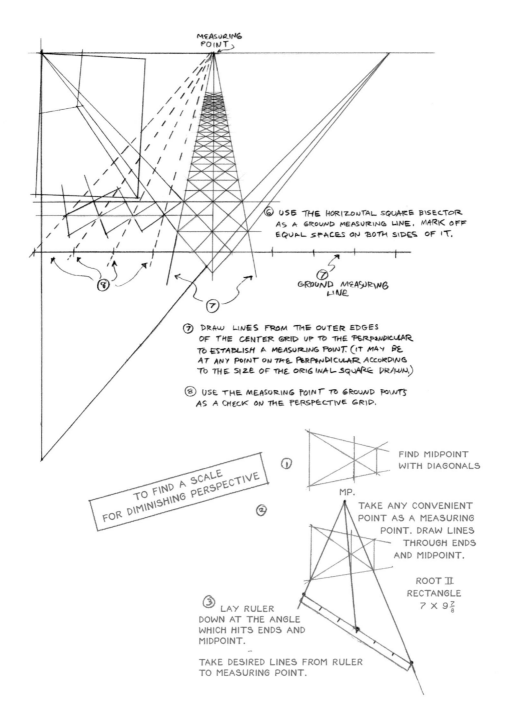

MEASURING
POINT

⑥ USE THE HORIZONTAL SQUARE BISECTOR
AS A GROUND MEASURING LINE. MARK OFF
EQUAL SPACES ON BOTH SIDES OF IT.

⑧

⑦ GROUND MEASURING
LINE

⑦ DRAW LINES FROM THE OUTER EDGES
OF THE CENTER GRID UP TO THE PERPENDICULAR
TO ESTABLISH A MEASURING POINT. (IT MAY BE
AT ANY POINT ON THE PERPENDICULAR ACCORDING
TO THE SIZE OF THE ORIGINAL SQUARE DRAWN.)

⑧ USE THE MEASURING POINT TO GROUND POINTS
AS A CHECK ON THE PERSPECTIVE GRID.

TO FIND A SCALE
FOR DIMINISHING PERSPECTIVE

① FIND MIDPOINT
WITH DIAGONALS

②

MP.

TAKE ANY CONVENIENT
POINT AS A MEASURING
POINT. DRAW LINES
THROUGH ENDS
AND MIDPOINT.

ROOT II
RECTANGLE
$7 \times 9\frac{7}{8}$

③ LAY RULER
DOWN AT THE ANGLE
WHICH HITS ENDS AND
MIDPOINT.

TAKE DESIRED LINES FROM RULER
TO MEASURING POINT.

FORM FOLLOWING GESTURE IN ANIMATION

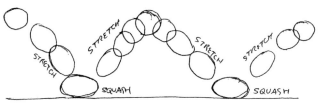

THE BOUNCING BALL SQUASH AND STRETCH

Some animators wish to avoid the cliché of the bouncing ball squash and stretch. In doing so, they either minimize or eliminate altogether the distortion of the parts of the animating figure. This not only robs the figure of its vitality but much of its humor as well. For caricature in animation must be not only caricature of the *form* in a model chart but caricature of the *gesture* as well.

The way to achieve a more sophisticated and interesting animation style is *not* to eliminate the "bouncing ball squash and stretch" but to enlarge on it.

This can be done by adding other forms and substances to the animator's repertoire—forms with their own laws of expansion and contraction.

Besides rubber balls, there are cloth, leather, earth, leaves, coil springs, saplings, dough, jelly, meltables and liquids such as water, molasses, and grease.

The comic power of suggestion in the action of objects was well exploited by the early animators. The malleability of organic matter can still be exploited in new ways. It only needs an animator of wit to discover them.

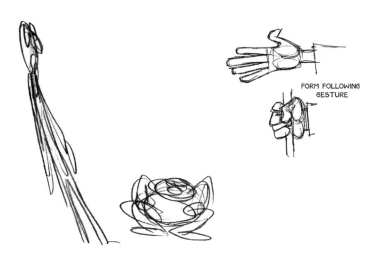

FORM FOLLOWING
GESTURE

ANIMATION NOTES, LONDON

These are pages from a sketchbook produced in 1973 and 1974 while working at Richard Williams Studio in London. The material is based on lectures and conversations with the legendary animators Richard Williams, Art Babbitt and Grim Natwick.

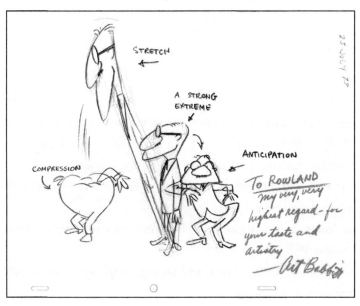

Drawing by Art Babbitt (Collection: Suzanne Wilson)

Rowland and Suzanne Wilson caricatured by Richard Williams

Sketch of Art Babbitt lecturing at the Richard Williams Studio

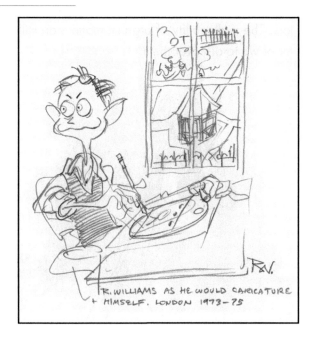

GRIM NATWICK AT RICHARD WILLIAMS STUDIO, LONDON

Grim Natwick was considered one of the world's greatest animators. He gave a series of talks to animators and was also available for informal conversation during this period (1973–74). We shared the same block of flats and I talked to him often at the studio and after hours. The following is a summation of these talks rearranged according to subject matter.

GRIM AND THE TRACK—At the time Grim was here I was working on Count Pushkin Vodka (The Trans-Siberian Express animated commercial) and searching for a way to visualize dramatically a musical track. Grim placed great emphasis on the track and the importance of getting to know it thoroughly in order to draw it. At the time he was here I had not started to evolve the theory of musical form being the basis for animation form. Although Grim never spoke of animation structure as being the same as music structure, on looking back, I see that a number of things he advocated fit into music structure. Art Babbitt's successive breaking of joints and overlapping action is comparable to the idea of sounding a group of notes in succession, rather than simultaneously. I suspect that the best animators have worked intuitively to principles that are analogous with musical principles. Grim and Art never expressed them that way, exactly.

DRAWING/ECONOMY—The most controversial theory of Grim's was to set up a series of related drawings and go into them and out of them and through them in the course of a scene. The animators here felt that the system was not economical due to the amount of mental calculation it took to incorporate a pose in a new way once you had used it. They found the numbering confusing and the doping difficult. Grim presented the idea as an economy and they rejected it on that basis.

Later in music class it occurred to me the analogy of Grim's practice with musical practice. The practice of starting with a first and second subject, going through it, repeating it, et cetera.

I think that Grim's idea could be called "using a series of HOME KEYS" (animation keys) and is vindicated on aesthetic grounds if not on economic ones.

This is what he said about it:

"Get key drawings that are so centralized that it is easy to get another similar drawing. Duplicate by exposing it differently. Plan it. Stop on a different drawing. Out of five or six different poses, find three or four positions to work around.

"Never think of one drawing. Think between three or four rough positions. Think of a series of drawings. Saving one drawing saves twenty minutes.

"Use your routine animation, then break away, and then go back into it. In lip sync animate the character in a three-quarter view. Leave the mouth off—in order to repeat or even

reverse the drawings. Make a little hook-up and reverse them. On Snow White we never repeated drawings. (?) (Question mark added by RBW.) Milk everything you can out of everything you have.

"If you have a walk or run do it as a cycle so you can spend the time getting an interesting one.

"Don't ever use a drawing just once if there is any possibility *to use it again.*

"Forget about in-betweens; get the key positions. Then find the nicest way to get from one position to another, remembering all the time that there are several more positions.

"Don't let it all *overlap. Don't entirely lose the position you're leaving until you're ready to settle into the next pose. Keep a little contact with the last drawing. Hold onto something.*

"Always think of at least three positions: the preceding, the present, and the forthcoming.

"Drive right into the main points. Leave out the frills but make the main thing look really right."

THE TRACK AND THE BEAT—Grim placed great emphasis on the beat in the track and using it to the utmost. He was an avid user of the metronome to set the beat in his head. He recommended making up a beat if there wasn't one implicit in the track. This is what he said:

"Don't treat the track lightly. That is your timing. For a walk, plan the action of the main body, then add arms and legs.

"The walk can be on three levels: a pattern for the legs, a different pattern for the body and a different pattern for the head.

"Split it into parts for a dance. Tie it to the sound track. Get that funny sound in there even if it's only one frame. In walks we always had a funny frame in there some way.

"If you have a 24 beat, break it into parts: 16's, 12's, 8's, and 4's. Then trace them together.

"Stagger actions—all kept on beats or partial beats: feet on 16's, body on 8's, arms on 4's, head on ? (question mark).

"Where possible try to get a costume you can break apart for levels.

"Example (For a cow)—the body bouncing on a 24-beat, the legs on 12's, the tail on 8's, a little bounce for the head—all traced together on 24 cycle with bell on a separate level.

"Get the big beats right—then you can almost ignore the little beats.

"Get the secondary beat visually secondary."

BOM BAH BOM

STACCATO ACTION—With Pushkin I went to Grim in need of a way to do a quick snapping action with a minimum of drawings. It was necessary to use a minimum because the drawings were highly rendered in a semi-realistic style. Grim laid out the spacing as below. Grim gave me the impression that this was an innovation for him and he dubbed it "Staccato Animation."

SHOT ON 2's—Soldier coming to attention: 1. At rest. 2. Leg and gun out. 3. Returning just past original position. 4. Heels displaced by downcoming foot. 5. At attention.

1. Extreme (hold)
2. Anticipation
3. In-between (Indicating start of, and direction of action.)
4. Impact
5. Extreme (Hold)

STRAIGHTS VERSUS CURVES—The practice of playing straights against curves was a pet idea of Grim's and I came to appreciate the power of straight lines from him. Straight lines as an indication of strongly impelled action, that is, both in static drawings and in animation.

Grim said:

"When animating I always draw the paths of action on a separate piece of paper as a guide (loops, arcs, et cetera).

"Curves are always beautiful to watch. That's why Bill Nolan used rubber hose animation.

"Straight lines give power.

"Flow from one joint to another, moving arms in a lot of grooves.

"Play the angled joint against the straight.

"The head can be moving in a circle, hands in a figure-8, feet in loops or arcs.

"The patterns that are made in space by the moving parts—that is called the Poetry of Animation.

What caused a splash? Where did it come from? Bring it out from <u>exactly</u> where the hit was, in straight lines."

PACE OR TIMING—

"Make it faster by fast spacing or by fast timing. Normal spacing is on two's; fast spacing on one's. Timing must fit the sound track.

"To get snap into it—get out of orthodox timing.

"Use one drawing or two frames for normal anticipation but obviously more are needed to get into a run or a big action.

"Get a key drawing that is the best drawing you can make. Then you can hold it. Hold it six frames; eight, ten or twelve frames or even one and a half feet. Very often a still drawing will help the picture—you can read the expression.

"Use wide spacing to hit the accent. Soften into your holds.

"For snap, space it as wide as you dare. It's best to go past and then return. This applies to softening into a hold.

"Eight frames is almost but not quite a hold. Don't think of eight frames as a hold. It's just a hesitation, soften in and soften out of it.

"On a figure running who skids to a halt: As he puts on the brakes stagger it 1, 4, 2, 3, 5, 4, 6, 5, 7. Have him go too far forward then come back. Slow down the pan as he gets his balance."

"There is a difference in the spacing of a walk. The foot moves faster going forward to contact. The impact of the foot hitting the ground tends to slow it down. Keep the pan locked with the foot positions on the ground.

On a three-quarter-waltz time try a triple bounce.

Hitting a beat...I've never found it wrong to hit one frame or possibly two frames ahead of the beat.

Hit the downbeat on a dance when the weight is down.

The two great things in animation are spacing and timing."

IN-BETWEENING—I always try to keep everything in three in-betweens or one. If I have four in-betweens, then I'll draw one, making it three in-betweens.

To get snap into your action, don't just in-between it, play one part against another. Play the joint against the straight line.

One of the defects of bad animation is too many close in-betweens. They make it jitter. To avoid ink and paint jittering avoid in-betweens too close together. Try to go farther. Avoid overlapping lines.

Jitter equals lines too close together. Make it broader. Avoid soft spacing.

Everything should be readable. Everything should be smooth, unless you deliberately jitter it because you want it that way.

The theory is to keep a little contact with the last drawing.

Hold onto something but the biggest danger is keeping in-betweens too close together.

QUOTES FROM GRIM NATWICK

I ask anybody's opinion. I may not use it—but it may help me find what I'm fishing for.

Very often the improvement makes it easier.

Rough out fifty or sixty drawings a day. Test it and then chisel it down.

It's easier to go too far and cut it down than to exaggerate it more.

Take those chances which might make it interesting or funny. It doesn't have to be funny but it should be interesting. It should be funny if it's unexpected.

Try something that you wouldn't dare to do—and most of the time it will work.

Get every possible gag in if it doesn't slow up the story.

Every time you increase your draftsmanship, you improve your animation.

I am an intense believer in going through a scene and roughing out ten feet or so; then getting the good drawings. Then you probably only need in-betweens.

A little bit of animation is like making a sentence using (Art) Babbitt's alphabet.

Don't be afraid to break a thing down.

Drive to one word or one point in each scene.

The eye will always follow the chief action.

Leave the best gags toward the end—the best at the last.

In a walk, the foot is always a little in front of the weight of the body.

Get a feeling of balance in every drawing. One part starts first, other parts follow.

In a tap dance, if the drawing looks good chances are it will work well.

Foot to the beat—hit it hard.

Is ugliness more interesting than beauty?

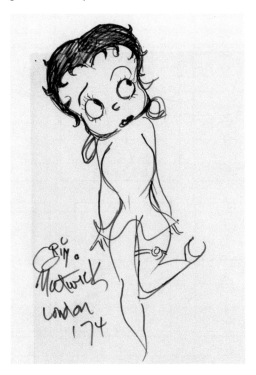

Drawing by Grim Natwick (Collection: Suzanne Wilson)

THE SECRET OF ANIMATION IS:

So-called animation effects ultimately come down to the "extreme" drawing. There is no fantastic effect that does not depend on an explicit, convincing single bizarre drawing. (Example: Elephants piling up on each other like cars on a freight train.) This idea is supported by timing and sound effects but it would never be believable without a convincing single extreme drawing which depicts the action exactly.

Animators are nothing less than the *master* cartoonists of the world whose most amazing creations are hidden in a series of less startling caricatures.

If one took those extremes out of context and held them long enough to examine, the world would be astonished.

There is no reason why a printed book could not have the same impact as animation.

All that is necessary is for the artist to be capable of depicting an animation extreme. No small order.

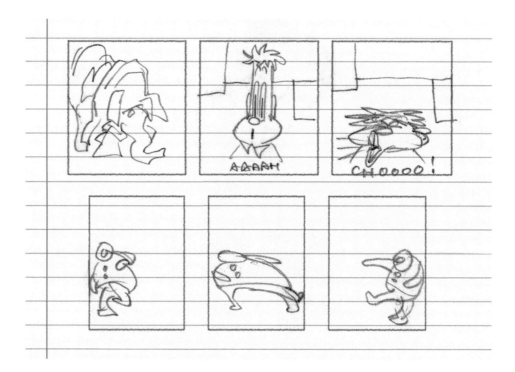

WHERE IDEAS COME FROM

Ideas come from other people's vision of life's truths, when your own ideas of truth clash against them.

Clichés are grist for the humorist's mill.

If you go to a cliché situation, find ten different ways to play a new version of it. (For example, the singles bar scene has surprise—the unexpected obvious.)

People are overexposed to story today. What are you going to show them that they haven't seen before?

RESEARCH—Imagine what it would feel like to be the character when the event happens to him. If you have writer's block, ask yourself why. Maybe you don't have anything to say.

Paradoxically, ideas can come through the limitations of choosing time, place and genre. Documentary, murder mystery, thriller, and comedy—all suggest their particular elements. In an action adventure the "hero at the mercy of the villain" is a convention of the genre. To fulfill the reversal in an original way is to *use* the limitations of the genre.

Study genres by watching films to see what they have in common. Read the scripts if possible to find the conventions. Conventions evolved as things that worked. As times change the conventions change. The first film to change the convention is the memorable one.

Do films change society or society change film? The same question refers to advertising. Society changes first obviously.

WAYS OF APPROACHING THE PROBLEM

1. Breaking it into its modular parts.
2. Reversing it. Starting at the goal and working back.
3. Negating it. Stating it as contrary to the way it's stated—and examining it that way. Problems are in two parts—data and program. One is an encyclopedia; the other is a process.
4. Try translating the parts into other codes or languages to see if the relationships become more obvious.
5. Lining up two ideas (structures) parallel to each other and matching out pieces (frames, voices, characters) from each to form a new pattern.
6. Conceptual Skeleton. A device for creating new ideas by combining two structures.

DISCOVERING USEFUL IMAGES

Images common to all symbolists, science fiction and works of imagination—

1. Complexity—A myriad of objects stuck together, patchwork.
2. Vastness—Vast cliffs, castles, ships, et cetera.
3. Mixed anatomies—Combinations of human with animal with insects, birds and machines.
4. Skeletal variations.
5. Levels—Flying and falling.
6. Esoterica—Mandalas, haloes, fiery objects, lights and lightning.

Dream Images—

1. Labyrinths—The city and under the city.
2. Obstructions—Ditches, moats, broken bridges and dead ends.
3. Flying devices—Umbrellas, birds, motor scooters and others.
4. Vertical conveyances—Elevators, conveyor belts and escalators.
5. Horizontal conveyances—Trains, trolleys, and tracks like labyrinths, bridges and tunnels.

More rarely seen images—

1. Animated objects—Houses, mountains, boxes, hoses, ropes, mechanical objects, rocks, trees and flowers.
2. Animated elements—A watery figure, a figure of fire, a wind figure, cloud figures, animated landscapes.
3. Machine combined with an organic form—Such as a flexible space ship, like a plastic manta ray (Soft sets).
4. A place or person which is in opposition to our normal lighting, such as lit from within.
5. A place different in density of atmosphere or gravity.
6. Out-of-place weather phenomena—Hot rain, snow in clear weather, sleet or hail of a different size or color, fog with lightning, unusual wind.
7. Reversed gravity or magnetism of a particular kind.

MORE ON THE CLICHÉ

Clichés are goods to the humorist as grain is to the miller. A cliché is a saying or image with enough insight or truth in it to be worn smooth by constant usage by the unimaginative. It has merit within it. A humorist uses his insight to bring out the aspects of it that simple repetition of it misses. In a cartoon the saying is accompanied by an image (or vice versa) that surprises but is appropriate to its referent.

Every genre of story is a system of clichés. It's a good system that has "stood the test of time." All it needs are new ingredients to be enjoyed all over again. Really new—not updated clichés to replace those of yesterday and not mere parodies of reversal.

The clichéd expectations of a jaded audience are a sparkling opportunity for fun and surprise! Set it up—and zizz it in there!

COMEDY: JOKES AND GAGS

Comedy is what happens after "happily ever after."

A joke absolutely depends on the setting up of a common image complete with all of its conventions, virtues and involvements. Example: Two men go duck hunting. After three days they had not gotten any ducks. "We must be doing something wrong," one of them says, "Maybe we're not throwing the dog high enough."

1. The situation of two men duck hunting sets up the complete conventional image of men in a blind with decoys, calls, costumes, guns and equipment and retrievers. This is the conventional image.
2. The fact of going three days without catching any ducks furthers the conventional image of skillful patience and persistence (Virtue.)
3. "We must be doing something wrong", brings out the difficulty and technique of the sport and emphasizes the good sense and intellectual aspects of the men. It also sets the listener off (down the garden path) to evaluating the subtleties involved—the blind, the location, the setting up of decoys, et cetera. This is involvement.
4. "Maybe we're not throwing the dog high enough." All the credit you gave the men as duck hunters is exploded.

The scene is set, the atmosphere created, relationships sketched and audience involvement brought in. Then, with the audience's disbelief suspended, it all pops like a balloon.

In a sense, a joke is an act of aggression against the audience: the hearer. Their own mind-set is used against them. There is a strong desire to retaliate—that is, to tell a joke back to the teller (to get even?). Why do people think the experience of hearing a joke is pleasurable? Why is laughter pleasurable?

In review: The teller enjoys superiority by telling. The listener feels superiority to the fictional characters but discomfort at being duped. He wants to "tell another" to get his own back.

Entertainment is the fun of seeing somebody else make mistakes. Comedy is little mistakes and tragedy is big mistakes.

ART ON A SURFACE

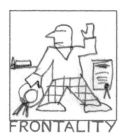

Frontality is a primitive way of seeing.
It is the seeing of *things*.
The forms and shapes are nouns.
The modifications and decorations are adjectives.
It is an object(ive) way of seeing.

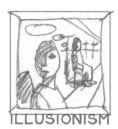

Illusionism is a camera way of seeing.
The camera sees a frozen gestalt pattern.
The pattern is a one-eyed two-dimensional code.
The code stands for visual relationships of space, line and form.
It is also an objective way of seeing.

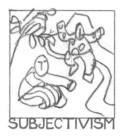

There is a subjective way of seeing.
The artist's eye is the subject.
The noun-object and its visual relationships are interpreted and shared.
The object and the subject are both seen.

Despite our extrapolations, all three visions are two-dimensional.
The "object" is two-dimensional.
The "space, light and form" is two-dimensional.
The "artist's eye and interpretation" is two-dimensional.
The most essential aspect of art-on-a-surface is its two-dimensionality.

The expressive but design-fracturing aspects of illusion are brought over into flat design. Tension is created by subordinating a powerful system within the dimensions of a simpler system: three-dimensional into two-dimensional. This demonstrates the scientific idea that systems are understood only through their limits: their limits define them.

WHAT IS ART?

A union of opposites—this is one half a definition, the critical half. The other half is creative—the leaping of the gap.

The critical half may be defined; the creative half must be intuited. We can only talk about the critical half. That is the nature of the two halves…one can be talked about and the other cannot.

In the critical half we can determine if the artwork is a union of opposites.

The opposites are the content. The union is the form. A good work may be strong in content or strong in form. An excellent work is strong in both.

A narrative work of art is a dynamic union of opposites. When one opposite overcomes the other, the narrative is done.

In a pictorial work of art the opposites are united in a dangerous balance of power. Ideally, one more stroke would upset the balance. That is the dynamism of the work.

In a joke or cartoon, opposites coexist in an impossible or absurd union.

Richness in a work of art is based on the quality and quantity of the opposites and the brilliance of the union.

Works of art may be judged by this criterion but not created by it. But they may be corrected by it—with intuition.

Art and Artistry

The fear and anxiety over defining art is the result of critics and artists alike not being able to separate content from technique in discussing art.

There is justifiable anxiety in defining art in any technical terms that would tend to limit expression and create an academy of fixed means. Yet art is expressed through technique of some sort.

Art itself is a complex of ideas: visual, philosophical, emotional and technical, synthesized into the artwork in a living, interacting paradox. Art lives as an organism. It is not a dead singular unit. It reflects the complexity of an individual.

But the technique of art, the means by which the complex of art is made, is another matter. This technique I call artistry. It is not individual as the artist's vision is individual, but universal as the laws of physics are universal. (This term *universal* is not to be confused with universal ideas such as love, goodness, truth, et cetera, which are universal abstractions. The universal laws I'm talking about are universal laws of aesthetics—almost in the sense of universal laws of mechanics.)

Artistry then, is the manipulation of complements: dark and light, hard and soft, plain and figured, figure and ground, motion and form, et cetera. All these complements can be *either* harmonious or contrasting—and nothing else.

The artist uses his taste and vision in making the work a complex of harmony and contrast.
Bad art is most often a result of a technical failure in the area of artistry.

1. Too much harmony; too little contrast.
2. Weak unrealized harmony; weak contrast.
3. An unplanned or unrealized scheme of harmony and contrast.
4. Portions of the work not fitting the main scheme of harmony and contrast.
5. Too much contrast breaking up the composition. (Nothing but contrast is impossible because it then becomes all harmony.)

To be a picture doctor, study the troublesome areas in this light.

$$\text{SIGNATURE} = \frac{\text{HARMONY}}{\text{CONTRAST}}$$

To deal effectively with harmony and contrast you must know the complements.
Discovery: Shape and Line are complements.

Shape and line combined =
Real physical media (media expressive)
Which in turn is a complement to
Illusion—
Which is made of—
Representation.

- Form and motion are complements.
- Art is subjective / Artistry is objective.

STATEMENT OF THEORY

The Paradox Principle:

The coexistence of complements = the unsolvable riddle = life.

Life is a question. Death is a conclusion.

The play is over when the mystery is solved.

PARADOX I—SURFACE VS. ILLUSION:

Paint vs. Image

Picture Plane vs. Pictorial Space

Dots, Lines, Planes vs. Solids

This is a drawing of "the character." The character is real but this is not him. This is a *drawing* of him and his world. To depict "the character" as if you were showing a drawing you did when you were there creates a system within a system.

The artist becomes the narrator. His style says "once upon a time"! That's why straight illusion is less than satisfying. Since it lacks three of the five senses it can never be "realistic" enough.

STATEMENT OF PARADOX—The more the character looks like a drawing, the more "real" he is.

PARADOX II—BALANCE:

Large vs. Small

Near vs. Far

Dark vs. Light

Object vs. Space

Figure vs. Ground

Dominance vs. Defiance

Harmony vs. Contrast

PARADOX III—COLOR:

Warm vs. Cool

Bright vs. Dull

Dark vs. Light

Broken vs. Flat

Compound vs. Primary

PARADOX IV—DRAWING:

"Signature" vs. Drafting

Organic vs. Geometric

Accuracy vs. Exaggeration

Emotion vs. Reason

Hard vs. Soft

Form vs. Motion

PARADOX V—TONE:

Collage vs. Scene (Illusion)

Silhouette vs. Solid

Positive vs. Negative

Compound Notan vs. Primary Notan (Silhouette)

Flat-Tone Shapes (No Drawing) vs. Broken-Tone Shapes (All Drawing)

THE REMEDY PARADOX—If a thing seems insufficient then subtract some of it. If a thing seems too much, then add to it.

Go to the complement. Dark shows off light. Warm shows off cold. Soft shows off hard. Dull shows off bright.

Expect the unexpectable,
Prepare for the unheard-of,
Anticipate the impossible,
Imagine the unimaginable,
And sooner than possible.

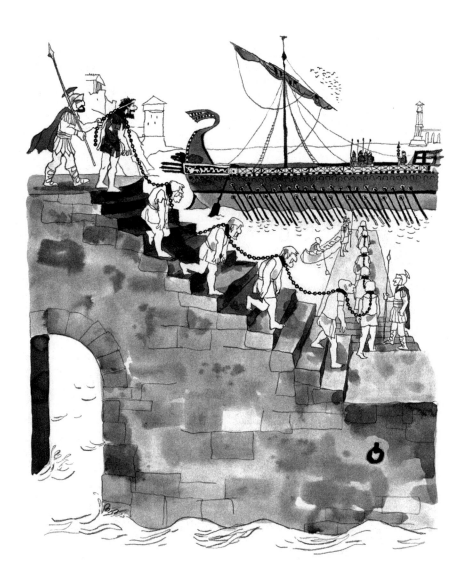

"What a magnificent ship—what makes it go?"
Originally appeared in Esquire *magazine, 1962*

11

GALLERY

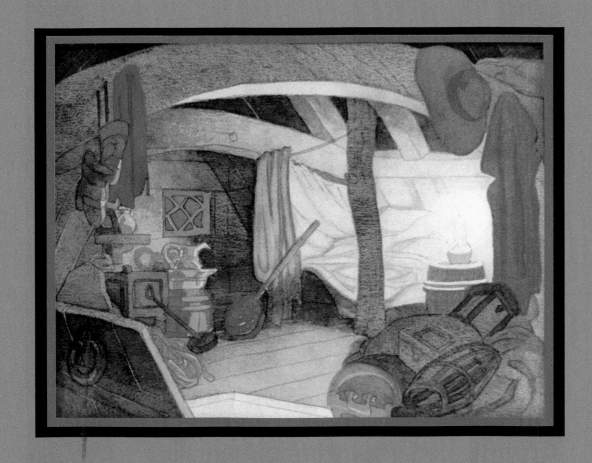

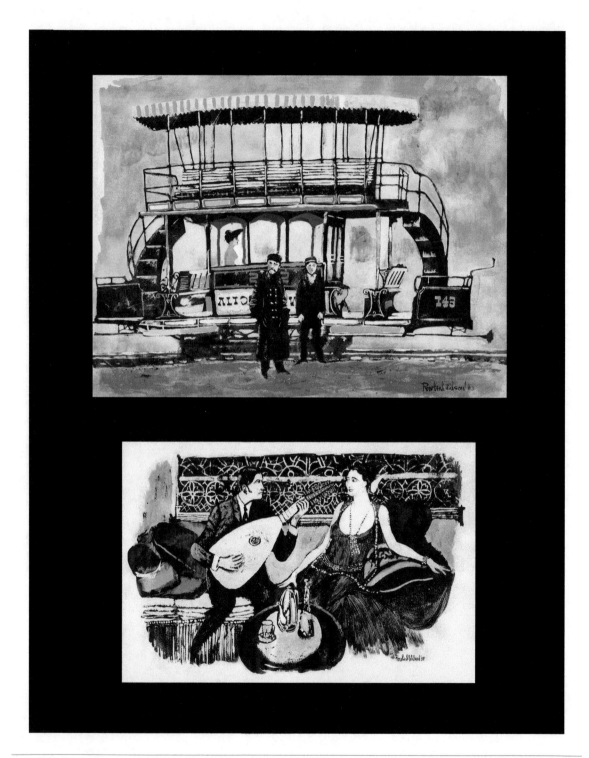

RESIST INK PAINTINGS

Top: The Canarsie Rockaway Beach All Points 1883, *Bottom:* Serenade

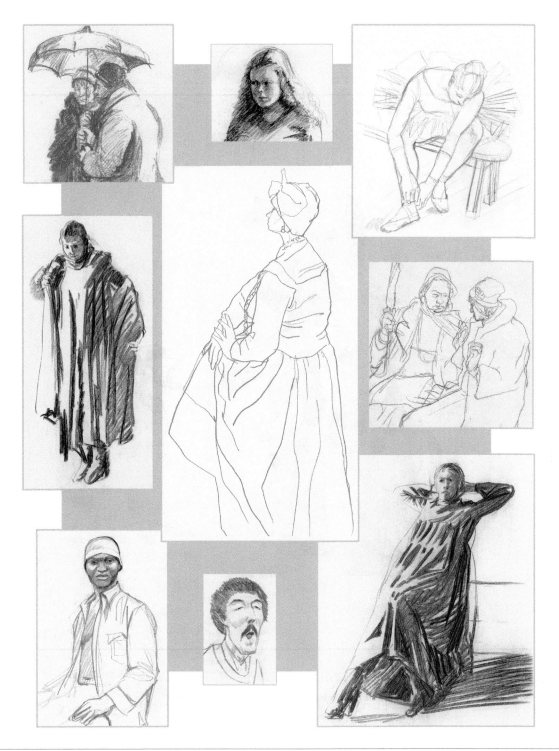

LIFE DRAWINGS, LONDON

"Keep working on it. I like the concept, but it lacks scope."

From THE NEW YORKER © Rowland Wilson/The New Yorker Collection/www.cartoonbank.com

"Look. You think they're hideous and I think they're hideous, but maybe the bishop doesn't think they're hideous."
From THE NEW YORKER © Rowland Wilson/The New Yorker Collection/www.cartoonbank.com

"Well, it was a great empire while it lasted."
From The Whites of Their Eyes

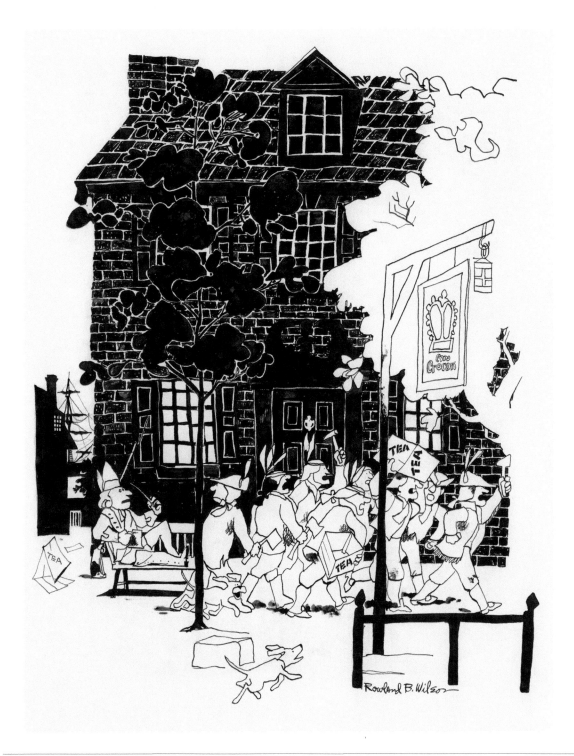

"What was all that hubbub in the harbor?"
From The Whites of Their Eyes

ATMOSPHERE SKETCHES FOR AN ORIGINAL STORY...

...*BASED ON FEATHERTOP BY NATHANIEL HAWTHORNE*

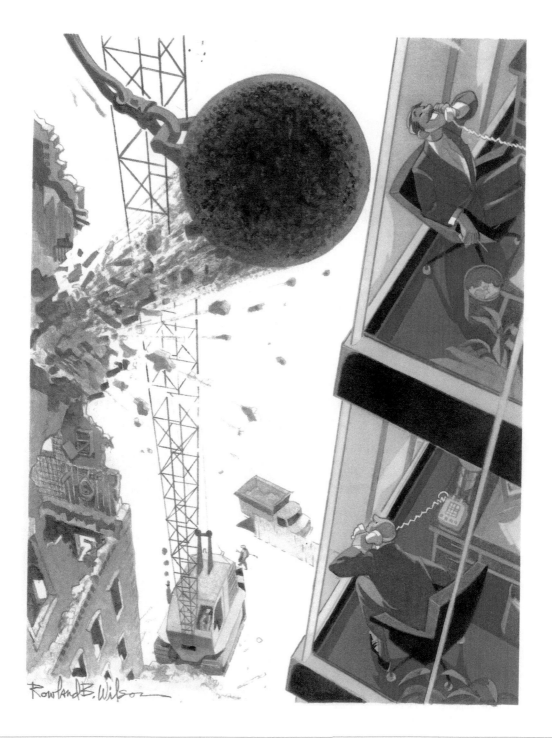

...BASED ON AN INSURANCE ADVERTISING CAMPAIGN

Originally appeared in *TV Guide Magazine*, February 12, 1977

Originally appeared in *TV Guide Magazine*, September 27, 1975

Originally appeared in *TV Guide Magazine*,
May 22, 1971

Originally appeared in *TV Guide Magazine*, October 9, 1971

Originally appeared in *TV Guide Magazine*, November 5, 1988

Originally appeared in *TV Guide Magazine*, November 22, 1980

ILLUSTRATIONS FROM TV GUIDE MAGAZINE

"I don't mind it really—I'm only here to gather material for a book."
Originally published in Esquire magazine, August, 1960

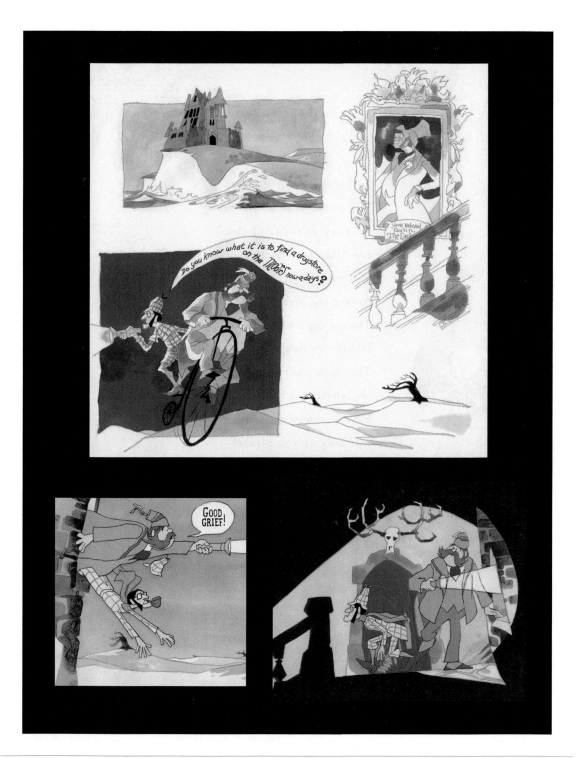

CONCEPT ART AND ANIMATION CELS—PHIL KIMMELMAN AND ASSOCIATES

A PIRATE SONG

Yo ho! Yo ho! Yo ho!

They say that we are not pea-cocks.

They say we're full of fleas!

Low unlaundered laughingstocks

Who sail a leaking litterbox

Around the West In-dies.

That our ship is a sty,

Is a lie we deny.

That our ship isn't neat,

We repeat, is a lie.

For we're as regular as clocks

And tidy as you please!

When Christmas comes

We wash our socks.

And on the Vernal Exquinox

We

change

our

Bee-vee-dees!

From PISTOL'S PIRATES

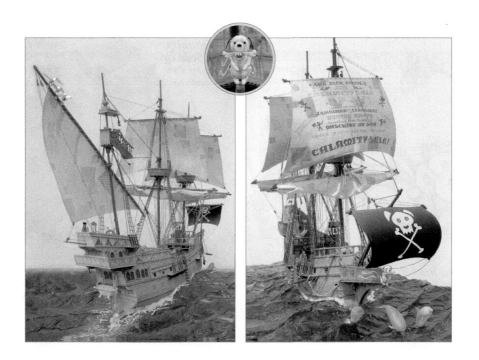

Model for pirate ship THE SEA MUTT from Pistol's Pirates

The Werx Brothers perform a hornpipe dance (From Pistol's Pirates)

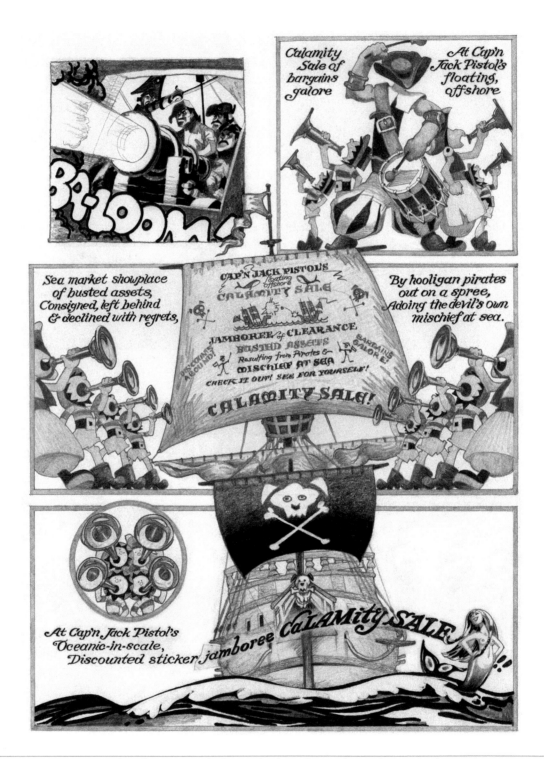

The pirates announce "Cap'n Jack Pistol's oceanic-in-scale, discounted sticker jamboree Calamity Sale" (From Pistol's Pirates)

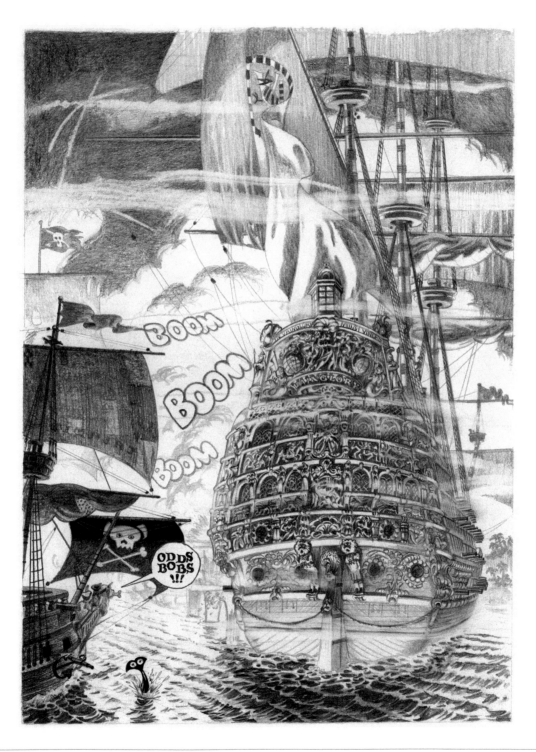

THE SEA MUTT encounters the British man-o'-war, THE HMS VAINGLORY
(From Pistol's Pirates)

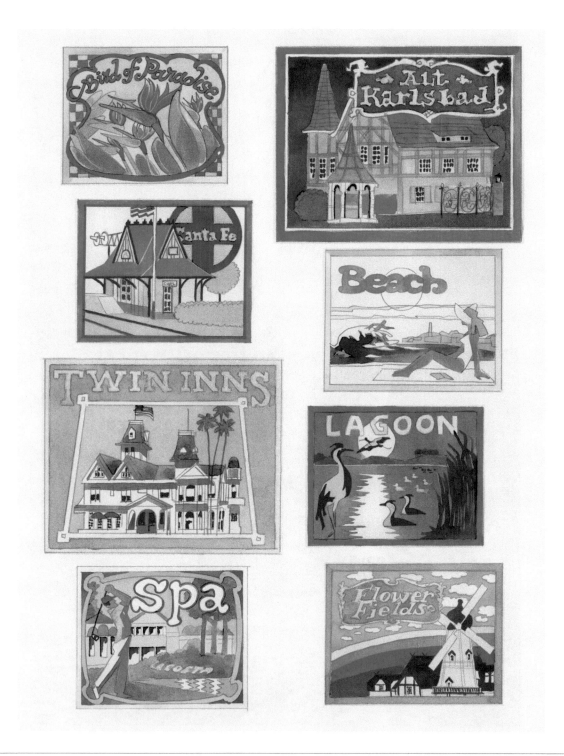

DESIGNS FOR A PUBLIC ARTWORK INSTALLATION, CARLSBAD, CALIFORNIA

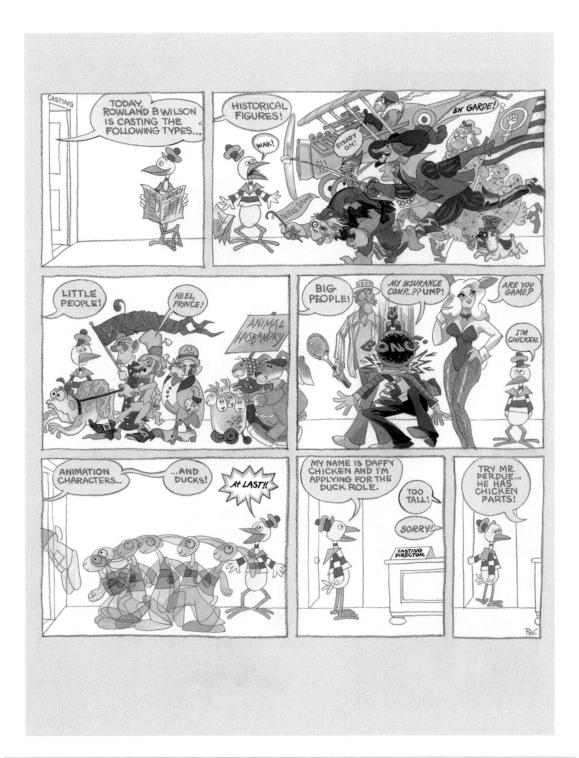

PROMOTIONAL ART FOR AMERICAN SHOWCASE

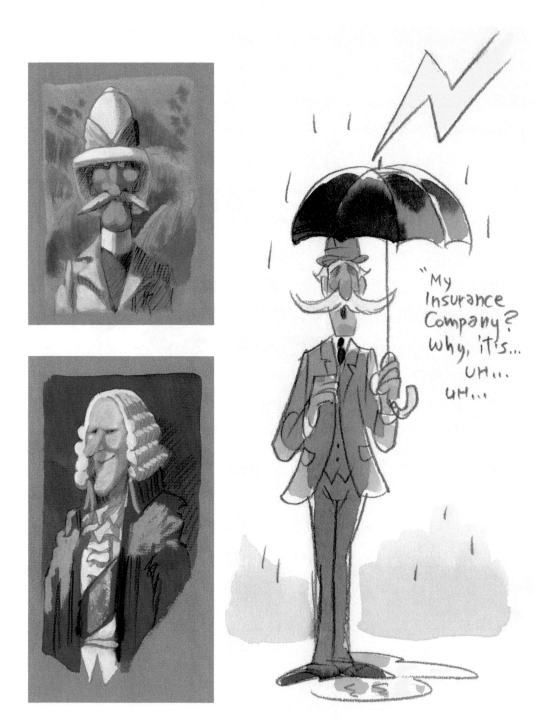

© Disney

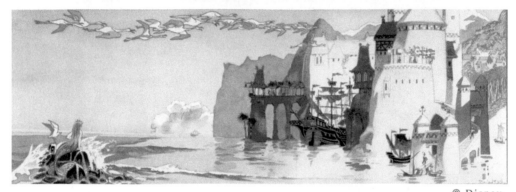

© Disney

Concept Art from Walt Disney's
The Little Mermaid

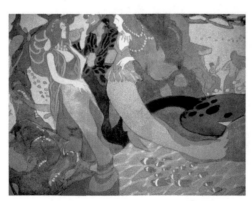

© Disney

© Disney

CONCEPT ART FROM WALT DISNEY'S The Little Mermaid
© Disney

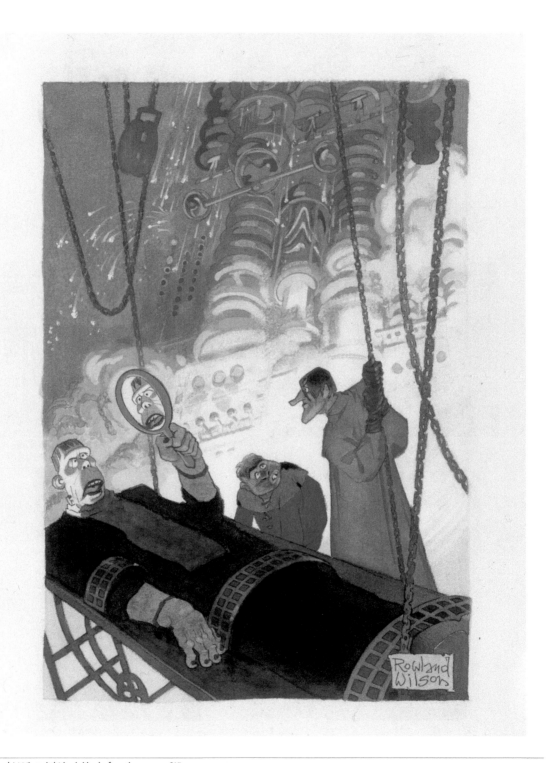

"My gosh! What did I look like before the surgery?!"

Reproduced by Special Permission of Playboy magazine. Copyright © 1988 by Playboy.

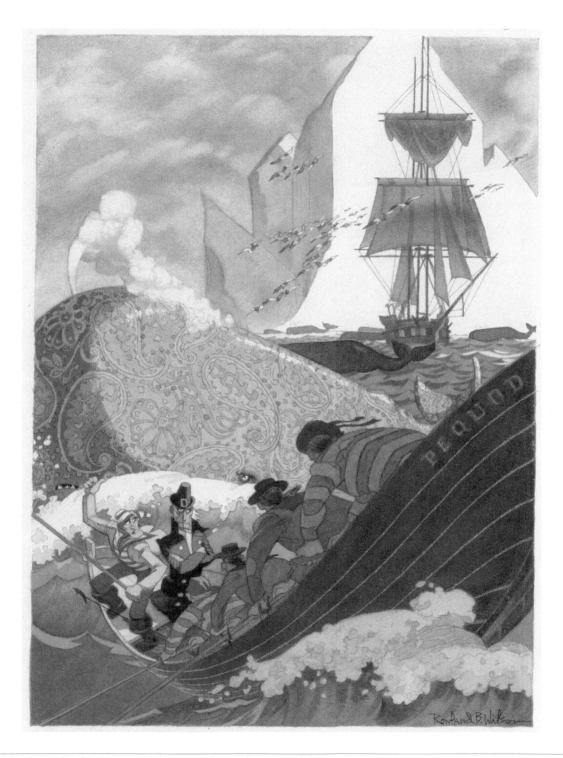

"Does it have to be white, Captain? Would you consider something in a paisley?"
Reproduced by Special Permission of Playboy *magazine. Copyright © 1978 by Playboy.*

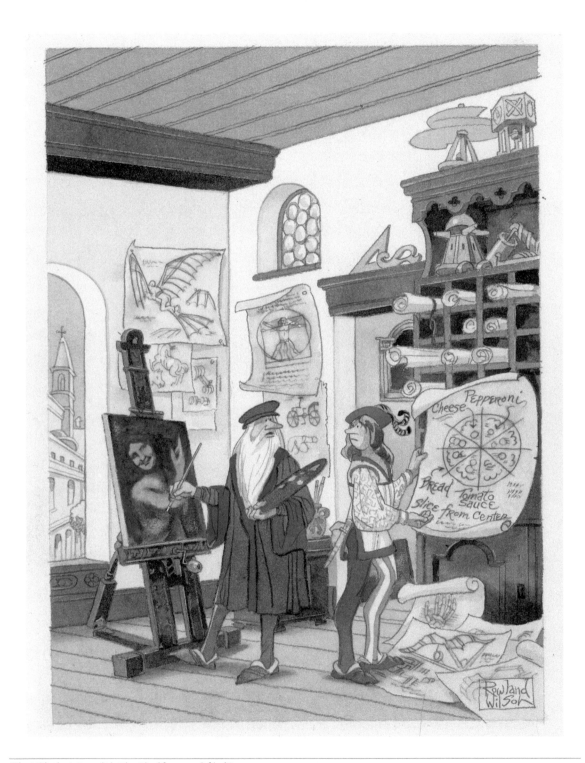

"That! Oh, that's just a little idea I had for a snack food!"

Index

Acknowledgments

FOCAL PRESS/ELSEVIER:

Katy Spencer

Amy Langlais

Lauren Mattos

Graham Smith

Anne McGee

Cedric Sinclair

Anais Wheeler

Dave Bevans

Joanne Blank

Carol Lewis

Beth Roberts

PERMISSIONS AND CLEARANCE RESEARCH:

Lella F. Smith

Margaret Adamic

Amanda Warren

Tanya Robinson

Gary Goldman

Eileen O'Malley Spangler

Merrideth Miller

Tracy McDonald

Steve Ciccarelli

Maxine Hof

Lisa Koes

Peter Vatsures

WITH SPECIAL THANKS TO:

Bill Peckmann, Denis Wheary, Phil Kimmelman, Michael Sporn, Richard Williams, Tina Price, Dean Yeagle, Kevin Gollaher, Stephanie Schreiber, Geraldine Lemieux, Margo Lemieux, Amanda Wilson, Reed Wilson, Kendra Wilson, Megan Wilson, Manfred Klein (for UglyQua font page 290), Orlando Busino, Chris Browne, Bob Weber Sr., Roy Doty and my Corona La Costa neighbors and their friendly dogs.

ROWLAND B. WILSON'S
TRADE SECRETS

POCKET GUIDE

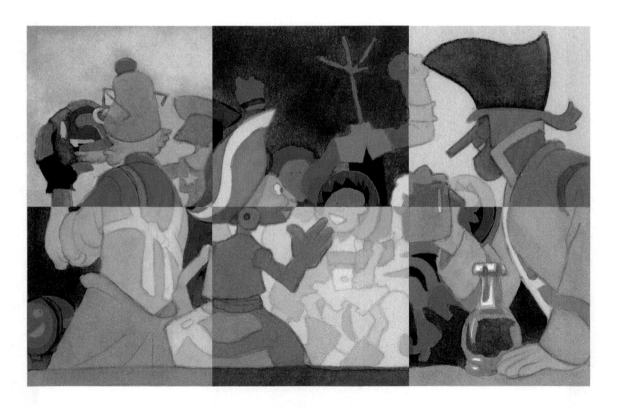

Rowland B. Wilson

THE ACT

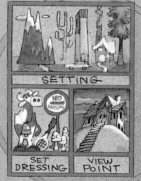

SETTING

THE SCENE

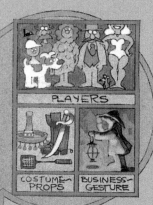

PLAYERS

SET DRESSING

VIEW POINT

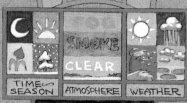

TIME SEASON

ATMOSPHERE

WEATHER

COSTUME PROPS

BUSINESS GESTURE

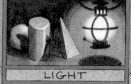

LIGHT

CARICATURE

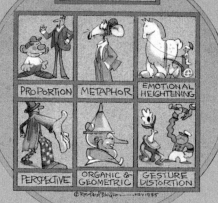

PROPORTION

METAPHOR

EMOTIONAL HEIGHTENING

PERSPECTIVE

ORGANIC & GEOMETRIC

GESTURE DISTORTION

INTERPRETATION

THE FLOW CHARTS visually guide you from concept to finished art. INTERPRETATION begins with the original idea and moves through designing characters, background, atmosphere, lighting and caricature.

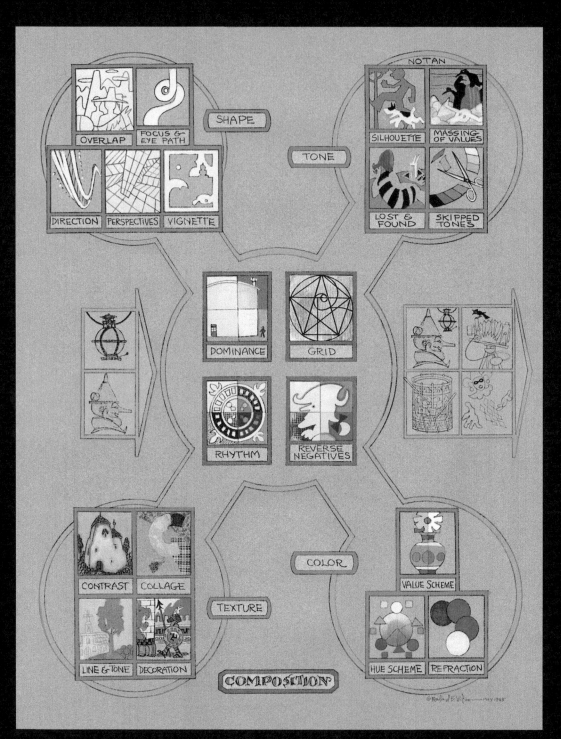

COMPOSITION helps you decide in order how to set up your artwork with regard to elements of shape, tone, texture and color to create the best design possible.

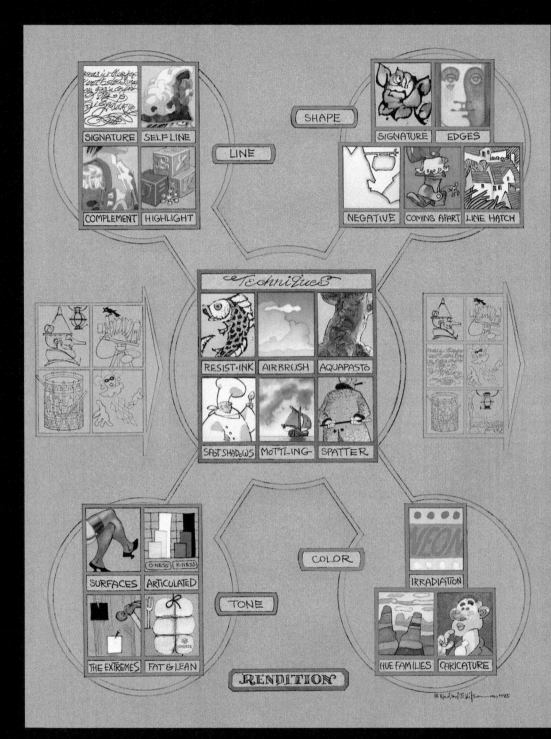

RENDITION aids in the completion of the project through considerations of individual style and specific techniques, bringing your art to fruition.

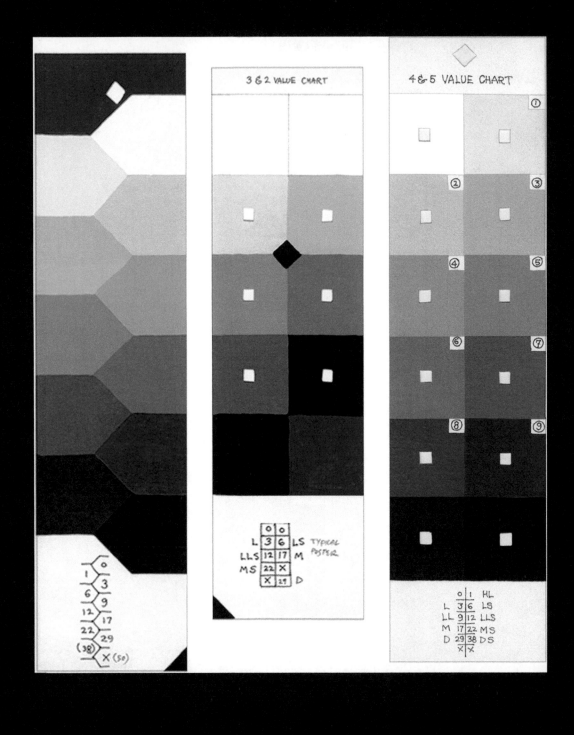

3 & 2 VALUE CHART

4 & 5 VALUE CHART

①

② ③

④ ⑤

⑥ ⑦

⑧ ⑨

	0	0	
L	3	6	LS
LLS	12	17	M
MS	22	X	
	X	29	D

TYPICAL POSTER

	0	1	HL
L	3	6	LS
LL	9	12	LLS
M	17	22	MS
D	29	38	DS
	X	X	

		0
1		
		3
6		
		9
12		
		17
22		
		29
(38)		
	X	(50)

VALUE CHARTS help you organize the tones in your design. Try to group light and dark values into large simple shapes for a stronger composition.

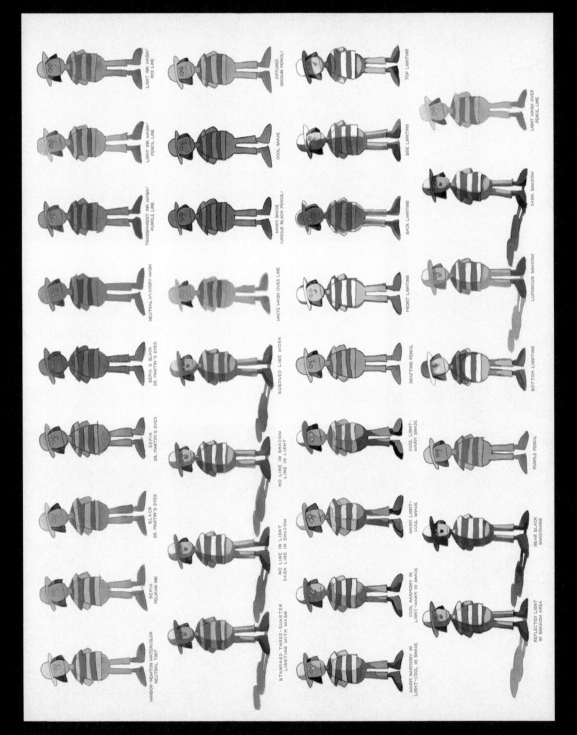

LIGHTING EFFECTS AND TECHNIQUES—This chart shows techniques using ink, watercolor and pencil; variations of line work; warm and cool harmonies and various treatments of light and shadow.

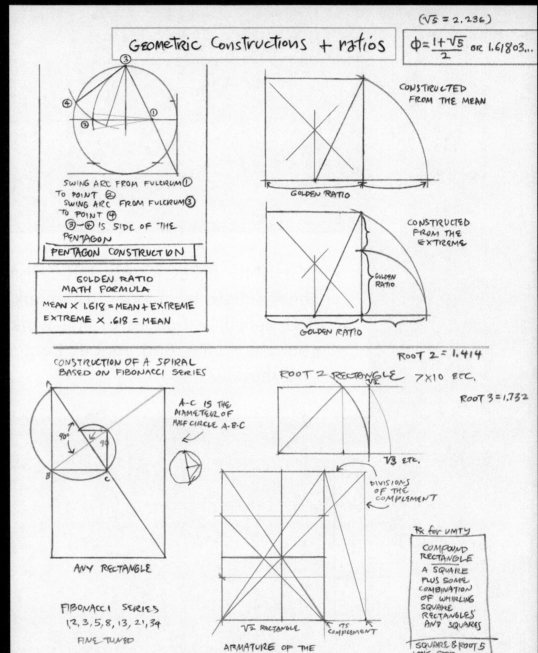

Geometric Constructions + ratios

($\sqrt{5} = 2.236$)

$$\Phi = \frac{1+\sqrt{5}}{2} \text{ or } 1.61803...$$

SWING ARC FROM FULCRUM ① TO POINT ②
SWING ARC FROM FULCRUM ③ TO POINT ④
③—④ IS SIDE OF THE PENTAGON

PENTAGON CONSTRUCTION

GOLDEN RATIO
MATH FORMULA
MEAN × 1.618 = MEAN + EXTREME
EXTREME × .618 = MEAN

CONSTRUCTED FROM THE MEAN

GOLDEN RATIO

CONSTRUCTED FROM THE EXTREME

GOLDEN RATIO

GOLDEN RATIO

CONSTRUCTION OF A SPIRAL BASED ON FIBONACCI SERIES

A–C IS THE DIAMETER OF HALF CIRCLE A·B·C

90° 90

ANY RECTANGLE

FIBONACCI SERIES
1 2, 3, 5, 8, 13, 21, 34

FINE TUNED

118, 191, 309, 500, 809, 1309, 2118, 3427

ROOT 2 = 1.414

ROOT 2 RECTANGLE $\sqrt{2}$ 7×10 ETC.

ROOT 3 = 1.732

$\sqrt{3}$ ETC.

DIVISIONS OF THE COMPLEMENT

$\sqrt{2}$ RECTANGLE ITS COMPLEMENT

ARMATURE OF THE RECTANGLE
(RECTANGLE + COMPLEMENT EQUAL A SQUARE)

Rx for UNITY

COMPOUND RECTANGLE
A SQUARE PLUS SOME COMBINATION OF WHIRLING SQUARE RECTANGLES AND SQUARES

SQUARE & ROOT 5 LOOK GOOD
14472 = 7×10 TYPE

GEOMETRIC CONSTRUCTIONS AND RATIOS
shows the Golden Ratio and how to construct
rectangles based upon it for more harmonious
compositions.

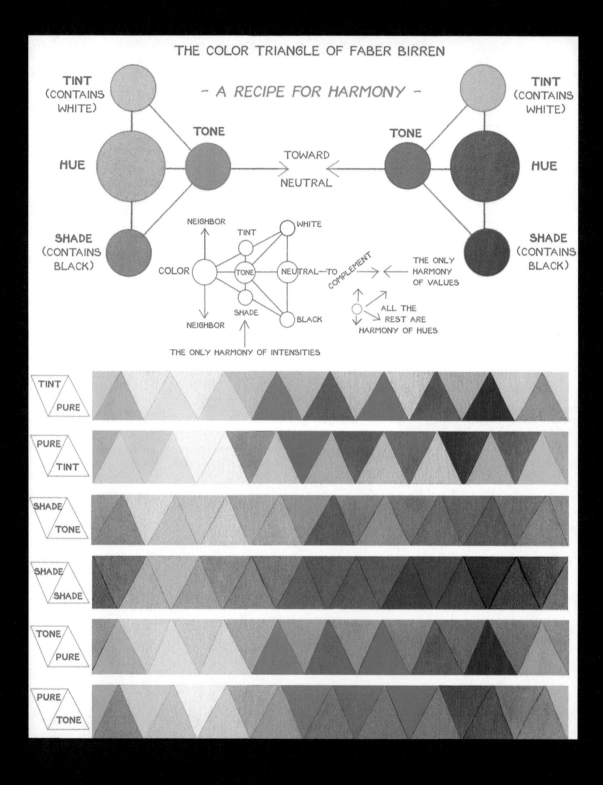

COLOR TRIANGLE—The Recipe for Harmony analyzes the properties of color in order to understand the differences among tints, hues, shades and tones. Examples demonstrate the variations.

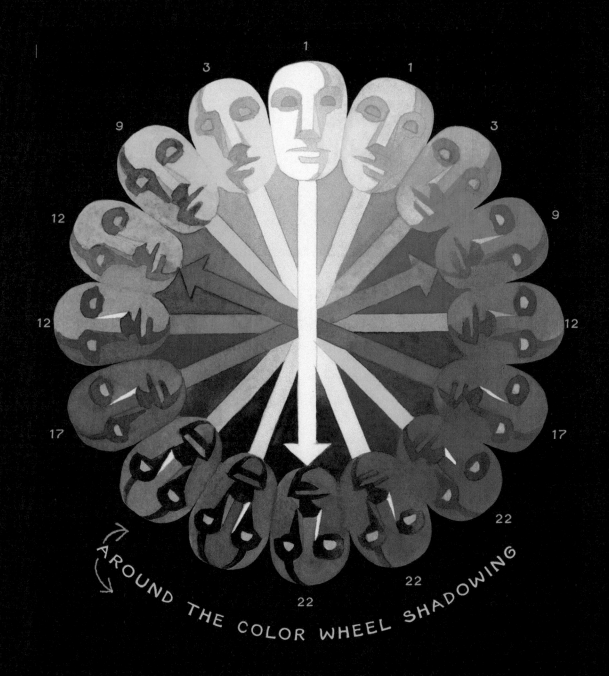

AROUND THE COLOR WHEEL SHADOWING

COLOR WHEEL is a guide for creating richer color by moving around the color wheel and mixing light and shadow areas from neighboring color instead of adding white or black.